LEGO® SPACE
BUILDING THE FUTURE

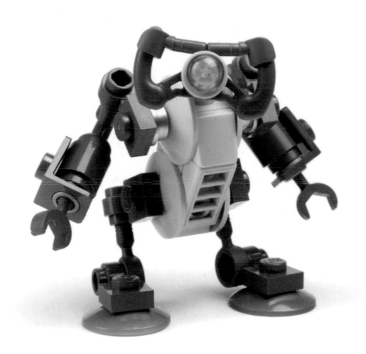

PETER REID and **TIM GODDARD**

no starch press

San Francisco

First printing

Printed in China

17 16 15 14 13 1 2 3 4 5 6 7 8 9

ISBN-10: 1-59327-521-8
ISBN-13: 978-1-59327-521-1

Publisher: William Pollock
Production Editor: Serena Yang
Cover Design: Tina Salameh
Interior Design: Chris Salt
Photographs: Ian Greig and Chris Salt
Stock Images: NASA
Building Instructions: James Shields
Additional Valor Squadron Models: Andrew Hamilton
Developmental Editor: Tyler Ortman
Copyeditor: Katie Grim
Proofreader: Laurel Chun

For information on distribution, translations, or bulk sales,
please contact No Starch Press, Inc. directly:
No Starch Press, Inc.
245 8th Street, San Francisco, CA 94103
phone: 415.863.9900; fax: 415.863.9950;
info@nostarch.com; http://www.nostarch.com/

Library of Congress Cataloging-in-Publication Data
Reid, Peter, 1974-
 LEGO space : building the future / by Peter Reid and Tim Goddard.
 pages cm
 Summary: "A beautiful, four-color book that showcases an epic LEGO universe. Full of advanced models guaranteed to inspire, as well as simpler models with building instructions"-- Provided by publisher.
 ISBN 978-1-59327-521-1 (hardcover) -- ISBN 1-59327-521-8 (hardcover)
 1. Space ships--Models. 2. Astronauts--Models. 3. Extraterrestrial beings--Models. 4. Planets--Models. 5. LEGO toys. 6. Astronautics--Miscellanea. 7. Outer space--Miscellanea. 8. Science fiction--Miscellanea. I. Goddard, Tim, 1977- II. Title.
 TL844.R45 2013
 629.4022'8--dc23
 2013028258

Production Date: July 24, 2013
Plant & Location: Printed by Everbest Printing (Guangzhou, China), Co. Ltd
Job/Batch #: 114806

CONTENTS

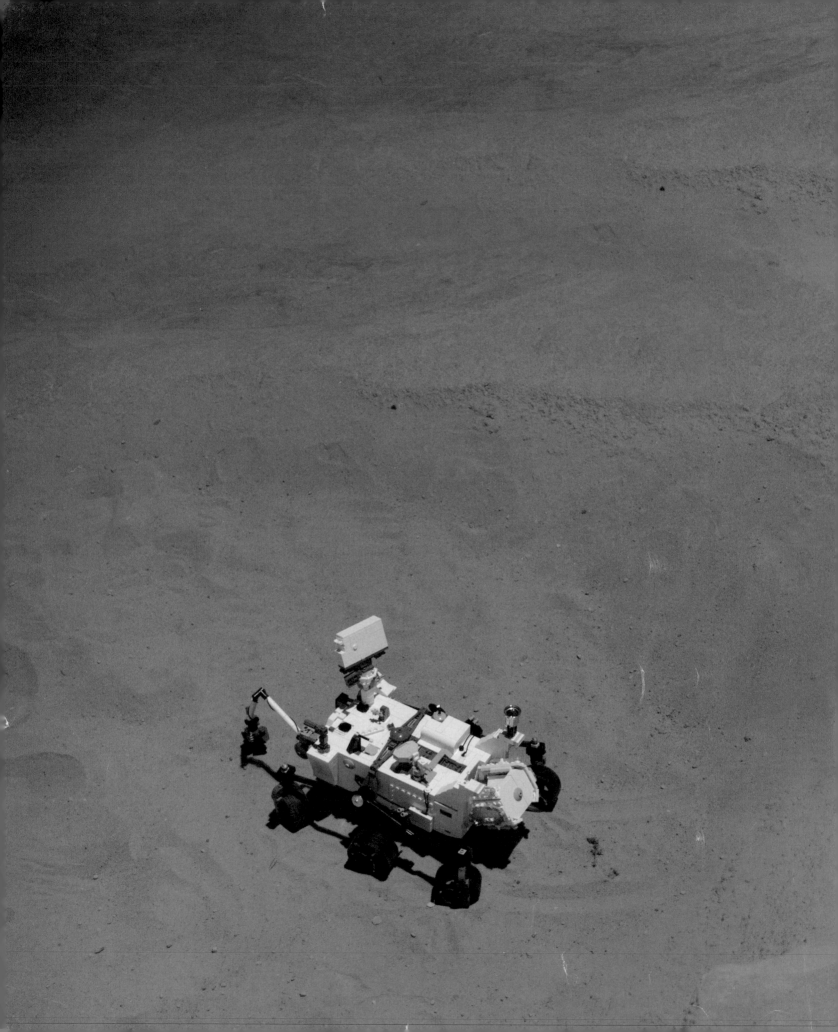

THE SPACE AGE

"Man must understand his universe in order to understand his destiny. Who knows what mysteries will be solved in our lifetime, and what new riddles will become the challenge of the new generations?"

—Neil Armstrong

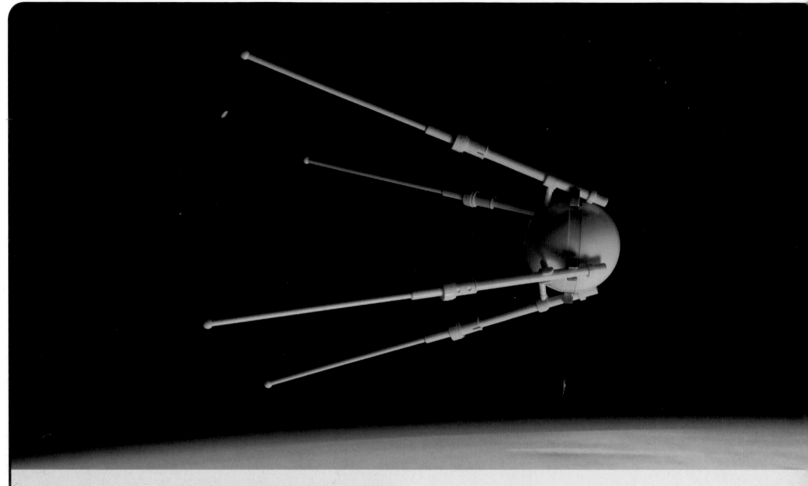

Above: Radio operators in the United States were able to pick up Sputnik's signals. It came as a shock to learn that the USSR had pulled ahead in the Space Race.

Top: Sputnik spent three months circling Earth, traveling at speeds of around 18,000 miles per hour.

In October 1957, an elite group of Soviet scientists made history. The world's first man-made orbital satellite, *Sputnik*, launched from the Tyuratam Complex in Kazakh. The event marked the dawn of the Space Age.

After blasting free from Earth's gravity, *Sputnik* settled into its planned orbit and began transmitting information back to Earth. The scientists were jubilant as they established radio contact with the world's first artificial satellite.

The compact sphere made a complete orbit every 96.2 minutes, transmitting a continuous pattern of beeps to radio operators across the globe. *Sputnik* exceeded its creators' expectations, dispatching information for 22 days before losing battery power. A valuable component of these signals was environmental telemetry, including atmospheric temperature and pressure readings. A decaying orbit drew the satellite slowly back to Earth, and after three months in space, *Sputnik* burned up as it reentered the atmosphere.

In response to the success of *Sputnik*, President Eisenhower ramped up the American space program and created the National Aeronautics and Space Administration (NASA). The failed launch of the American *Vanguard TV3*, just months after *Sputnik*, only increased NASA's resolve. Manned launches soon followed the satellites. Again, the Soviet Union won the race, with Yuri Gagarin being the first man to reach outer space. It was a unique age of scientific exploration.

Just 12 years after *Sputnik* orbited Earth, the first humans stepped onto the surface of the Moon. The American *Apollo* landings were a breathtaking demonstration of technology, engineering, and the human spirit.

But three years later, the lunar program came to an abrupt end. Sending astronauts to the Moon was prohibitively expensive, and public interest in the program was in decline. Plans for a manned mission to Mars were shelved as the projected budget spiraled out of control. The chance of mission failure, and subsequent loss of crew, was analyzed and deemed unacceptably high.

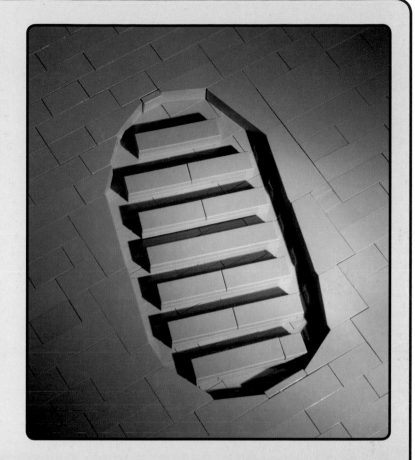

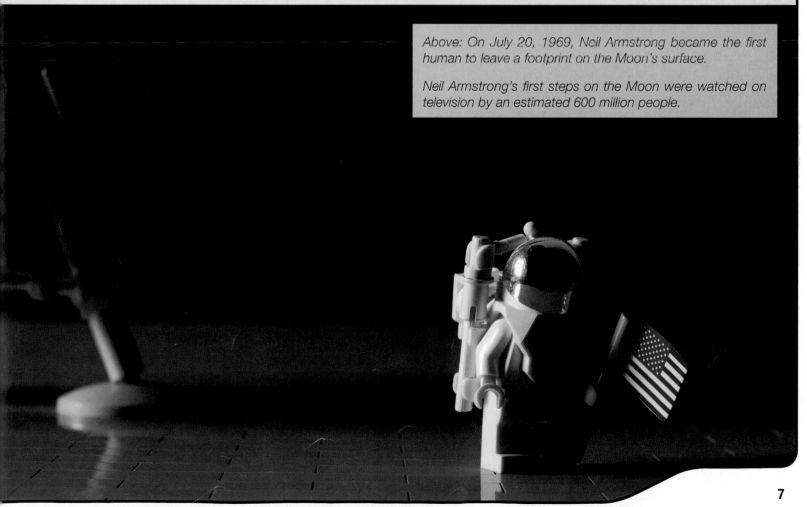

Above: On July 20, 1969, Neil Armstrong became the first human to leave a footprint on the Moon's surface.

Neil Armstrong's first steps on the Moon were watched on television by an estimated 600 million people.

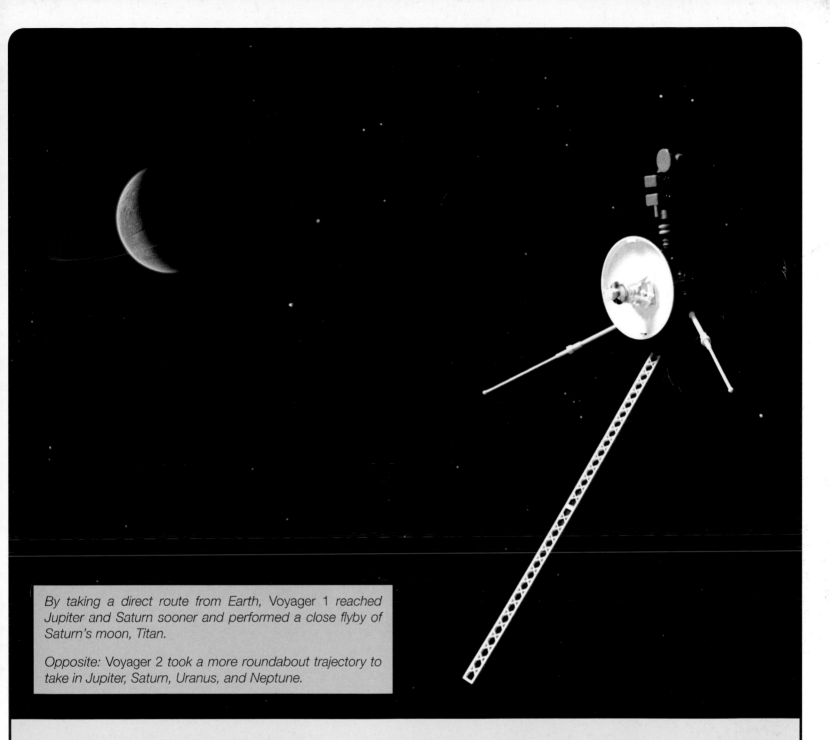

By taking a direct route from Earth, Voyager 1 reached Jupiter and Saturn sooner and performed a close flyby of Saturn's moon, Titan.

Opposite: Voyager 2 took a more roundabout trajectory to take in Jupiter, Saturn, Uranus, and Neptune.

In place of people, probes were sent to explore the cosmos.

In 1977, 20 years after *Sputnik*, the *Voyager* probes were launched. These two identical probes were sent on different routes through the solar system, with carefully calculated launch dates. Both probes embarked on a grand tour of the solar system, studying the outer planets and moons while minimizing power consumption. It was the most ambitious space mission of its time, and it produced hauntingly beautiful images of the outer planets.

The probes carried golden discs etched with sounds and images depicting life on planet Earth. These snapshots of humanity were regarded by some as a dangerous invitation. If intelligent life forms ever found *Voyager* and deciphered the messages on the discs, they would be able to work out precisely where the satellite came from. The information on the discs portrayed a lush planet and extended a friendly greeting to potential observers.

9

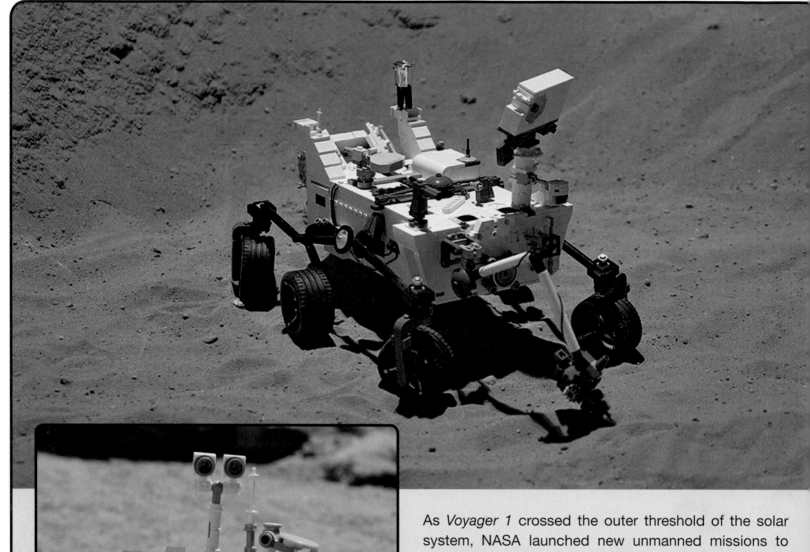

As *Voyager 1* crossed the outer threshold of the solar system, NASA launched new unmanned missions to Mars. A series of solar-powered rovers traversed the martian surface, taking valuable scientific readings for future colonists.

The fourth rover to successfully touch down, *Curiosity*, was part of the Mars Science Laboratory mission. It was designed to spend two years exploring Gale Crater, an area on Mars where liquid water once flowed and which might have once harbored microbial life.

As the largest, most sophisticated machine to be sent to the red planet, *Curiosity* was a technological triumph. The rover's directives included detailed surface mapping, geological analysis, and searching for evidence of water.

In August 2012, after traveling for nine months, the rover touched down on the martian surface. *Curiosity* gathered invaluable scientific data. Highly detailed maps and telemetry from the rover helped shape the course of future Mars missions.

Above: Opportunity *proved to be a tenacious explorer. The rover exceeded its operational lifetime dozens of times over.*

Top: Curiosity *was designed and built to explore Gale Crater for evidence of biological processes and changes in the martian atmosphere.*

BIRTH OF THE FEDERATION

By the middle of the 21st century, there was renewed interest in manned space exploration.

During a time of global peace, space agencies around the world united and formed the Federation. The greatest scientific minds of the age worked together, joining forces to plan a permanent settlement on the Moon. The Sea of Tranquility, the site of the original *Apollo* landing, was the first choice for a permanent lunar colony. In 2069, the Federation launched a series of shuttles bound for the Moon, carrying the colonists and robots who would build the first off-world colony.

Tranquility Base was self-sufficient. A team of scientists raised a wide variety of seed crops on a hydroponic farm. They used genetic manipulation to produce fast-growing, high-yield fruit and vegetables. When fully ripe, the plants were harvested and processed into vacuum-packed food cubes. With more than enough to go around, surplus stock was given to the crews who made regular stops at the base. Food cubes had an indefinite shelf life, making them ideal for long-haul space flights.

Delicious and nutritious, food cubes quickly replaced the freeze-dried nutrient packs endured by early space pioneers.

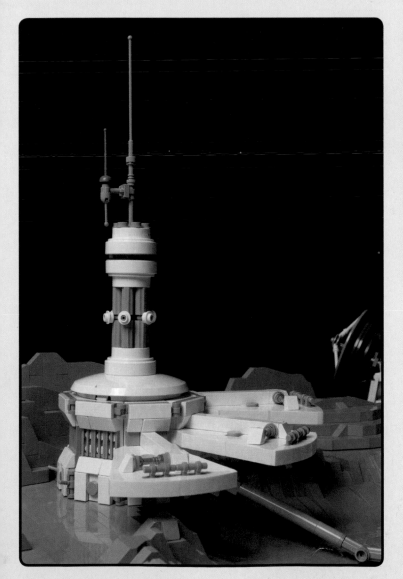

Above: The domes of the hydroponic farm provided a rare glimpse of plant life to the residents of the otherwise bare moonscape.

Left: The control tower was Tranquility Base's center of operations.

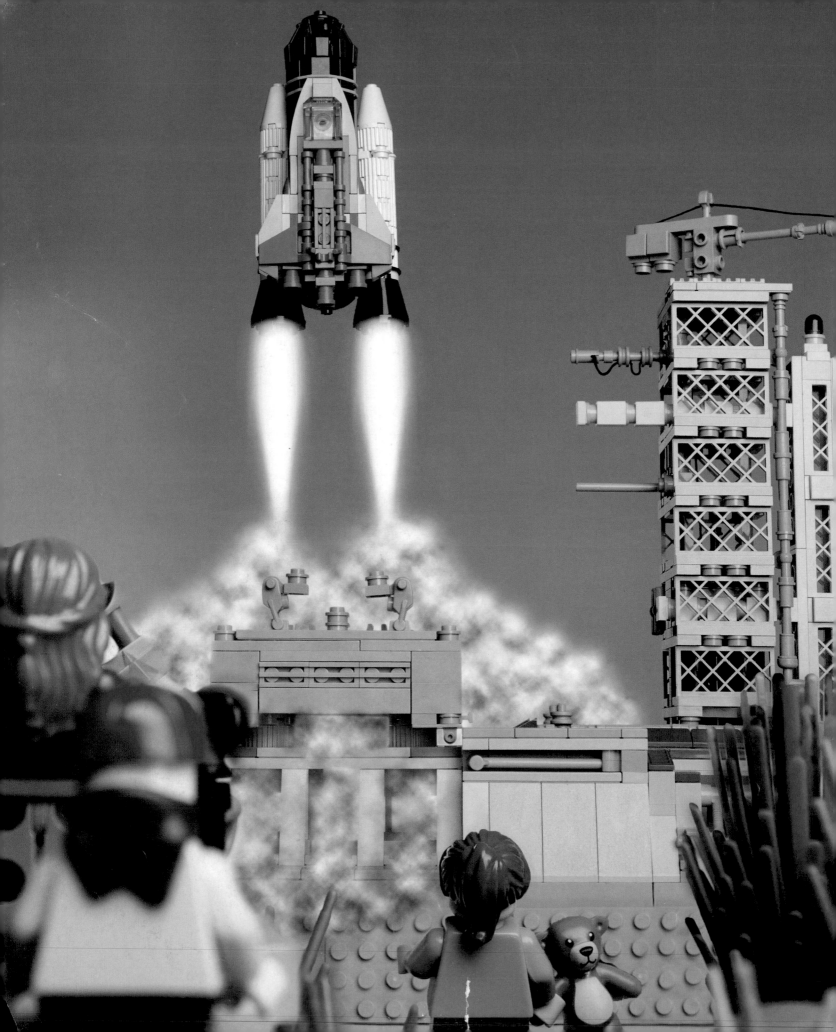

Federation scientists devised a relatively simple method of extracting and refining large quantities of Helium-3 from the lunar surface. Scarce on Earth, Helium-3 was a highly sought after commodity, used to power fusion engines. The robotic mining operation was vast. Large quantities of ore had to be processed in order to extract the smallest amount of Helium-3.

A network of transport lanes allowed the swift and safe disposal of waste materials. When a site had been cleared of all available Helium-3, it was filled in and the operation restarted the process at a new location.

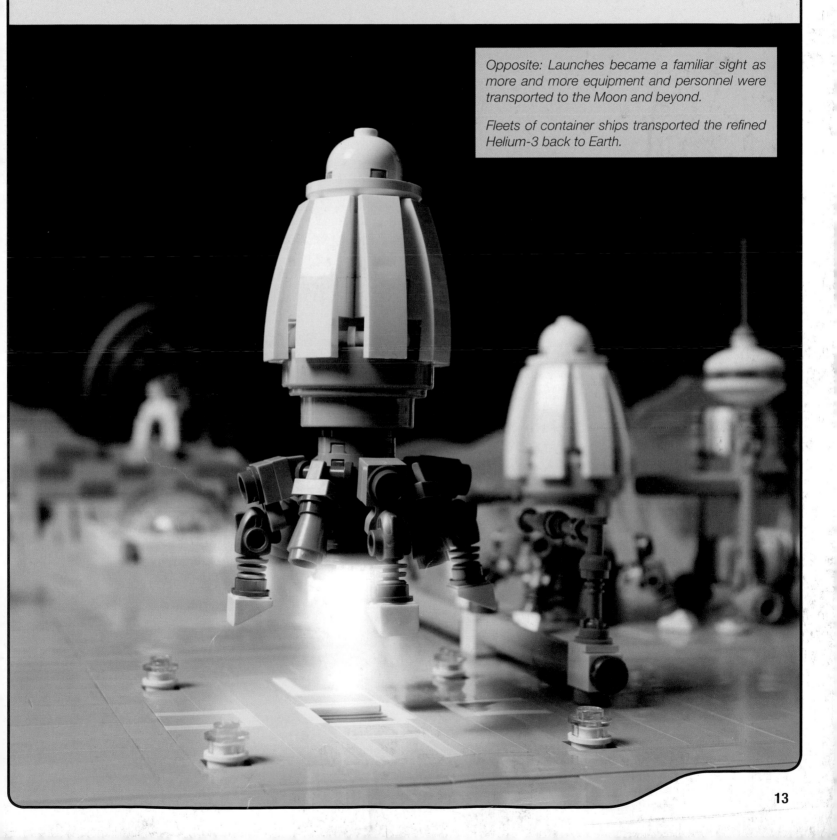

Opposite: Launches became a familiar sight as more and more equipment and personnel were transported to the Moon and beyond.

Fleets of container ships transported the refined Helium-3 back to Earth.

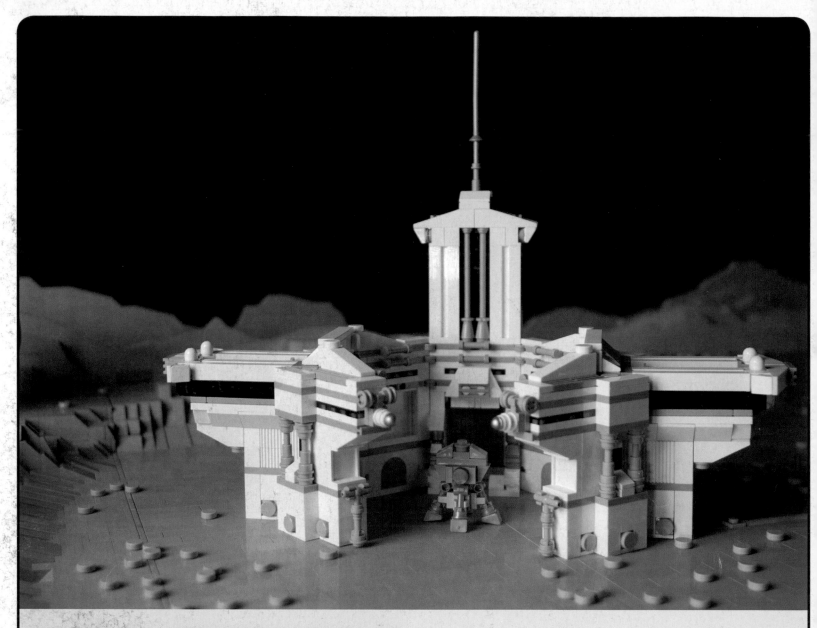

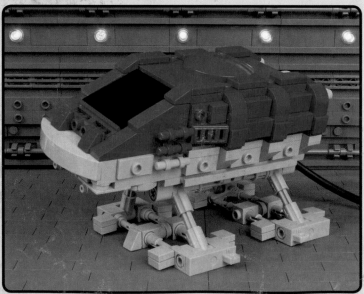

Over the years, Tranquility Base expanded and its role changed. As the Helium-3 mining operation moved to other areas, the original base complex became a dedicated research center and training academy. It was here that the new generation of Federation pilots honed their skills.

The success of the lunar program enabled the Federation to finance further expansion projects. As a profitable organization, the Federation contributed massively to the global economy.

Above and Left: Training facilities at the Tranquility Base Academy produced the very best pilots.

Opposite: Cydonia Base on Mars

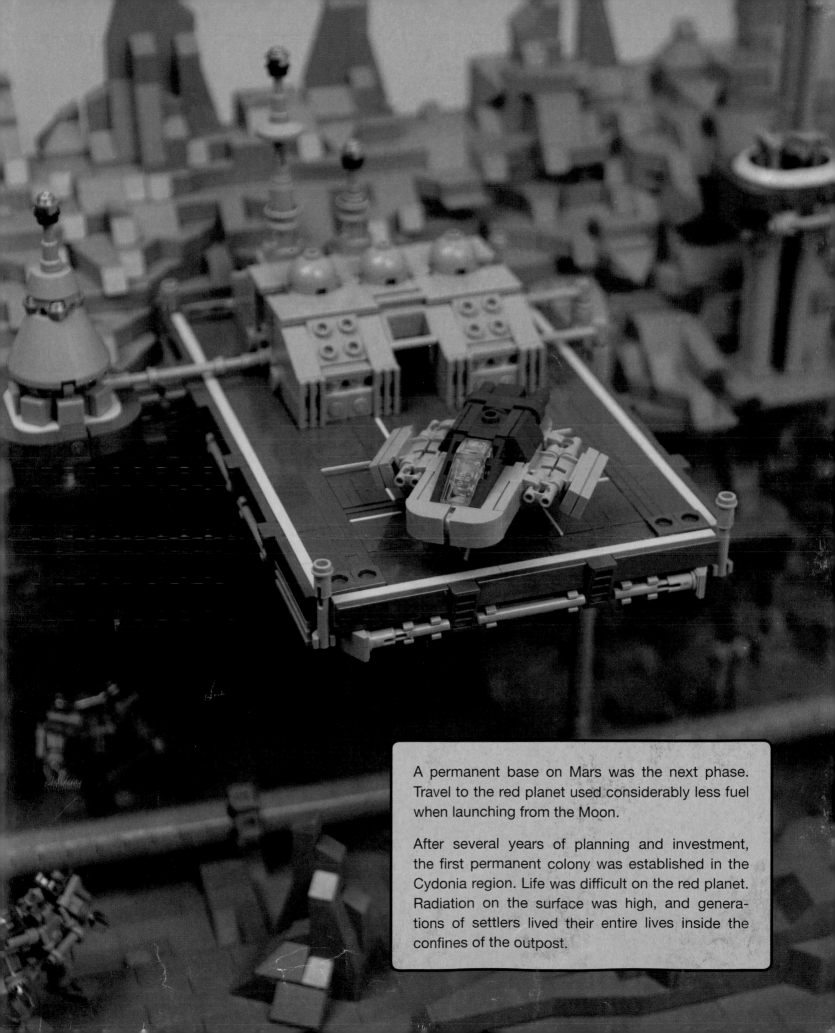

A permanent base on Mars was the next phase. Travel to the red planet used considerably less fuel when launching from the Moon.

After several years of planning and investment, the first permanent colony was established in the Cydonia region. Life was difficult on the red planet. Radiation on the surface was high, and generations of settlers lived their entire lives inside the confines of the outpost.

SPUTNIK

The first man-made satellite to orbit Earth, *Sputnik* became an iconic symbol of the Space Race. Earlier designs for a Soviet orbital satellite had proved too complex, leading to problems and delays in construction. *Sputnik* was designed to be much simpler, and it gave the USSR a head start in the Space Race.

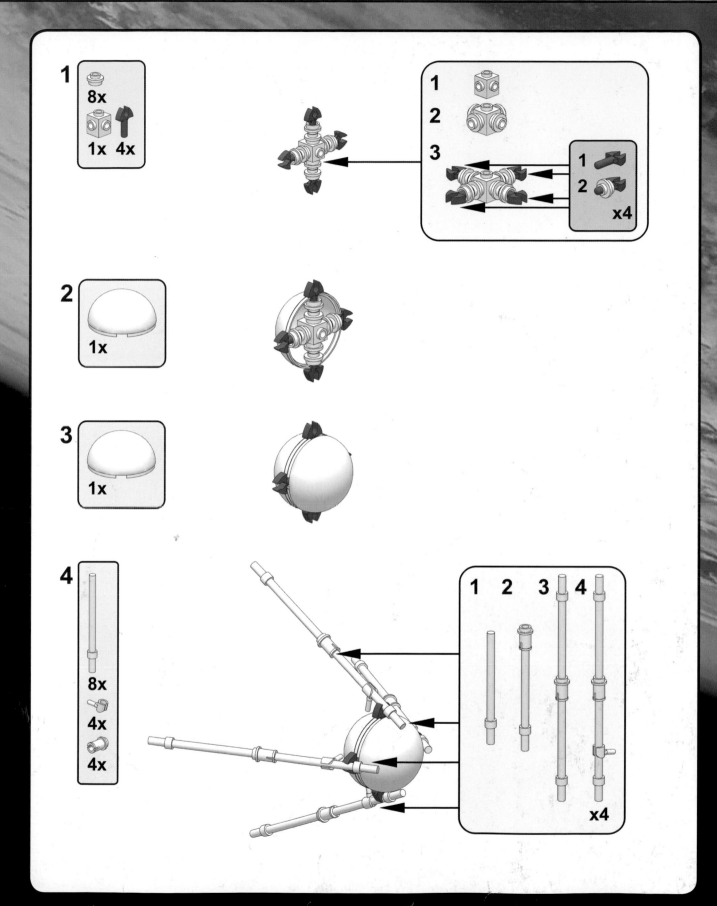

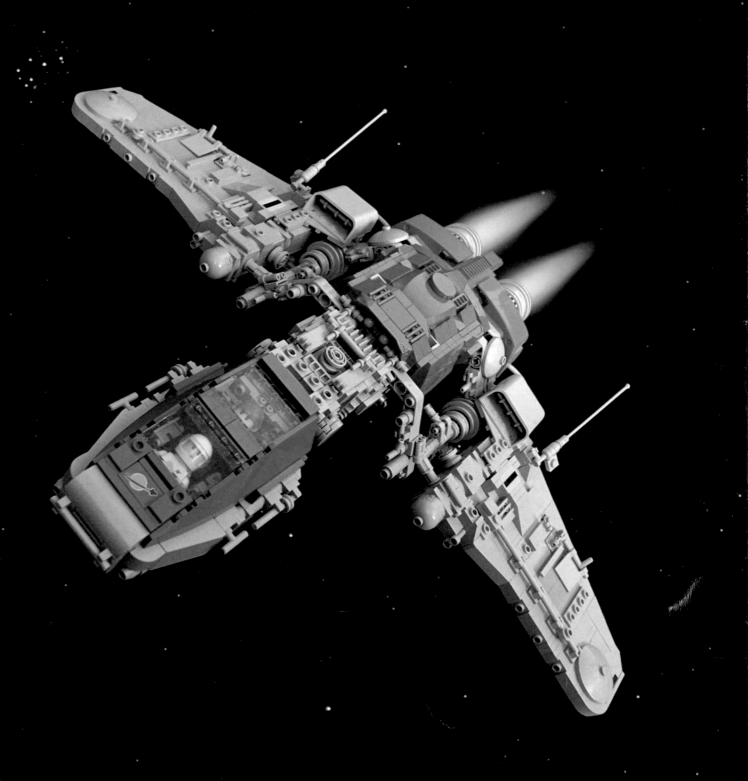

THE FEDERATION

"The Federation is the future of humanity. We must explore now with renewed purpose, pushing to the furthest reaches of the solar system."

—*Admiral Kazak*

Above: Life in space took some getting used to for those born and raised on Earth.

Below: Older ships needed frequent maintenance for repairs and replacement of worn parts.

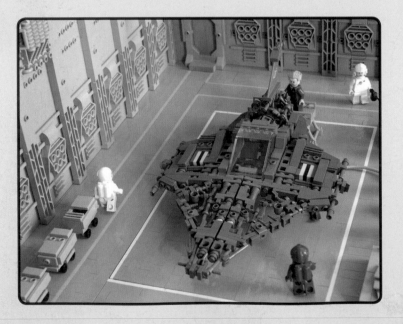

During the Federation's early years, equipment was borrowed from various international space programs. Reconditioned shuttles and rockets from former space agencies proved vital during the early missions, despite their limited capabilities. Pilots and engineers complained about worn components, unreliable navigation systems, and dangerous engine housings.

Mindful of these problems, the Federation began constructing a new fleet of ships. Substantial profits from space tourism and lunar mining allowed them to recruit the world's greatest designers and engineering teams.

Within a decade, most of the old equipment was phased out. A new fleet took to the stars. Painstakingly designed and tested in the Tranquility Base laboratories, these new spacecraft were built to extraordinarily high standards. Constant technological discoveries and the advantages of low-gravity construction gave the fleet a distinctive visual style. During those glory years, it seemed as though anything was possible.

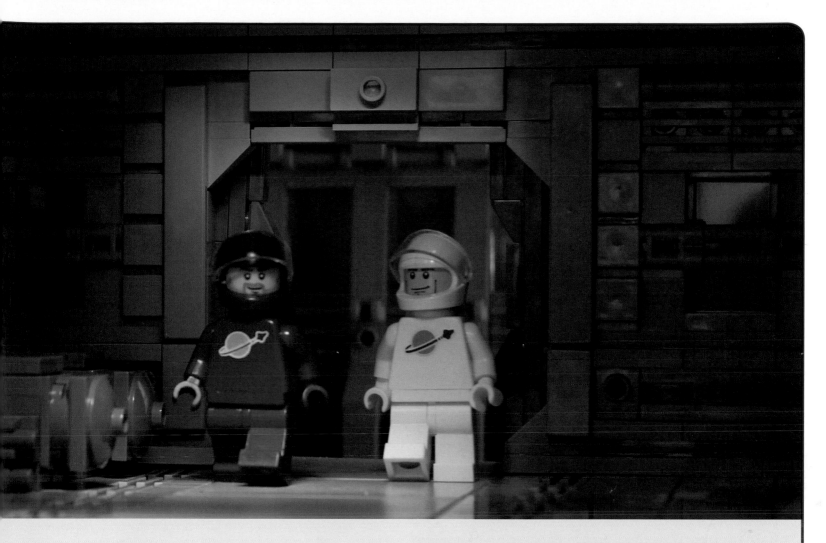

The lunar and martian colonies were the core Federation settlements. A frontier space station, Krysto Base, was built in orbit around Jupiter. Located far beyond the asteroid belt, this space station was a crucial part of the Federation's eventual goal of outer-system expansion.

From Krysto Base, the Federation prepared for a detailed survey of the Galilean moons. Long-haul supply vessels transported vital equipment between the Core worlds and Krysto Base.

The station was under the control of Admiral Kazak, a highly regarded Federation officer. His distinguished career had taken him through the ranks of the Federation to a command position on the frontier. Admiral Kazak coordinated new missions to the outer system. Krysto Base was the final way station before pilots flew into the great unknown.

Below: Krysto Base was the Federation's first large-scale orbital outpost.

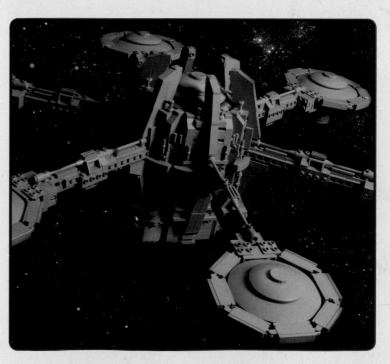

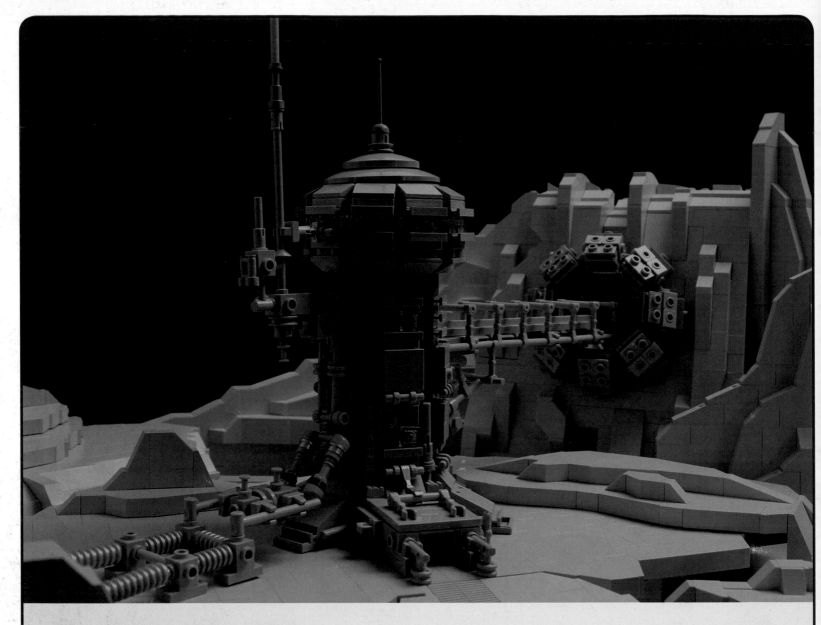

DISASTER ON HYPERION

The Omega incident was a stark reminder of the dangers of life in space.

The first attempt to exploit the riches of the outer system ended badly. The Federation had constructed Omega Base, a small processing plant on Hyperion, one of Saturn's moons. After just six months of active service, a malfunctioning maintenance robot depressurized the base, section by section, killing dozens of Federation personnel.

Above: After the Omega incident, processing work was moved closer to the occupied worlds.

Opposite: Massive distances between the planets meant that a journey to the outer system could take many months.

It took hours for the emergency beacon signal to reach Krysto Base, and the vast distances involved meant it took the response team months to reach Hyperion. Sending a rescue party was a futile gesture. Everyone on the base was already dead.

The base was decommissioned and abandoned.

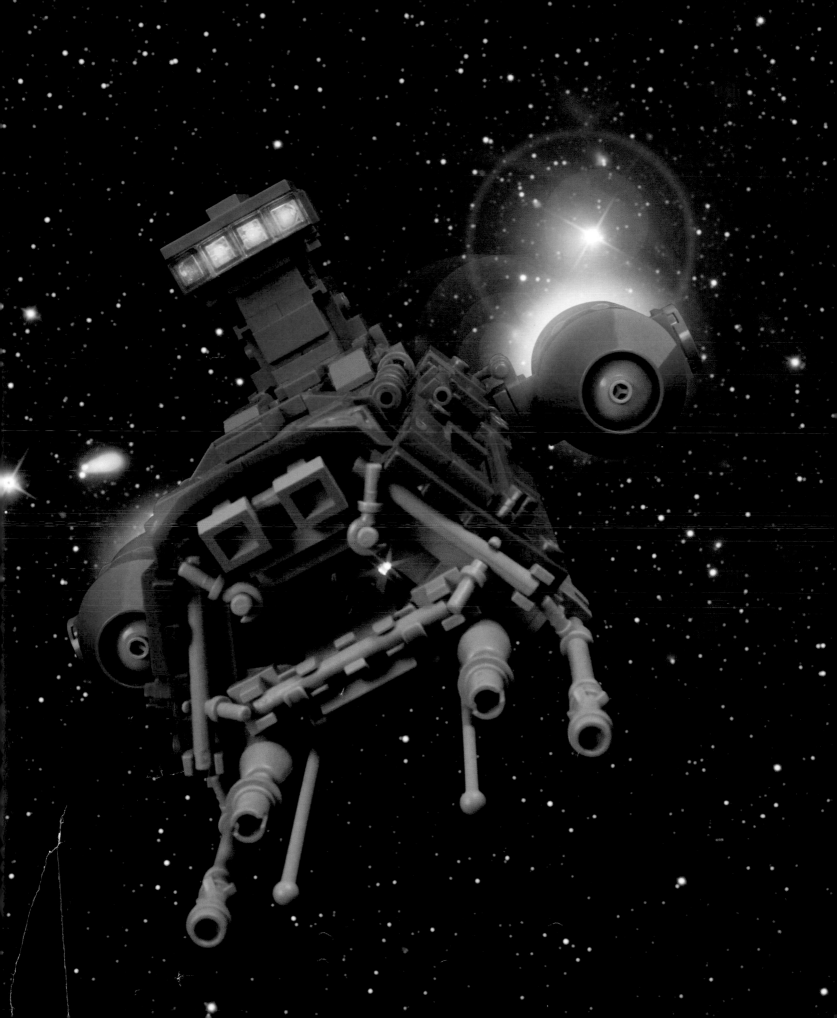

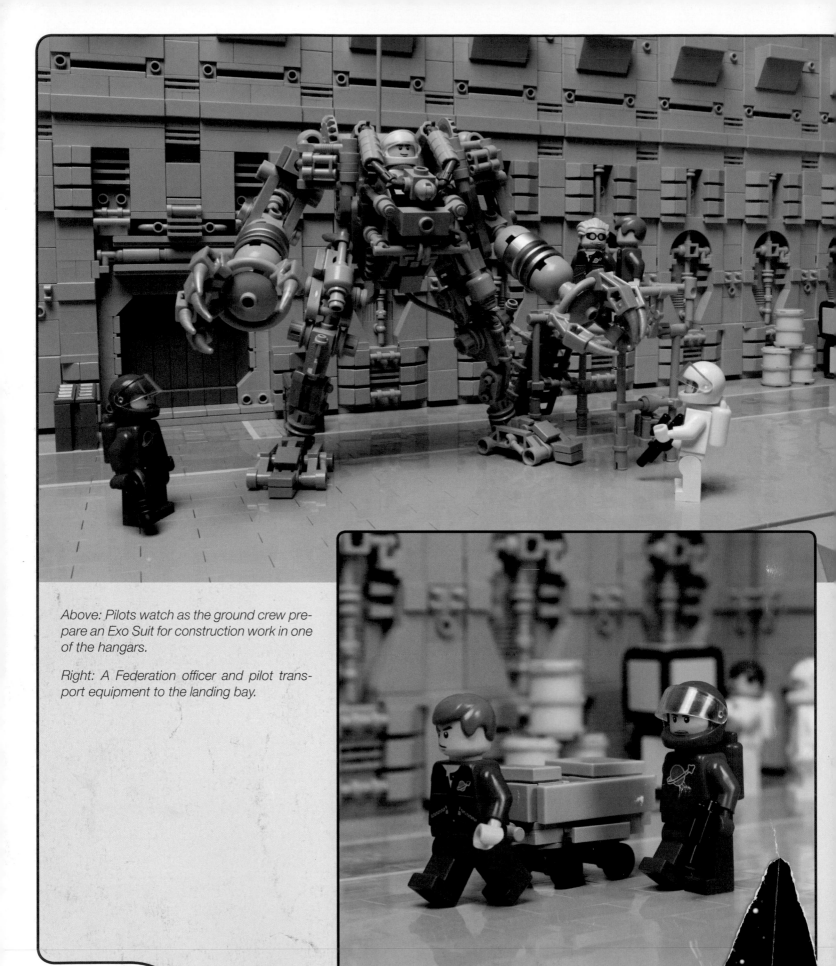

Above: Pilots watch as the ground crew prepare an Exo Suit for construction work in one of the hangars.

Right: A Federation officer and pilot transport equipment to the landing bay.

Right: All trainee pilots were required to pass a grueling series of computer-based logic and math exams before flight training began.

Below: A Hover Loader transports spent fuel as LL-142 is prepared for launch.

PILOTS

The red Federation flight suit was a badge of excellence. Places in the training program were limited, and only the very best candidates were considered.

Getting accepted was just the first step. Flight training was an arduous five-year program, where students were tested to their limits, physically and mentally.

The program was designed to ensure that only the finest graduated. Many dropouts were still excellent pilots who found work piloting non-Federation supply ships, but the program was a one-shot deal. Second chances were not given. The intense boredom and loneliness of long-haul space travel had been known to drive pilots insane. Flight simulators were designed to faithfully replicate the experience. Trainees were prepared to cope with extended periods of solitude, and small teams were required to work closely in cramped conditions.

Pilots were constantly assessed during these tests. Any sign of emotional weakness was flagged and monitored closely.

In a good year, just five percent of the intake would graduate to be career pilots.

After qualifying, the newly decorated pilots were shipped out to the lunar colony. After induction and review at Tranquility Base, they were assigned to missions that ensured the smooth running of the Federation.

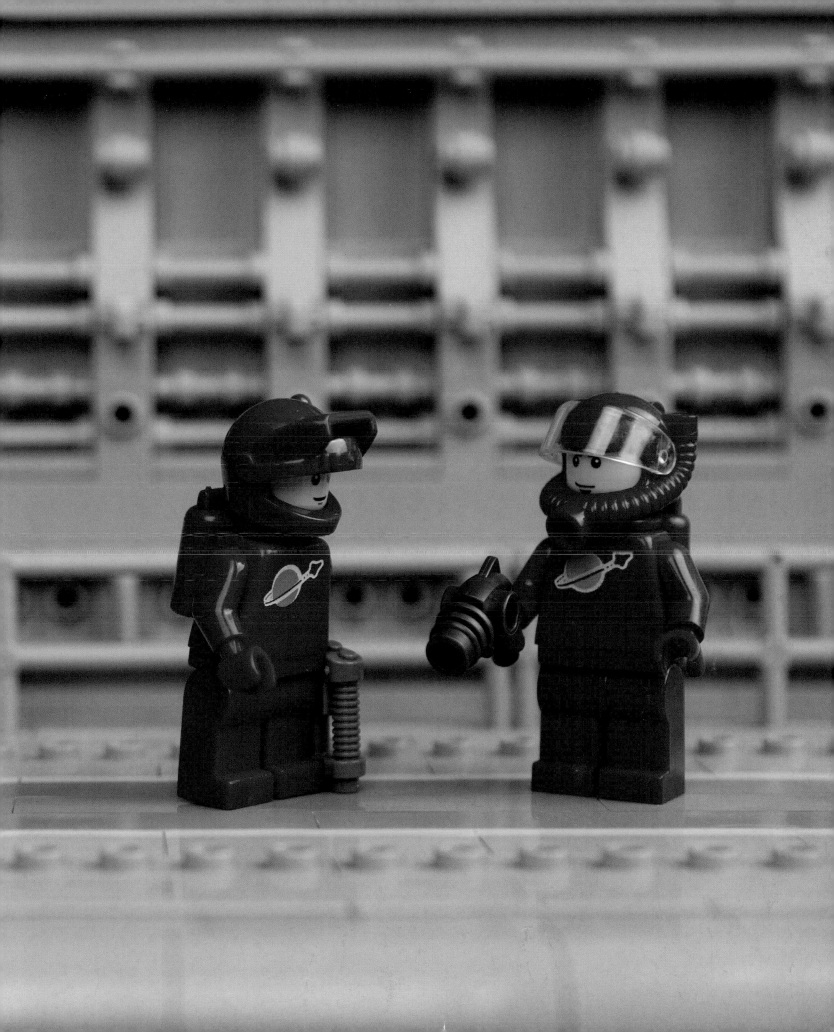

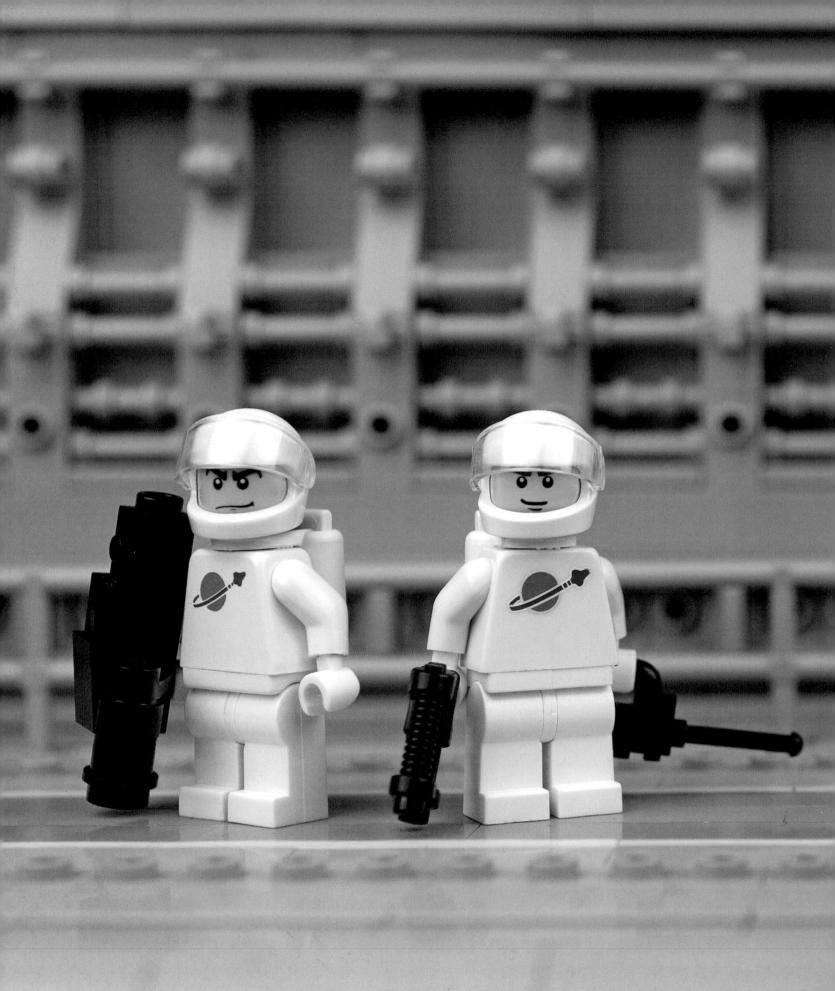

GROUND CREW

Ground crew engineers worked just as hard as the flight teams but mostly within the confines of Federation bases. Romance and glory were for the pilots. The boys and girls in white kept a lower profile but were no less important.

While the pilots flew supply routes and scientific missions, ground crew kept everything running smoothly behind the scenes. They were responsible for fleet maintenance and logistics, looking after the equipment, and ensuring the safety of the pilots.

Ground crew were a vital part of the Federation machine. Without their expertise and dedication, the fleet would have ground to a halt. They were hardworking, highly skilled engineers who weren't afraid to get their uniforms dirty. After long shifts transporting fusion drives and scraping the gunk out of exhaust manifolds, engineering crews would wind down in the mess halls.

There was a good-natured rivalry between the ground crew and the pilots. Reds and whites worked well together, but their working lives were very different. Flight teams were allocated the lion's share of the budget, often receiving new ships while ground crew made do with basic, occasionally faulty equipment.

The ground crew were a tenacious, pragmatic workforce. Fiercely loyal to the Federation, they took pride in their work.

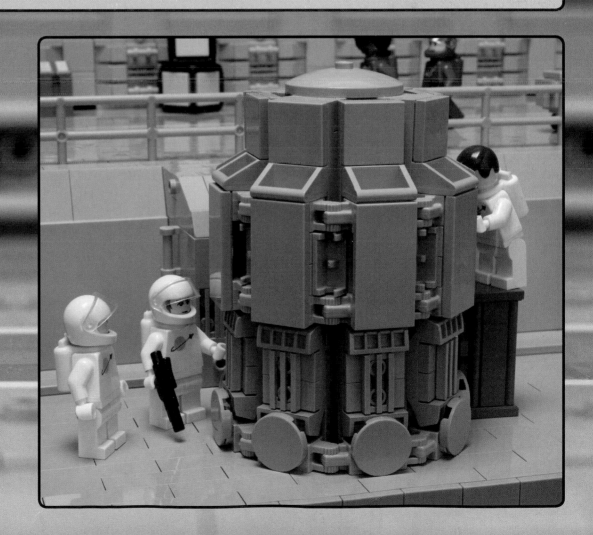

LL-290 TRANSPORT SHUTTLE

The *LL-290* shuttle is widely used throughout the Core Systems. A short-range vessel, the standard model is not rated for interplanetary travel. Twin fusion engines provide impressive power for such a small class of ship, but the range is limited.

Numerous modified shuttles can be seen throughout the system. The compact vessel is a reliable workhorse of the Federation.

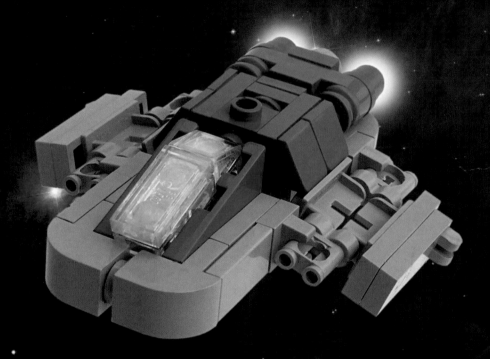

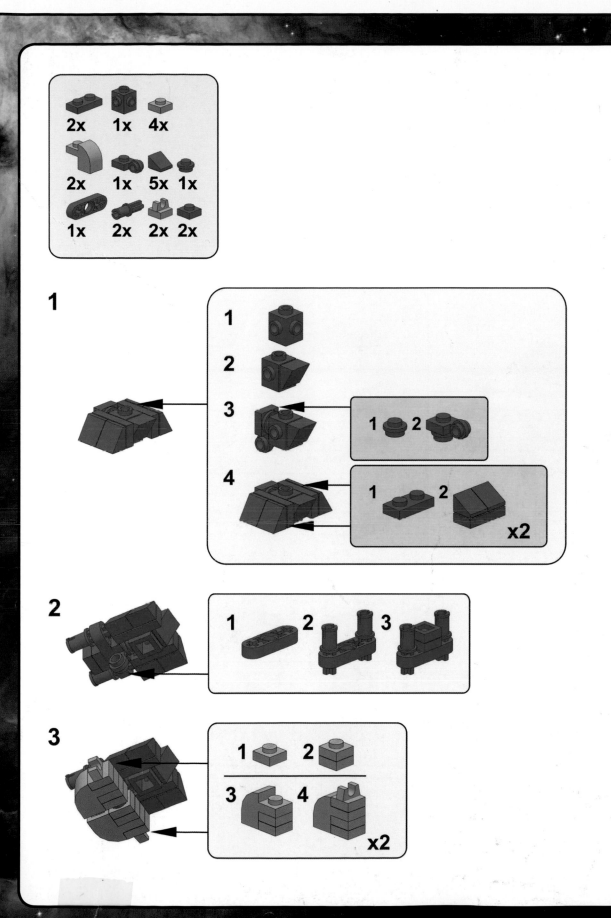

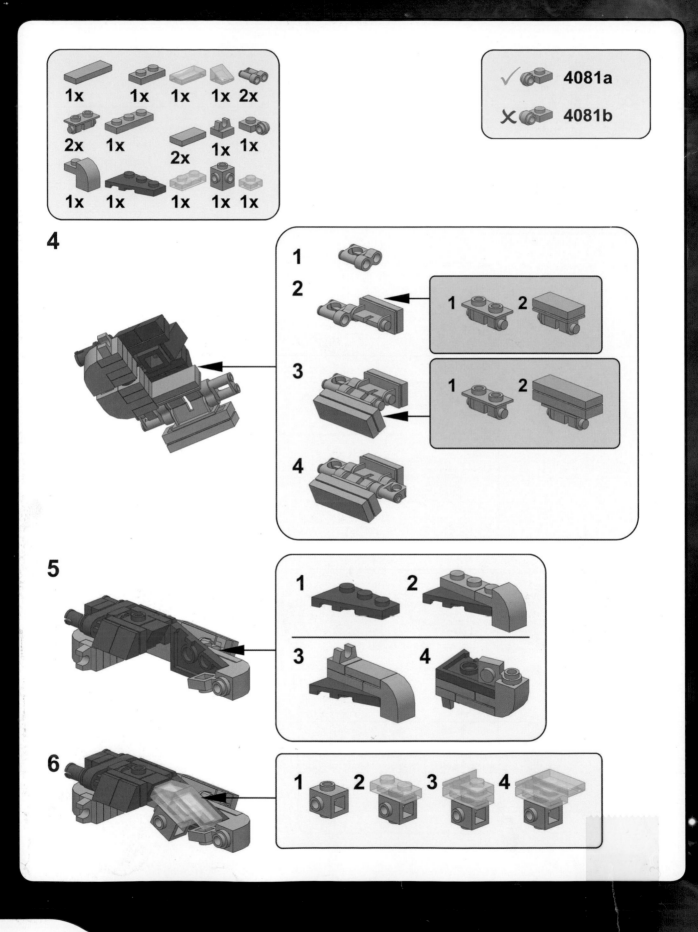

4081a

4081b

32

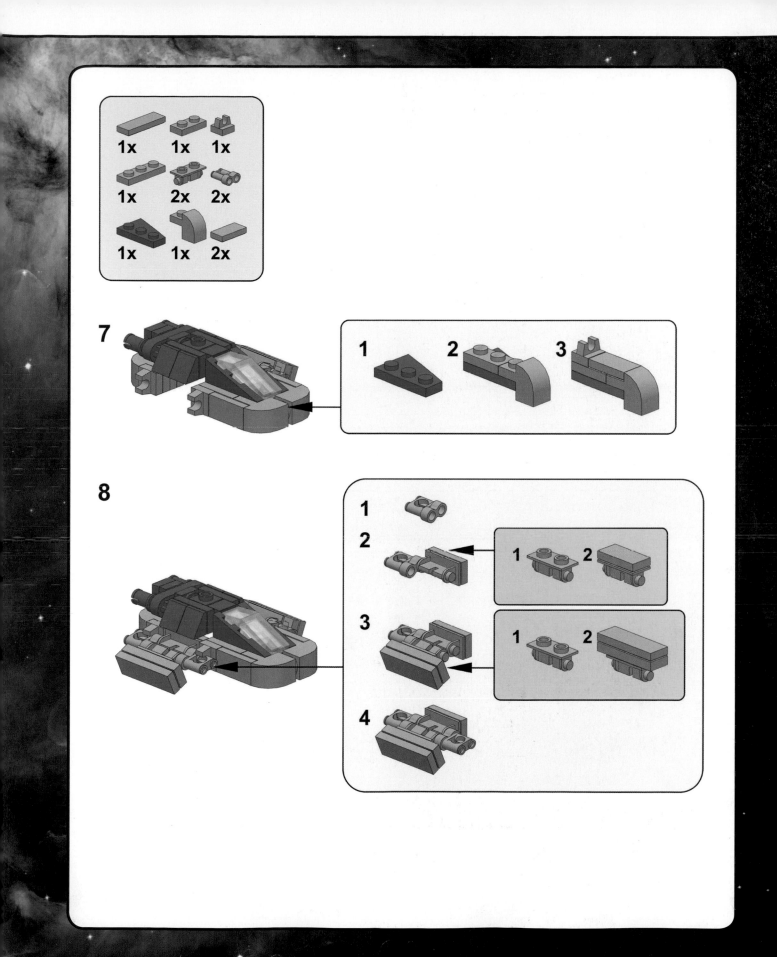

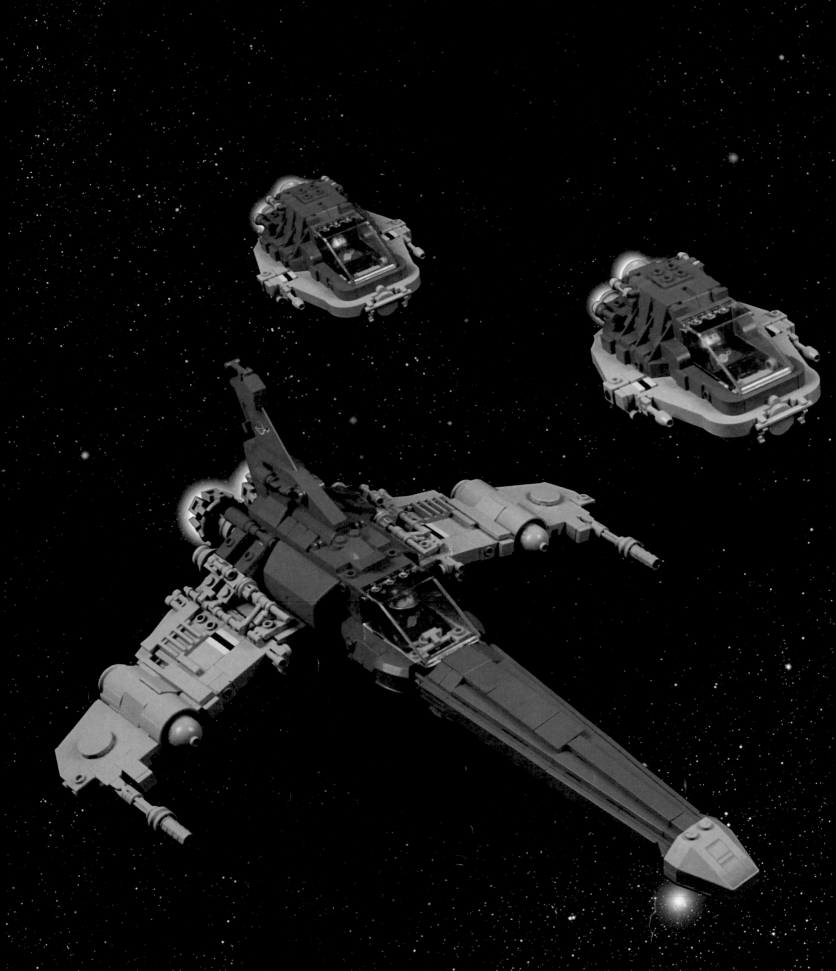

SHIPS OF THE FEDERATION

"The new generation of Federation spacecraft is the perfect symbol of mankind's advancement. We are in a golden age of design and technology: the age of Classic Space."

—Admiral Williams

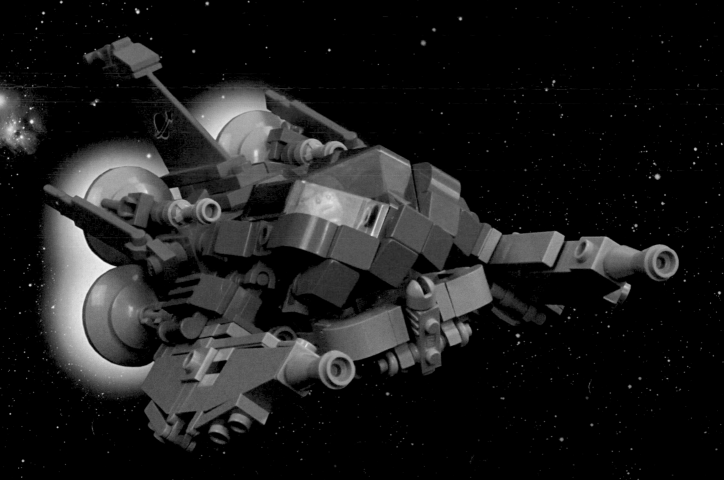

LL-117 ICARUS

Despite requiring maintenance after every mission, the prototype *Icarus* is a high-performance one-man ship. For such a small craft, the *Icarus* excels in maneuverability, handling, and speed, outperforming most other ships of a similar size. Its compact and efficient design has impressed the Federation review committee, and a redesigned version is a likely candidate for production.

Its limited range means the *Icarus* is incapable of interplanetary travel without refueling. This issue will likely be ironed out for the production version.

Below: The LL-117's engine requires frequent maintenance to monitor moving parts for signs of fatigue and to prevent buildup of solid fuel residues.

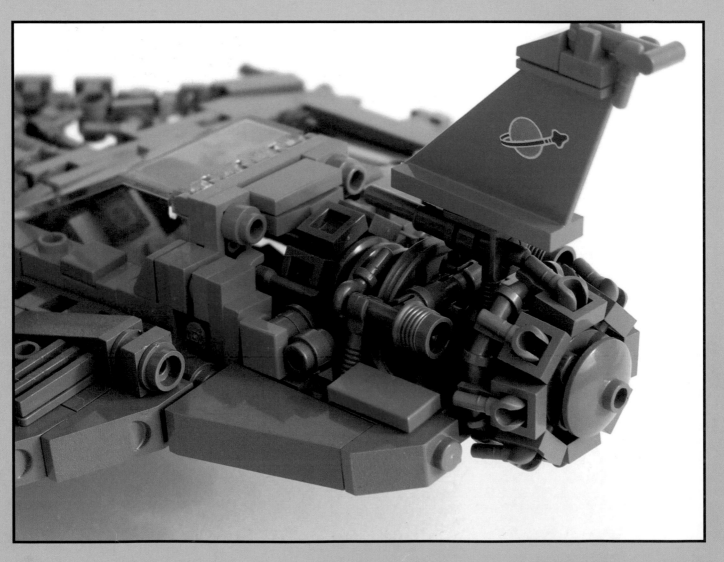

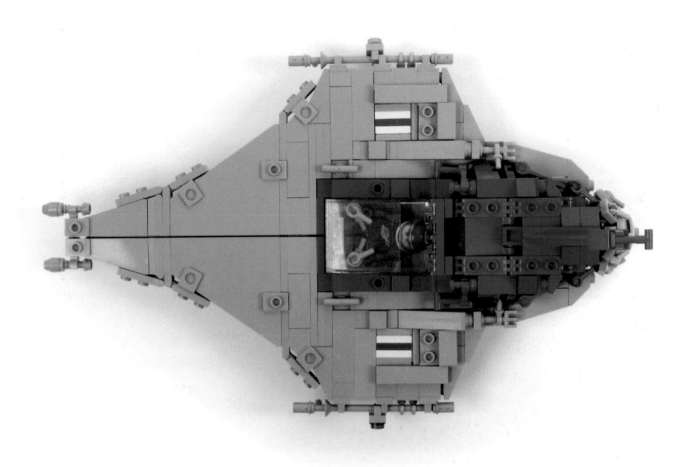

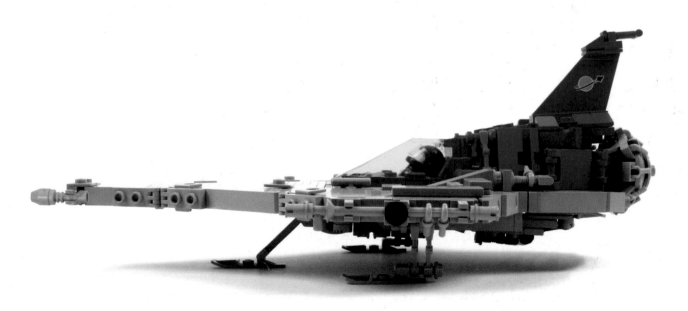

LL-137 BLUE CANARY

The *Blue Canary* is one of the oldest Federation ships still in active service. After nearly half a century, the ship is still used for scientific missions.

The *Blue Canary* has an unblemished flight record, a testimony to both the pilots and those who helped build it all those years ago. Construction logs credit Admiral Gould as instrumental in bringing the ship from concept to prototype. Without Gould's technical knowledge during the construction process, the Federation program could have turned out very differently.

The *LL-137* is protected by a series of angled hull plates, designed to deflect space debris. The hull plating is considerably thicker than the current standard and can absorb damage that would destroy most ships its size. The ship is armed with a pair of beam lasers that can deflect or destroy any approaching asteroids.

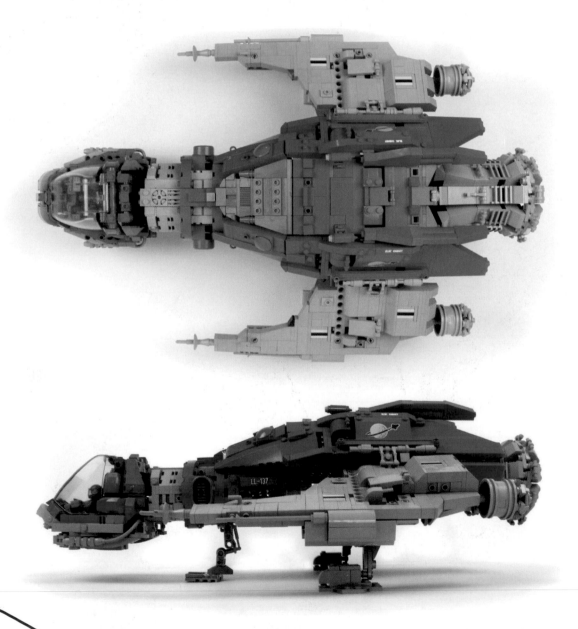

LL-409 SCOUT

Adjustable wings and light hull plating make this craft quite lethal for inexperienced pilots. *LL-409*s are armed with twin pulse lasers, but the ship's unstable flight patterns make its weapons extremely difficult to aim.

This short-range craft is primarily used on the martian colonies. The low gravity of the planet enables this seemingly fragile ship to operate with unprecedented maneuverability at medium to low altitudes.

A squadron of *409*s escort incoming ships along the planetary flight paths and have been known to perform remarkable acts of aerobatic showmanship during their duties.

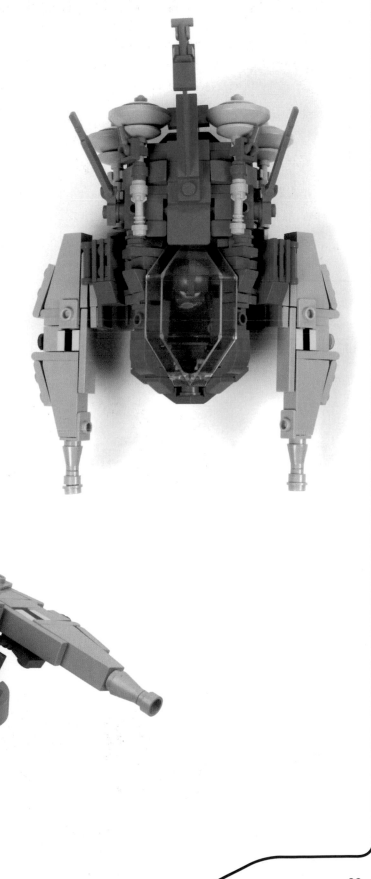

LL-142 INTERCEPTOR

The *LL-142* is a unique ship designed to carry out a range of scientific survey missions in and around the asteroid belt.

The *Interceptor* plays a vital surveying role. The bulk of its midsection houses an integrated computer system with a massive onboard database that tracks the movement of millions of asteroids and meteors as they move through the solar system.

Above: The powerful main engine and larger-than-average fuel tanks allow for prolonged research missions.

Left: The Interceptor *is armed with a pair of wing-mounted pulse lasers that protect against approaching space debris.*

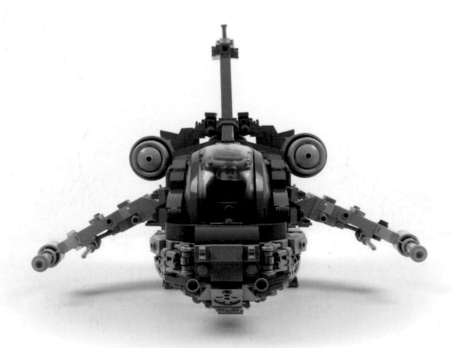

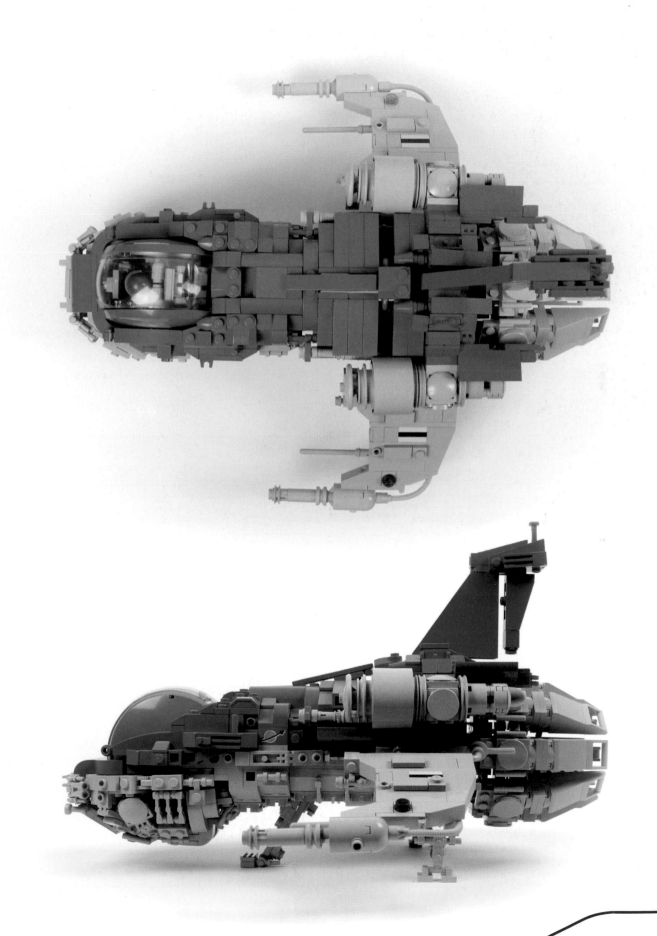

LL-497 EXPLORER

The galaxy's original *Explorer* was the brainchild of Jens Knudsen, a legendary ship designer whose work inspired some of the Federation's most iconic vessels.

The *LL-497* is a tribute to those glorious early designs. Its large delta wing and high fuel capacity make it one of the few Federation ships of its class capable of launching from the Moon, traveling beyond Jupiter, and returning to the Moon without refueling. The *Explorer* can also launch from Earth but requires a costly three-stage rocket launch system to do so.

Right: The copilot's navigation system allows complex flight paths to be calculated while in transit.

Below: The Explorer *is prepared for another mission.*

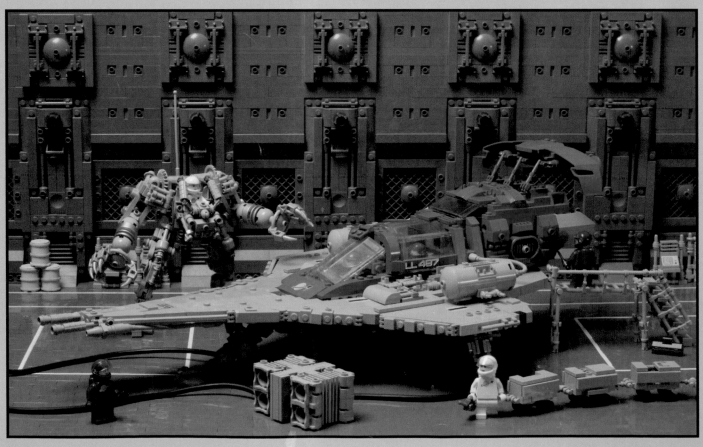

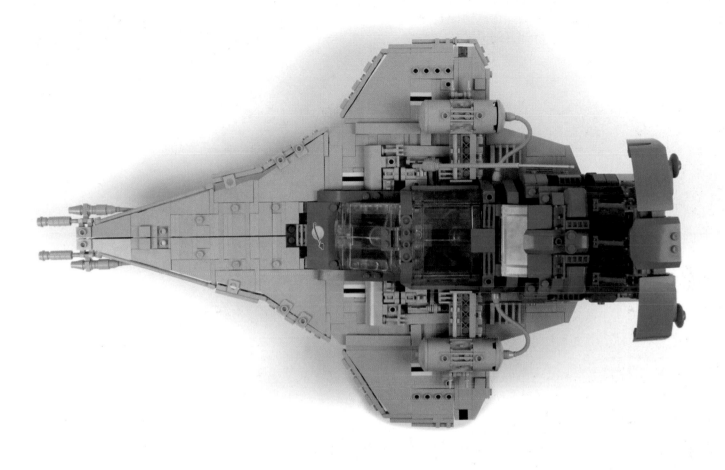

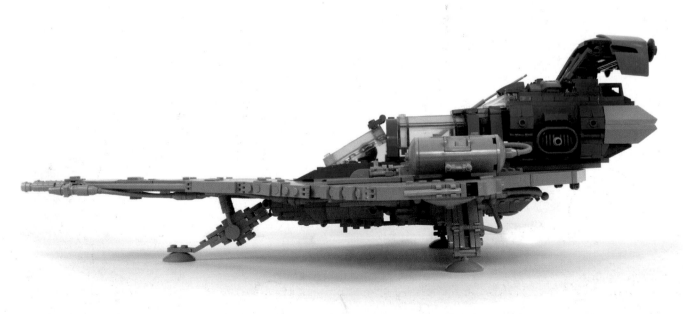

LL-550 VIPER

The *Viper* was developed as an attempt to maximize low-altitude, high-velocity acceleration and maneuverability. The ship uses a propulsion technology similar to the antigravity racers on Earth. Its fully pressurized cockpit allows for limited, short-range space flight.

Right: The twin booms contain pulse lasers, and the Viper has additional mounting points for further weapon upgrades.

Below: The engine configuration of the Viper will be familiar to followers of the antigrav racing leagues.

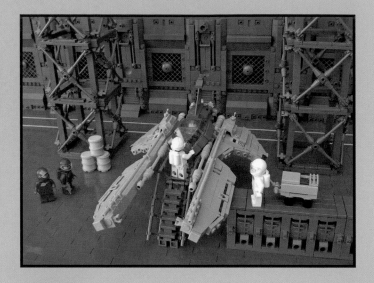

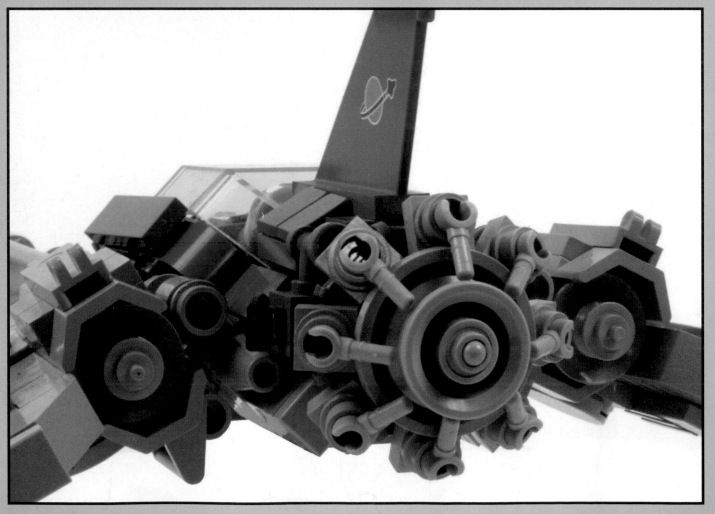

44

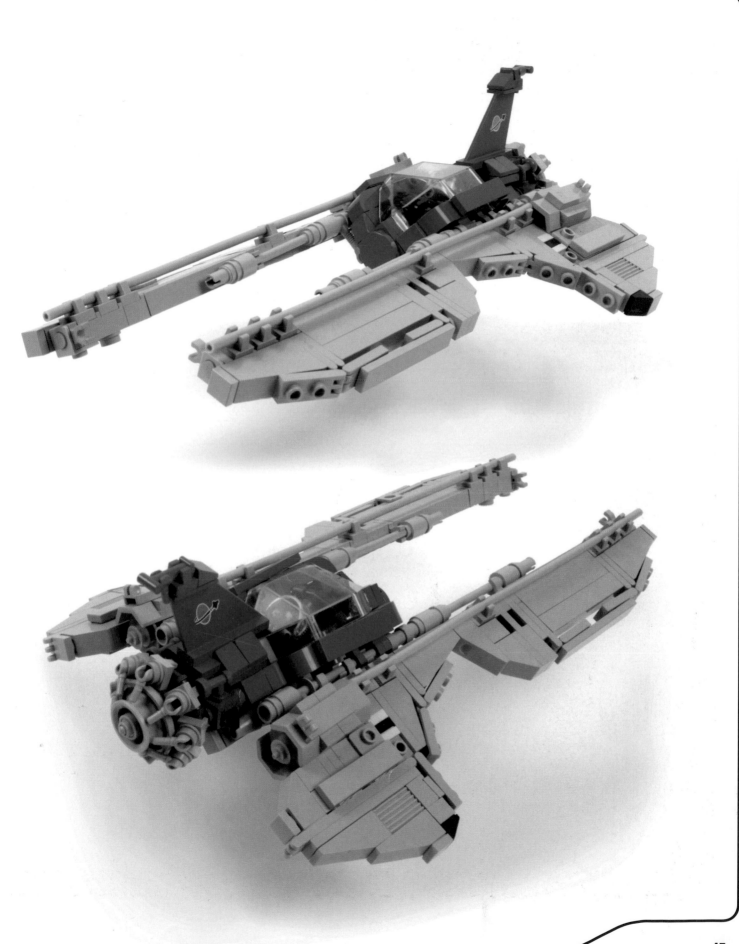

LL-605 MARAUDER

Regarded by those who have flown it as the finest in the fleet, the *Marauder* is notable for its superb performance. An advanced atmospheric compensation system means the ship can perform in a wide variety of conditions that would render most ships inoperable.

A complicated series of energy processors and fuel distribution networks take up most of the internal space, meaning there is little room for cargo. Despite the cramped conditions, the handful of registered *Marauder* crewmen considered themselves lucky to fly the very best ship in the fleet.

Above: The Marauder's *propulsion system generates more applied thrust per square inch than any other Federation ship.*

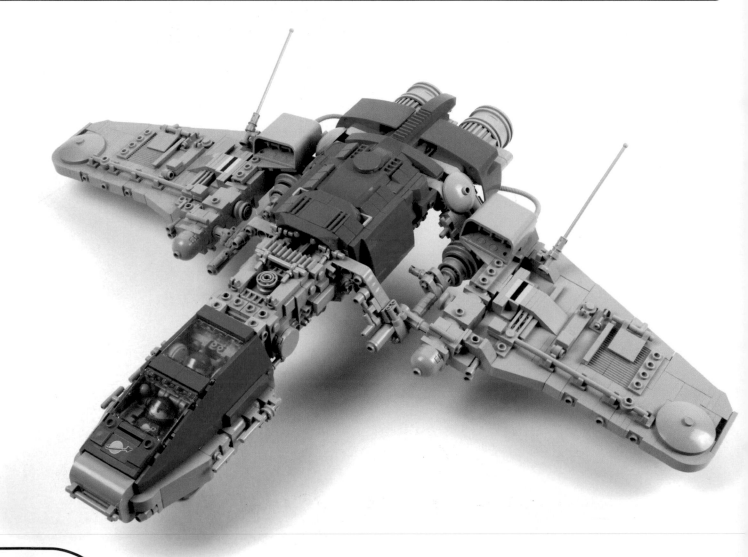

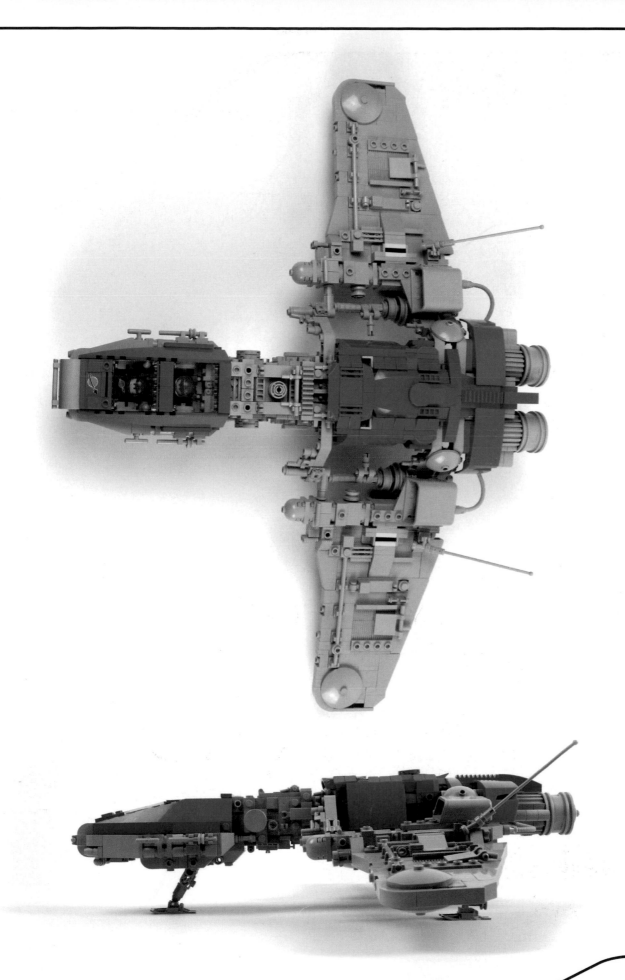

LL-790 SHUTTLE

This multipurpose, one-man craft has proved its worth on countless missions. Another Federation workhorse, the *LL-790* might lack visual flair, but it is one of the safest and most reliable medium-range ships in service.

In larger capital ships, the *LL-790 Shuttle* is often used as an escape pod. Its navigation system is simple enough for civilians to plot a course to safety. Survivors of emergency escape pod launches have commended the shuttle designers for providing such a comfortable refuge.

Pulse lasers, life support, and navigation modules are fitted to every shuttle.

Below: The LL-790's range is considerable given its small size, thanks to the massive fuel reserve that dominates the aft section of the shuttle.

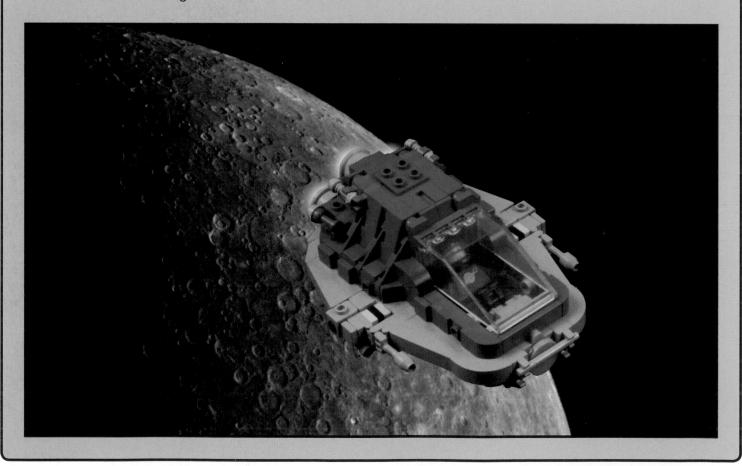

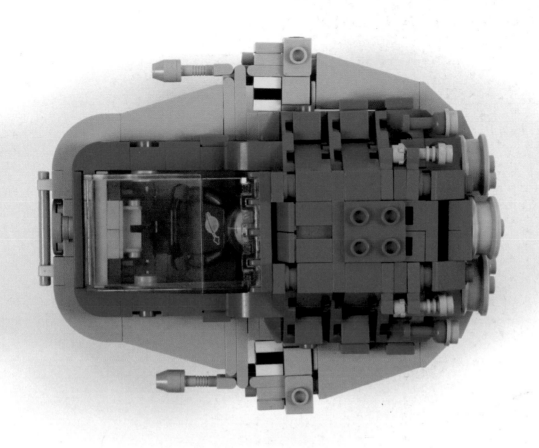

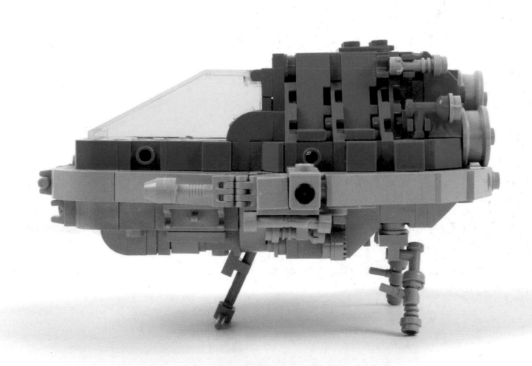

LL-989 WILDFIRE

Little is known about the *Wildfire*. The ship is a result of the Federation's top secret Nielsen Project.

Shrouded in mystery, the *Wildfire*'s exact objective remains unknown. Reports suggest the ship is capable of incredible speed, but opinions vary regarding the exact purpose of the adjustable wings. The project remains classified.

The current whereabouts and operational status of the vessel are unknown.

Right: The first leaked image of the Wildfire *hinted at its unique wing structure and asymmetrical weapons system.*

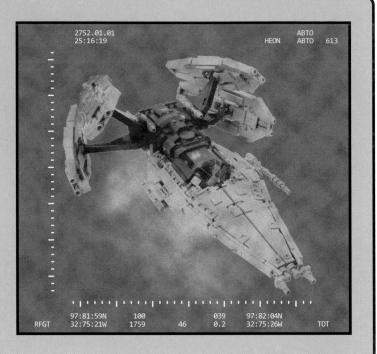

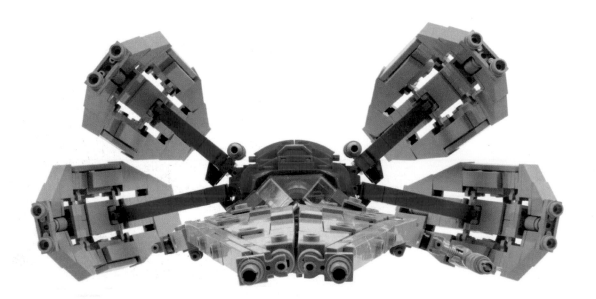

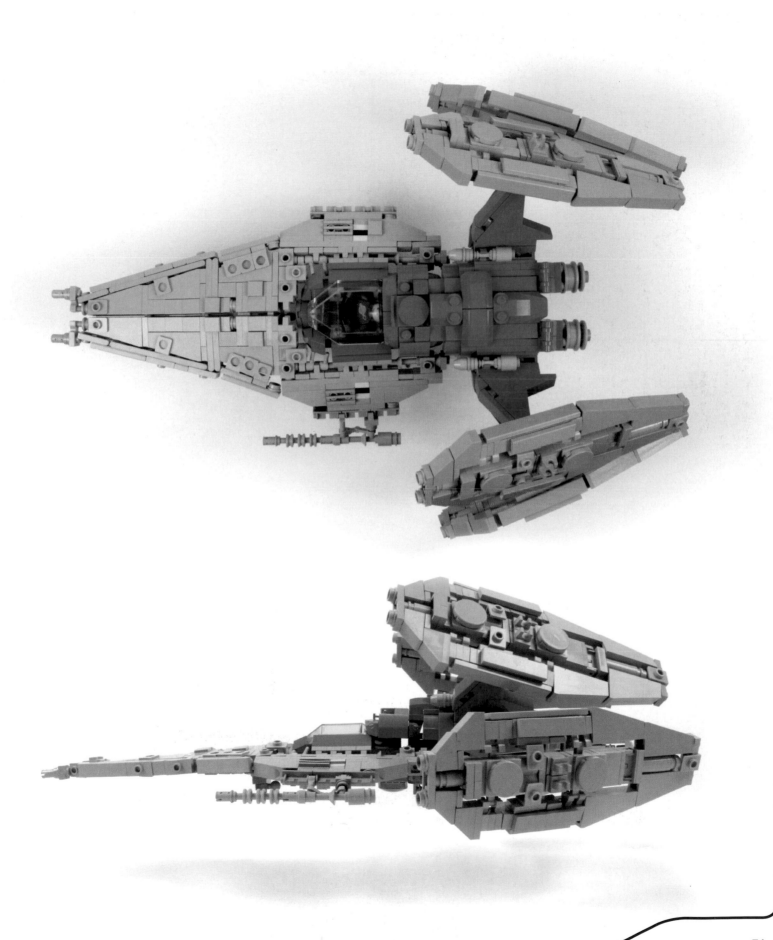

EXO SUIT

Exo Suits carry out a wide variety of duties through-out the Federation. The complicated logistics of fleet operation would not be possible without these mighty machines.

Exo Suits perform in a range of different gravities and can be modified for specific roles. They are perfectly suited to harsh, off-world environments and are crewed by a team of highly skilled operatives who deftly pilot the mighty machines around the hangars.

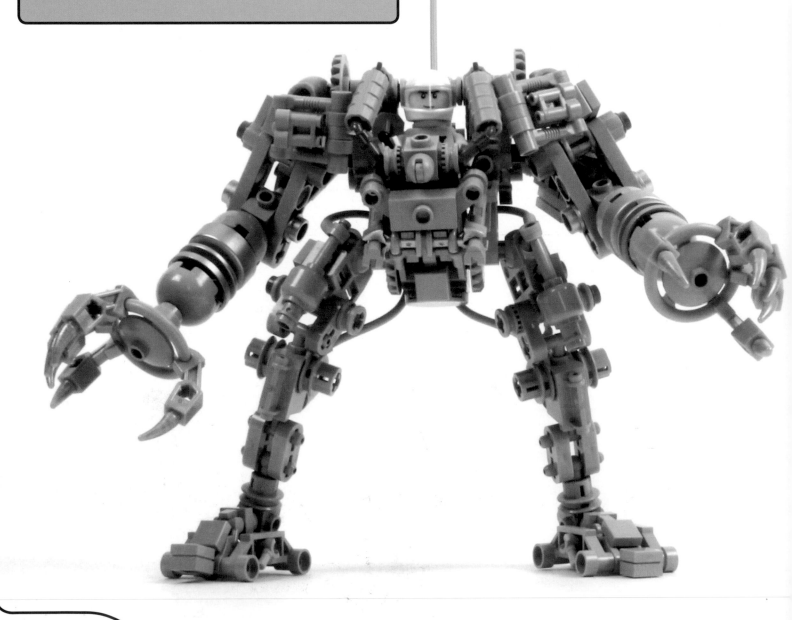

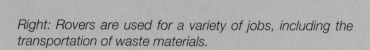

ROVER

A standardized, multipurpose vehicle, the Rover is commonplace. Working alongside the rest of the ground crew, vehicles such as the Rover play an important role in Federation logistics. Rovers are mass produced and used extensively on the Core System colonies.

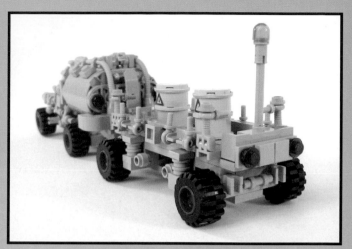

Right: Rovers are used for a variety of jobs, including the transportation of waste materials.

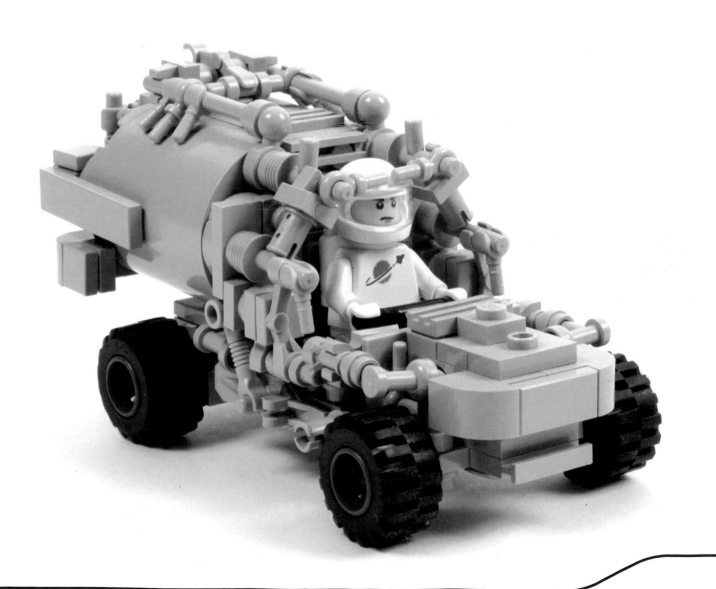

SENTINEL

Sentinel Walkers are primarily used for patrol and messenger duties.

They are outfitted with an advanced navigation and communication system, which makes them ideal for perimeter patrol. Their all-terrain feet are able to cope with a variety of difficult surface conditions.

MOBILE ROCKET LAUNCHER

Designed for the remote deployment of orbital payloads, this larger-than-average vehicle is the brainchild of Captain Diment, a former lunar colonist and pioneering engineer.

A two-man crew is required to operate the launch sequence. Because of its size, the launcher is only used on the Moon. The cost of transporting such a large vehicle elsewhere is prohibitive.

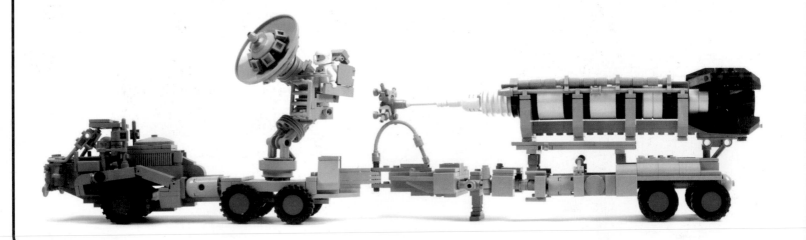

HOVER LOADER

Hover Loaders are an integral part of the ground crew maintenance system. Supplies and equipment constantly need to be delivered to the maintenance and flight teams.

Hover Loaders are limited to a relatively low altitude due to their unique electromagnetic propulsion system.

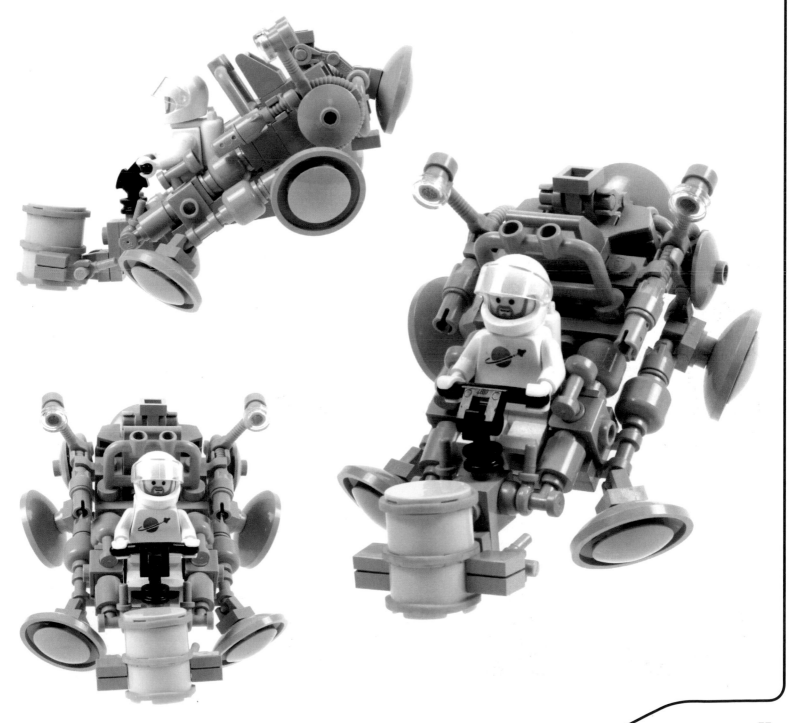

LL-893 SKIMMER

Used exclusively on the lunar and martian colonies, the two-man *Skimmer* is mainly used for low-altitude reconnaissance missions.

The innovation team at BlueMoose Design developed the prototype, and *Skimmer* went into production after a positive Federation review.

Right: Twin induction coils mounted in the Skimmer's undercarriage provide lift.

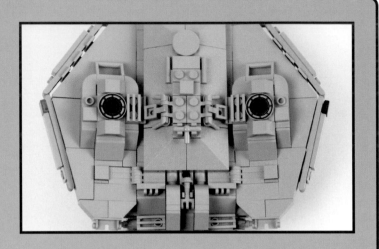

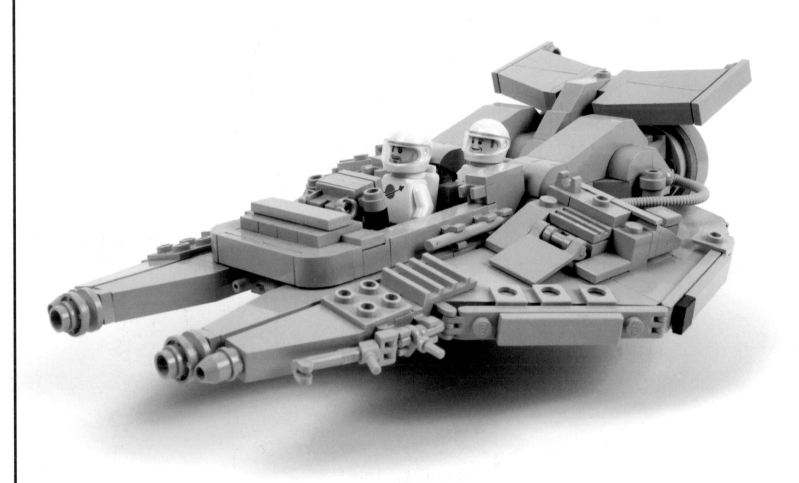

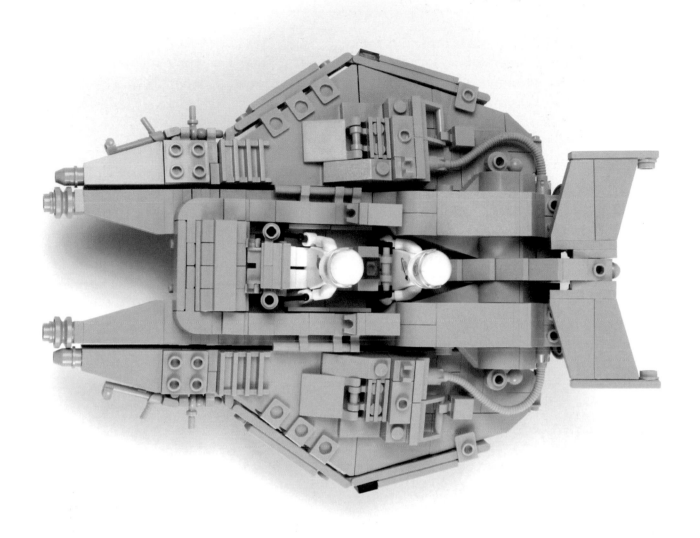

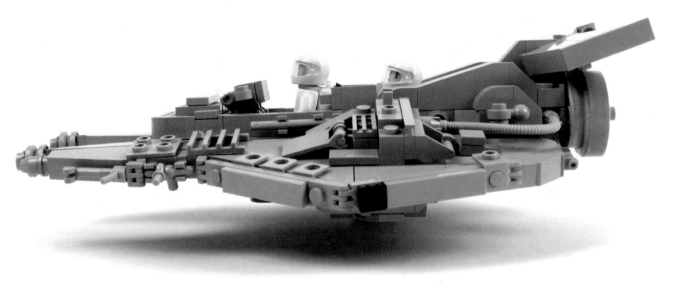

ROBOTS

Specially manufactured robots have taken on uniquely important roles in the Federation. They are able to work in the harshest environments, where radiation would kill human workers. These machines carry out their duties without question or complaint. Once deployed, most Federation robots are programmed to stay away from humans.

Scattered across the Moon are groups of mechanoids, their power cells still charged after years of continuous work. They receive orders via the Ground Control transceiver network.

Blips are the smallest of the Federation robots. They are used as runners, transferring information between members of the team. Because they can travel large distances without recharging, these tiny mechanoids are also used in mapping and reconnaissance duties.

The M364 Turtle plays an important role in the Federation Helium-3 mining program. Specially adapted by Anodyne Systems, the lunar Turtle variant scans the surface for mineral deposits, alerting other robots to any rich deposits. Turtles are also used to transfer equipment across the Moon's surface.

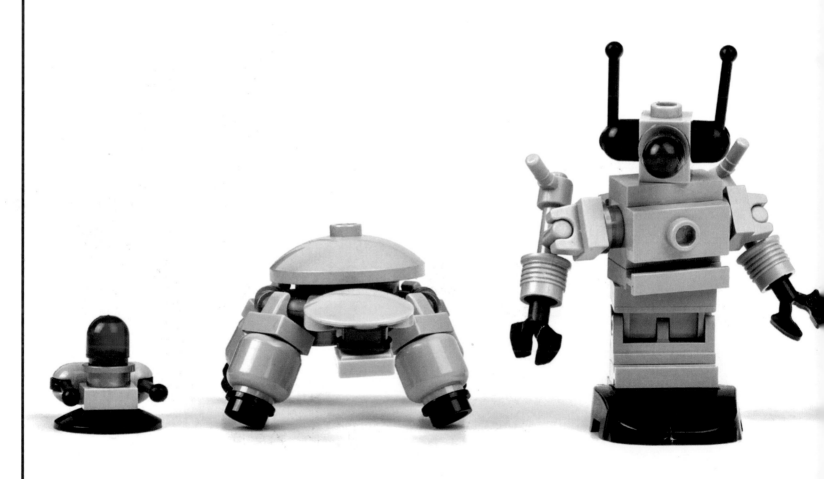

Rho series mechanoids are an old design, popular before the formation of the Federation. The original designers hit upon a reliable, efficient machine that was perfectly suited for numerous tasks. Updated models still appear on occasion.

The Taro series mechanoid is a tough machine, capable of withstanding relentless cosmic bombardment. The rugged construction keeps them operational on the lunar surface. Large, shielded bodies protect them from harmful cosmic rays. Taro units are powerful machines, adaptable to numerous working conditions.

The Crusader series robot is a military design, retooled for security and management of lunar mining operations. Even the smallest robotic mining team has a Crusader in charge. The other robots seem to respect their authority, perhaps because of their history.

Left to right: Blip, M364 Turtle, Rho, Taro, and Crusader series mechanoids

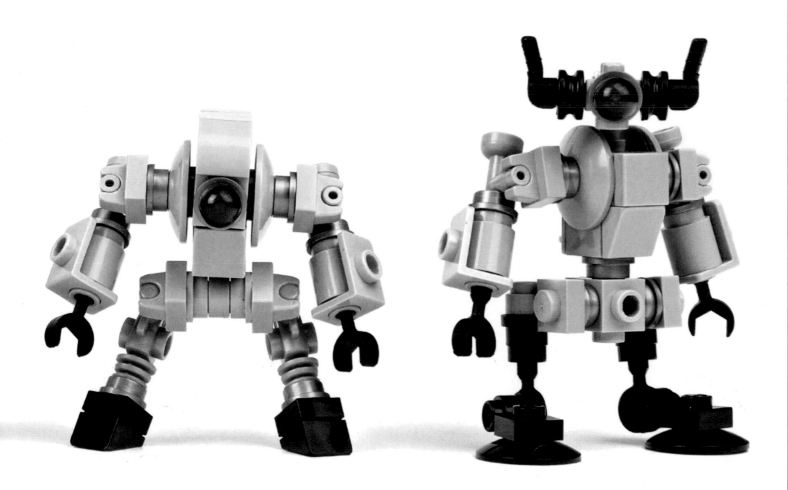

INHOSPITABLE CLIMATE ENGINEERS

"My team is ready for whatever challenges might await us on the Galilean moons."

—Commander Bear

The Federation was keen to expand its reach and set up colonies beyond Mars. A large-scale project to survey planets and moons in the outer system was initiated to find suitable locations for new outposts.

Jupiter's extensive system of moons had remained largely undocumented since the early probes passed them on their way out of the solar system. From Krysto Base, Admiral Kazak coordinated a new series of unmanned missions, dispatching mechanoid surface teams to each of the large satellites. The harsh conditions and distance from the Core worlds made these moons dangerous places for humans to explore. Robot teams were sent to the four Galilean moons simultaneously.

Long curious about the possibility of microbial life in the frozen seas of Europa, the active volcanoes of Io, and the heavily cratered surface of Callisto, scientists followed the progress of these missions closely. The true surprises were to be found on Ganymede.

Orbital scans carried out during the approach revealed an impact site in Ganymede's Osiris quadrant, which caught the immediate attention of Admiral Kazak. Meteor strikes often left behind rich mineral deposits and had been known to yield interesting scientific data.

This discovery made Ganymede a prime site for further research, and the mission parameters for the robots were altered accordingly. Their new task was to assess potential landing zones and set up a series of beacons to guide the incoming engineering team safely to the surface.

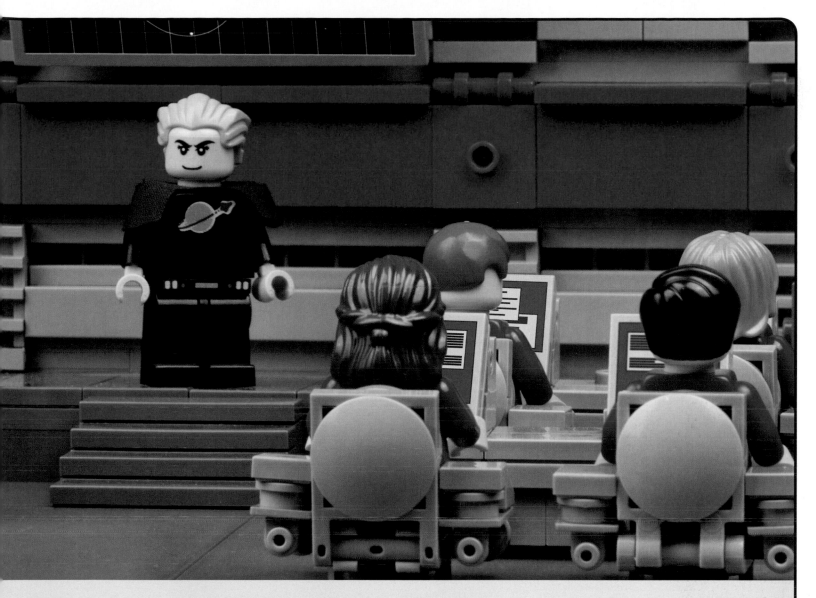

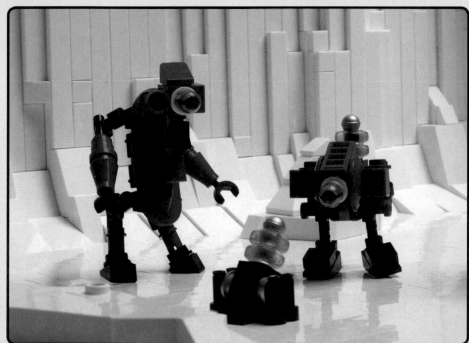

Above: Admiral Kazak and his technical officers plan the Galilean moon survey missions.

Left: Designed to withstand harsh conditions, robot teams formed the first wave of most exploratory missions.

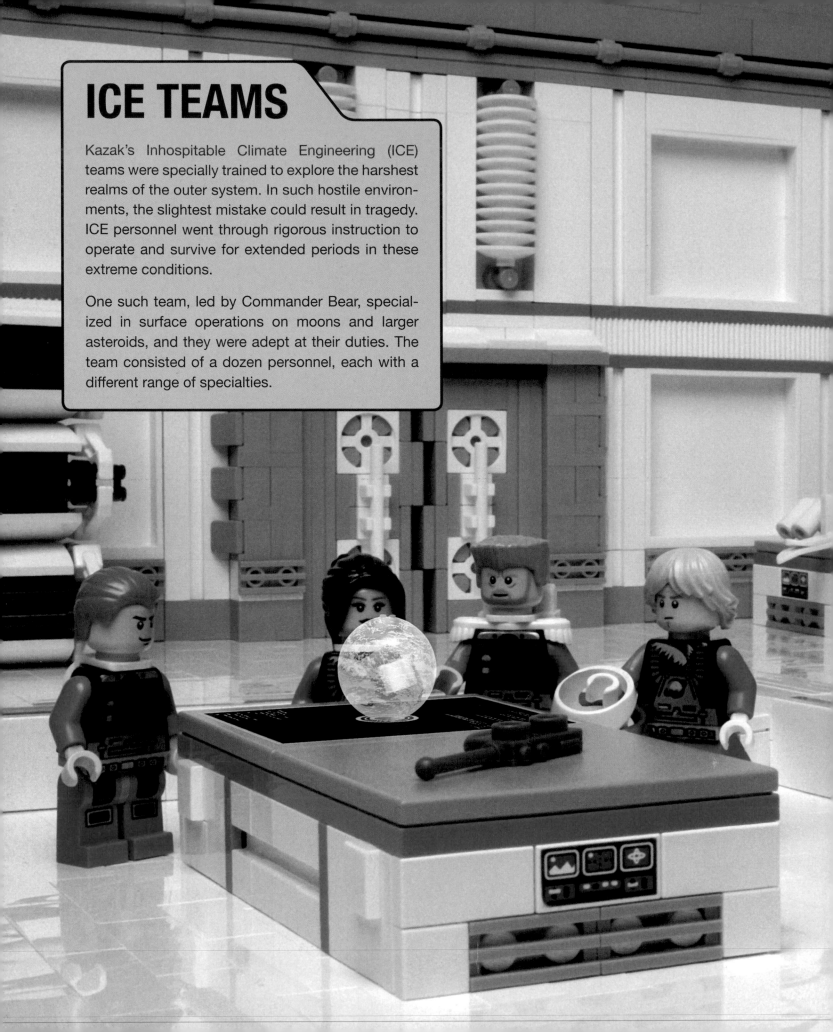

ICE TEAMS

Kazak's Inhospitable Climate Engineering (ICE) teams were specially trained to explore the harshest realms of the outer system. In such hostile environments, the slightest mistake could result in tragedy. ICE personnel went through rigorous instruction to operate and survive for extended periods in these extreme conditions.

One such team, led by Commander Bear, specialized in surface operations on moons and larger asteroids, and they were adept at their duties. The team consisted of a dozen personnel, each with a different range of specialties.

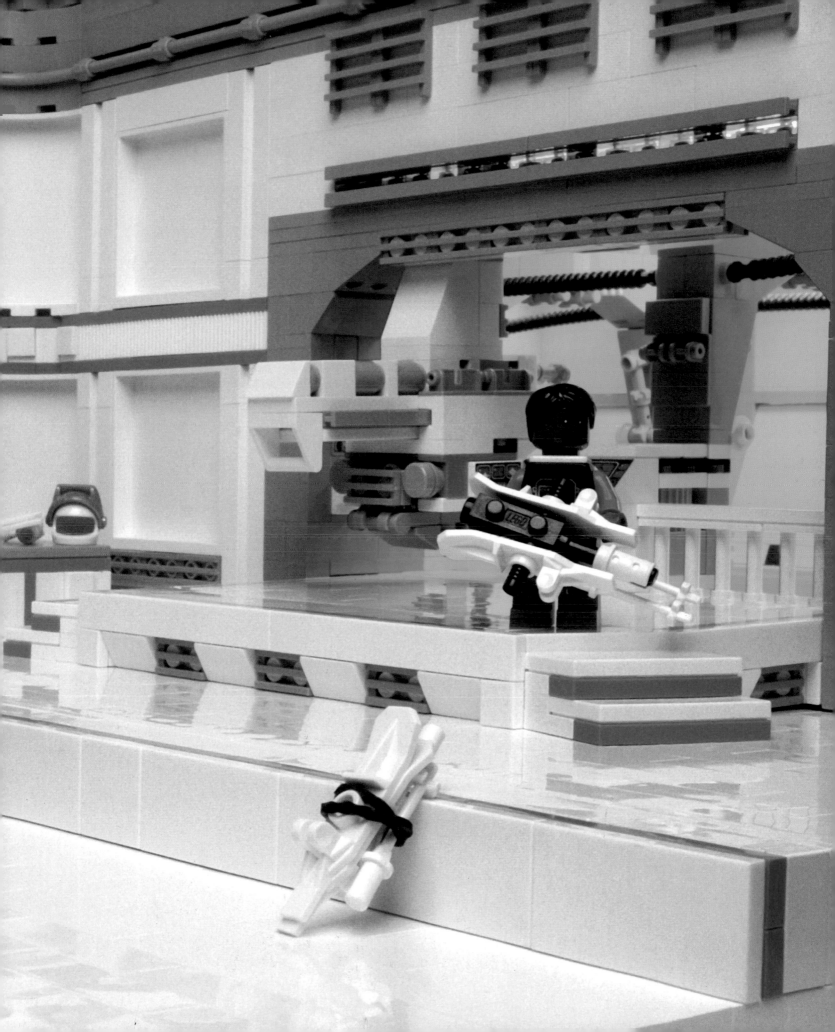

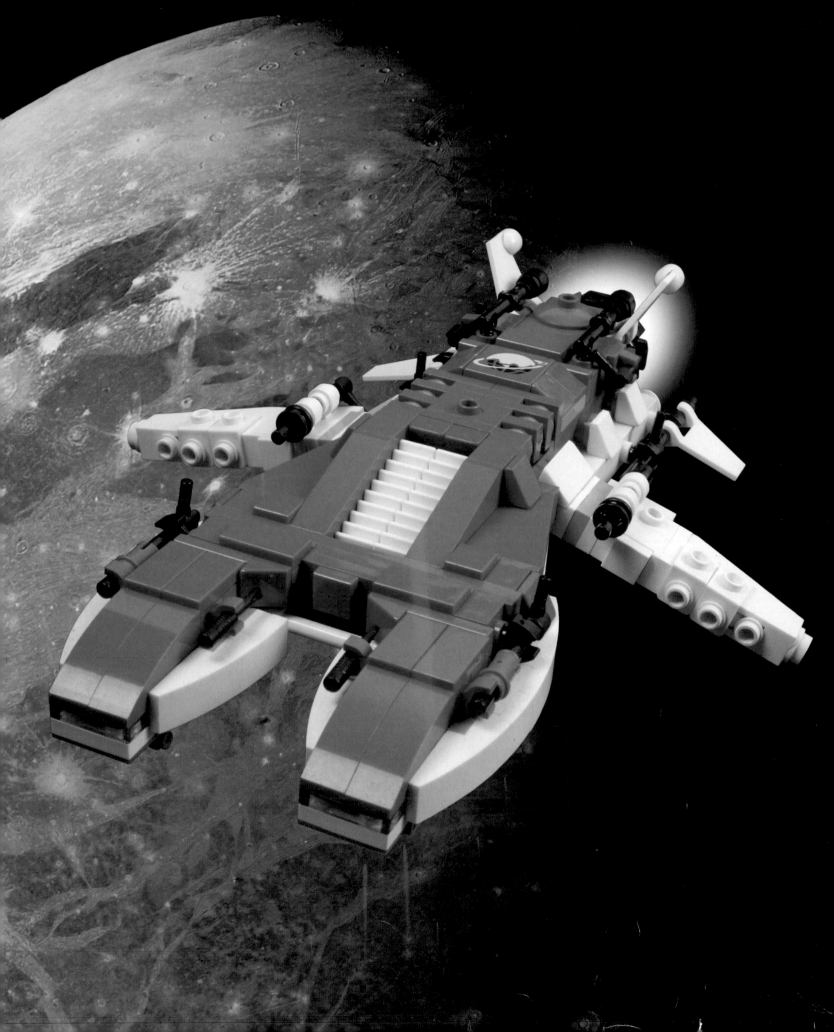

Commander Bear's ICE team spent most of their time aboard *Zycon Five*, a midsized vessel designed to transport survey teams for extended periods of unsupported operation.

In addition to the facilities typically found on such a ship, *Zycon Five* was equipped with a state-of-the-art research lab capable of extensive chemical and biological analysis. The ship was not rated for planetary landings, so the team depended on the *Kodiak* drop ship for surface transfer.

The impact zone proved stable enough to support the weight of the drop ship, so the robots set about clearing loose debris from the immediate area and leveling the uneven surface. With the landing zone prepared, they began to place marker beacons around the impact zone and extract core samples from beneath the surface ice.

When the robots had completed their mission, they transmitted the final results of their close-terrain analysis back to Commander Bear's team on *Zycon Five* and took shelter against the cruel wind of Ganymede.

The chemical analysis of the rock samples was intriguing. The robots had found fused carbon and metal fragments containing molecular compounds that could have been organic matter. Admiral Kazak's instructions had been quite specific: The commander was to report any unusual findings on Ganymede without delay. He forwarded the transmission to Krysto Base, and the team settled in to await further orders.

They didn't have to wait long. The admiral's response was swift. They were to prepare an away team to investigate and extract debris from the site. The team was to set off immediately.

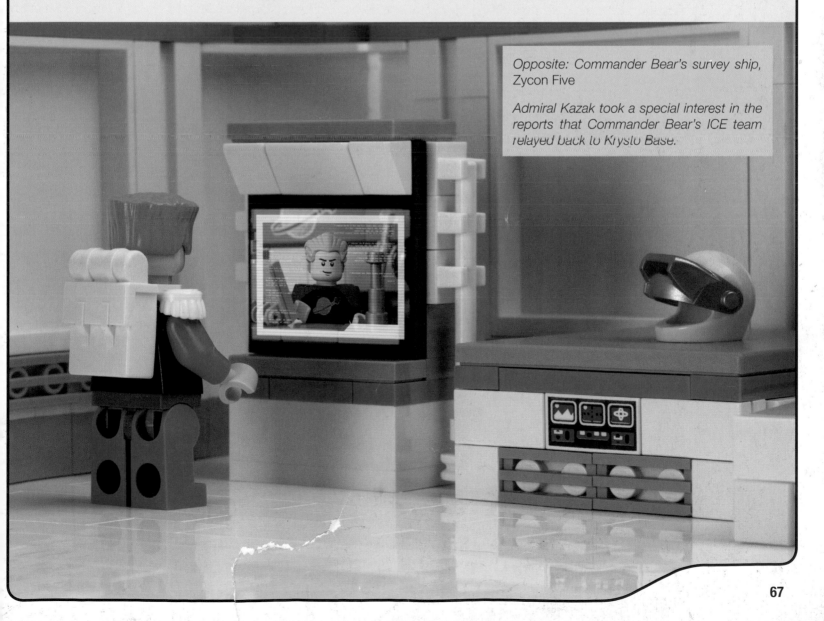

Opposite: Commander Bear's survey ship, Zycon Five

Admiral Kazak took a special interest in the reports that Commander Bear's ICE team relayed back to Krysto Base.

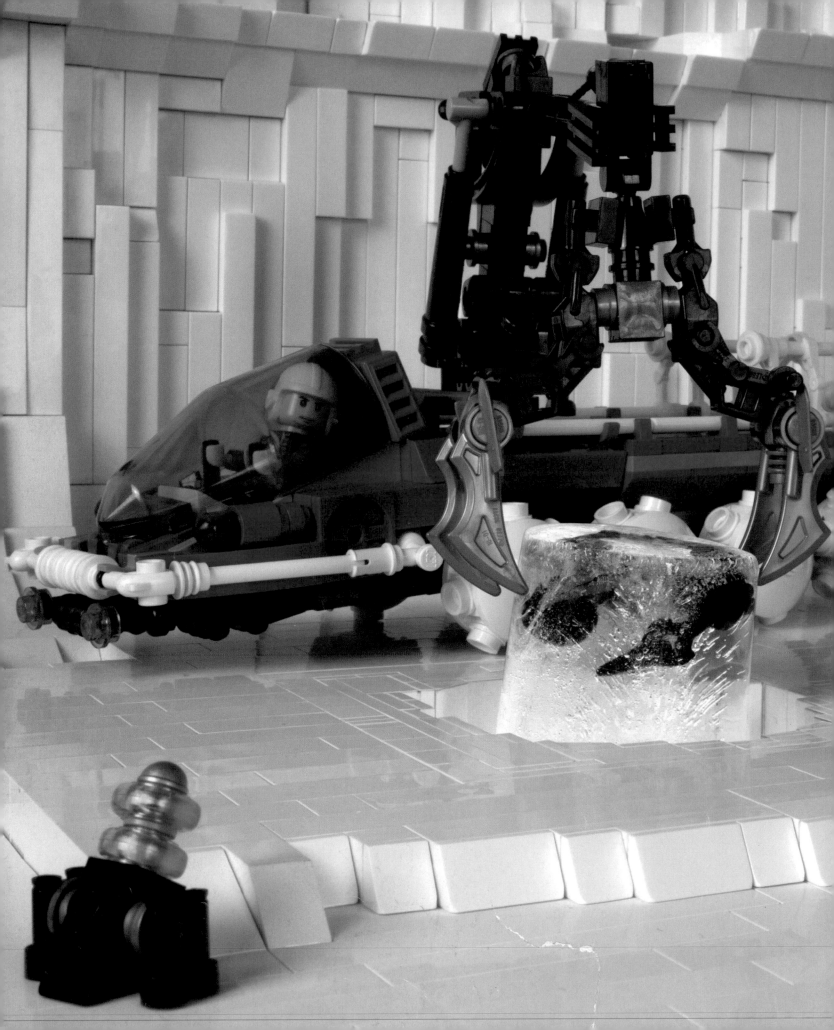

After the savage storm abated, Commander Bear's team prepared to leave the drop ship. They were a small unit, laden with equipment for the task ahead.

The team was accompanied by a modified VX-163 launcher. Normally configured as a satellite launcher, the vehicle had been specially adapted before this mission. A large claw attachment and additional stabilizers allowed for heavy lifting. The team moved into position and began cutting.

The first few sample areas they tried contained nothing of interest. After several hours of fruitless digging, the ICE team found something. The sample seemed to contain an indistinct stain in the cloudy ice. The VX-163 pilot operated the claw delicately, as the rest of the team moved to the next excavation point. There were five more samples, each of them cut out and extracted with careful precision.

The entire operation took a grueling 12 hours.

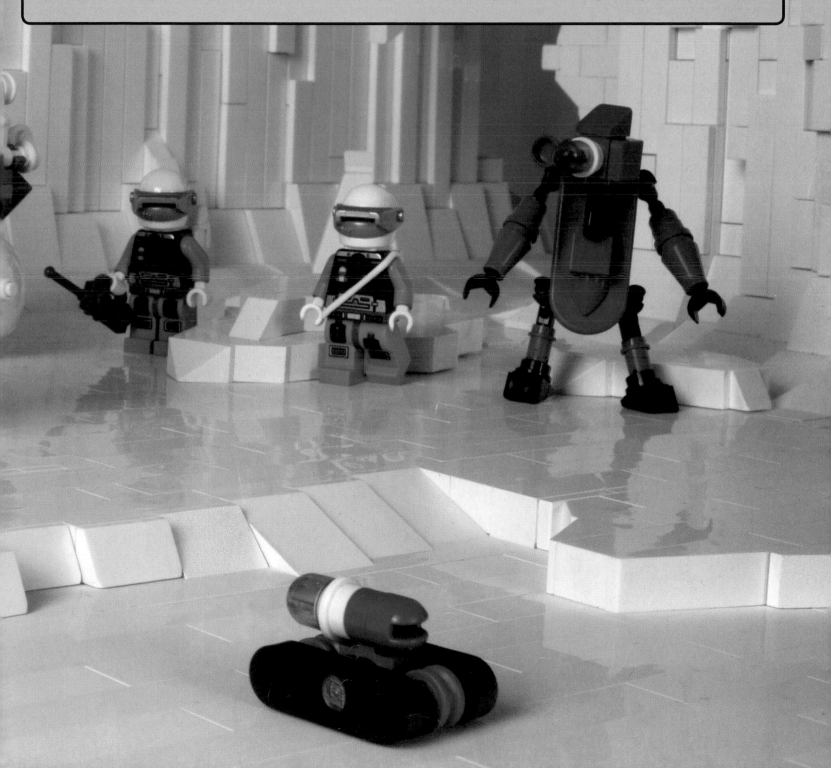

The ice core samples were transported back to *Kodiak* and packed in protective insulated cases.

The crew strapped themselves in as the launch countdown sounded. The shuttle blasted from the icy surface, plotting a course for the orbiting *Zycon Five*. A storm raged and rocked the shuttle as it passed into the upper atmosphere of Ganymede.

Kodiak's powerful thrusters burned a path into the blackness of space. *Zycon Five* loomed in orbit, quickly becoming visible and then filling the view port as the drop ship moved into position and docked underneath the cruiser.

When the docking clamps were engaged, the ICE team transferred to the larger ship. The samples were moved to the onboard lab. Commander Bear transmitted details of the mission to Admiral Kazak. The team was recalled to Krysto immediately.

Opposite: The analysis of the ice sample yielded unexpected results.

Below: Kodiak *approaches* Zycon Five *with its extraordinary cargo.*

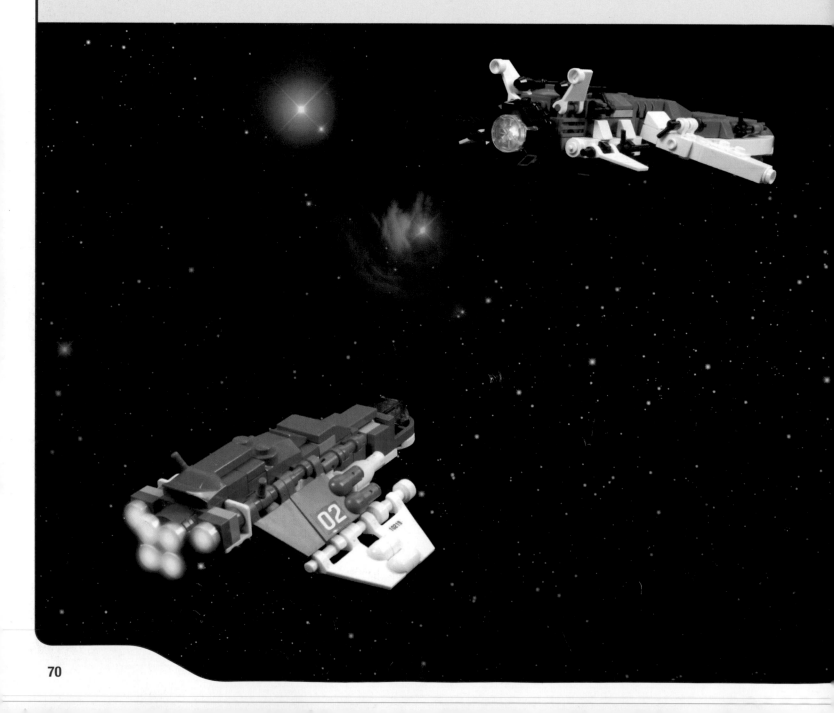

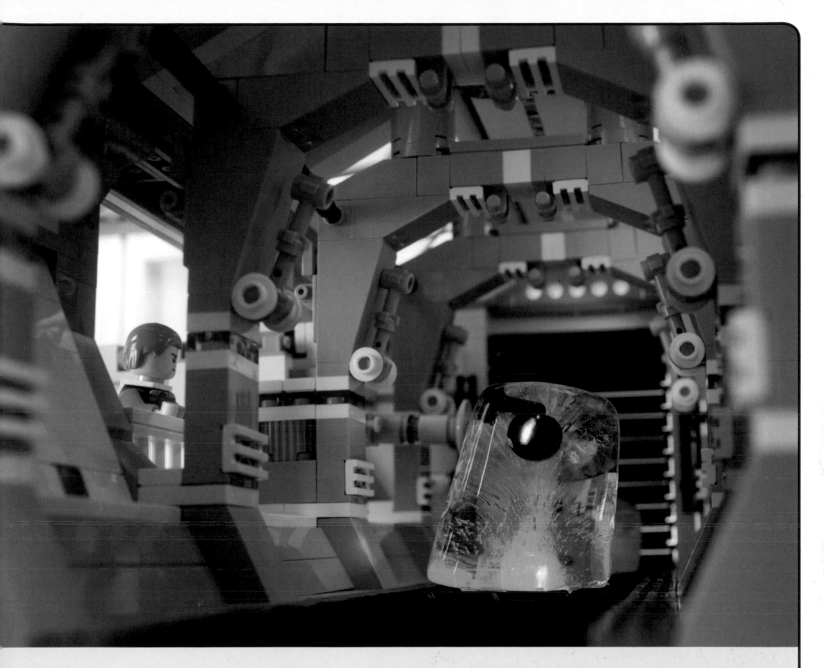

The crew realized they had something unique on board. Defying the admiral's order to leave the samples alone until they could be analyzed on Krysto, one ICE engineer began a preliminary study of the largest specimen. It had partially thawed as it passed through the analysis chamber. Scans showed an unsettling shape within.

There was something sinister about the samples. Commander Bear noticed the crew seemed ill at ease. A brief bout of turbulence as they skirted the edge of a massive cloud of dust and rock put everyone further on edge.

As the ice thawed, one of the Ganymede samples began to glow a sickly green. It was faint at first, but it quickly grew brighter. Some of the team appeared mesmerized by its unearthly light. They moved toward the sample, bathed in an unnatural shade. Commander Bear saw the incident and intervened. He made sure the samples were moved to a secure storage bay, where their strange light could not be seen.

The crew gave their unusual cargo wide berth after that. The real research would be done by Admiral Kazak's science division on Krysto. The team was tired. It had been an exhausting mission.

After three days, *Zycon Five* reached Krysto Base. The samples were signed over to Admiral Kazak's research team.

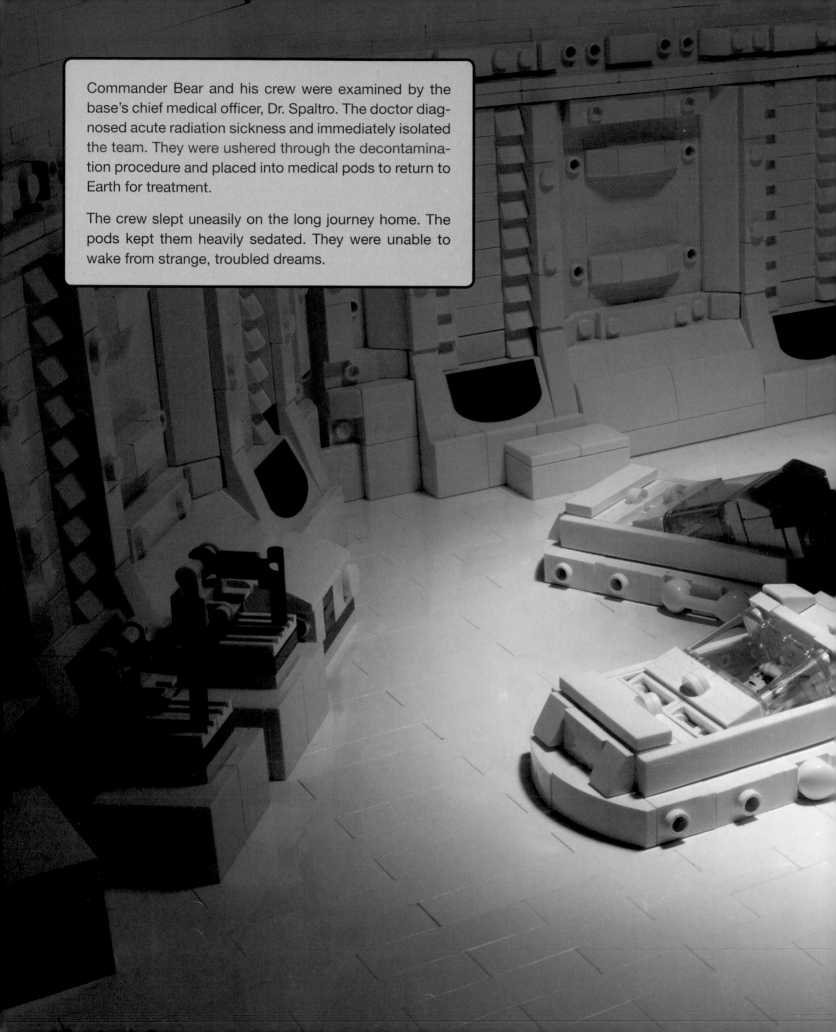

Commander Bear and his crew were examined by the base's chief medical officer, Dr. Spaltro. The doctor diagnosed acute radiation sickness and immediately isolated the team. They were ushered through the decontamination procedure and placed into medical pods to return to Earth for treatment.

The crew slept uneasily on the long journey home. The pods kept them heavily sedated. They were unable to wake from strange, troubled dreams.

ICE VEHICLES

ICE teams were equipped with top-of-the-line vehicles, equipment, and support mechanoids during operations.

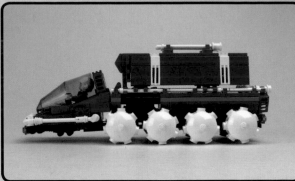

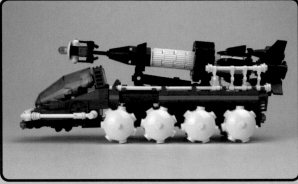

VX-163

An eight-wheeled, all-terrain specialist ICE vehicle, the VX-163 has a variable configuration, making it useful for a variety of scenarios. Adaptations include a personnel carrier, claw attachment, and satellite launcher.

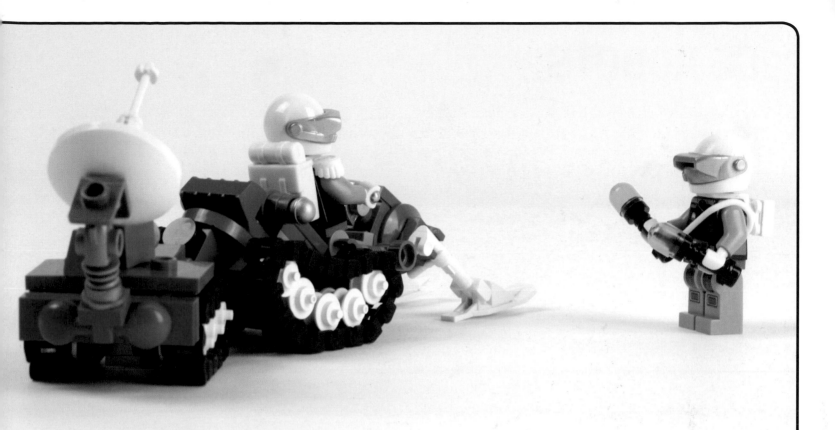

SNOWMOBILE

Designed to be lightweight and compact, the Snowmobile is used by the ICE team on the outer planets and moons.

It is a short-range vehicle, capable of traversing variable terrain and maintaining a telemetry link with the orbiting *Zycon Five*.

ICE ROBOTS

Robots are used extensively by the ICE teams. They are able to endure much longer periods of exposure to the elemental forces on the planets and moons than their human counterparts.

Each robot has its own role to play.

The Surface Tracking Analysis unit (STAn) is a small, highly maneuverable machine. With a low center of gravity and wide, heavy-duty tracks, it is able to travel over uneven surfaces in order to take rock and ice samples from areas inaccessible to humans.

The Orbital Liaison and Impact Examiner (OLIE) specializes in the analysis of craters and other rock formations created as a result of meteorite strikes. Its side-mounted scope contains a range of lenses and imaging equipment.

The Hazardous Environment Climate and Topography Research unit (HECToR) maps weather systems and geological formations via a network uplink to orbiting satellites or research ships.

The Proteus and Crusader mechanoids often work together as a team to prepare landing sites. Proteus units can be fitted with a selection of tools to clear surface detritus, and the Crusaders use internal triangulation matrices to determine the optimum locations for landing beacons.

Below left: STAn and OLIE

Below right: HECToR

Opposite: Proteus and Crusader units deploy a navigation beacon.

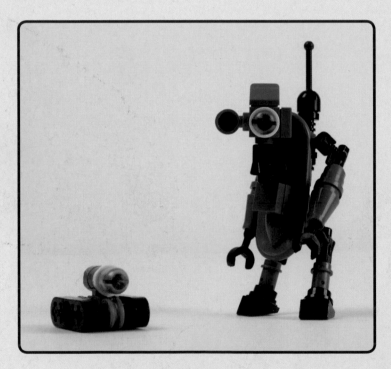

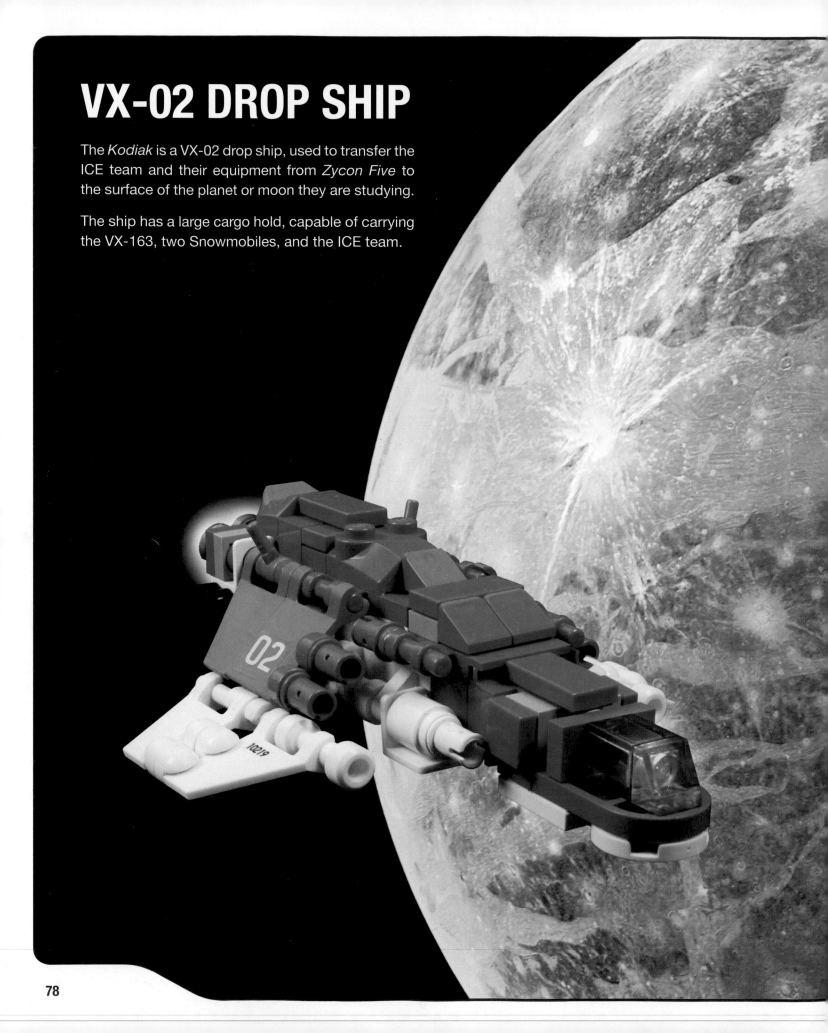

VX-02 DROP SHIP

The *Kodiak* is a VX-02 drop ship, used to transfer the ICE team and their equipment from *Zycon Five* to the surface of the planet or moon they are studying.

The ship has a large cargo hold, capable of carrying the VX-163, two Snowmobiles, and the ICE team.

1

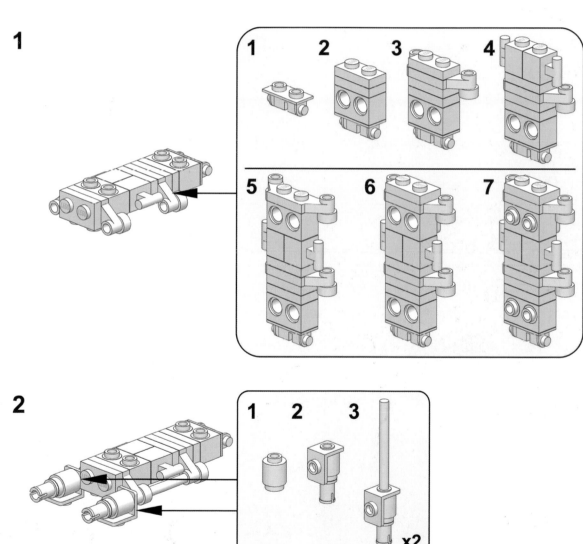

2

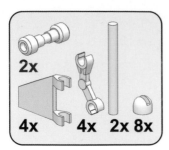

3

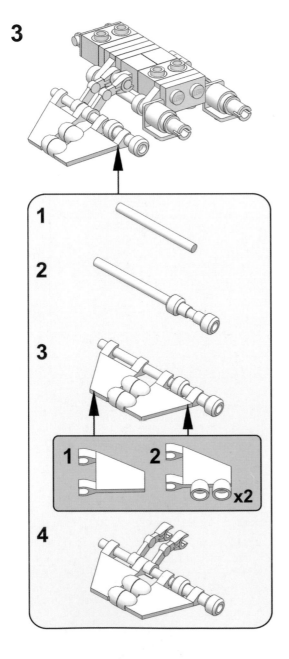

4

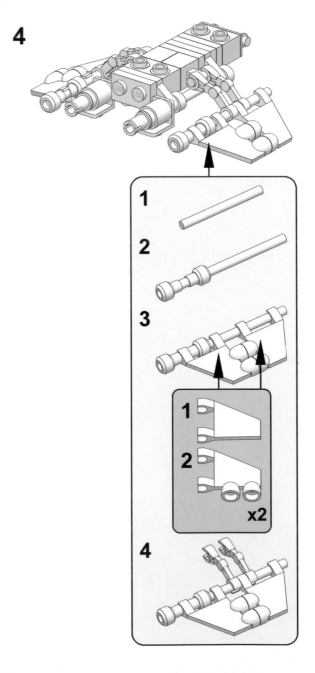

2x

5

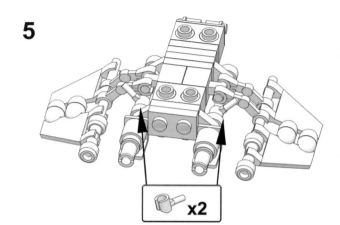

x2

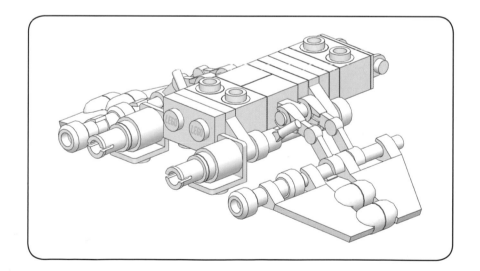

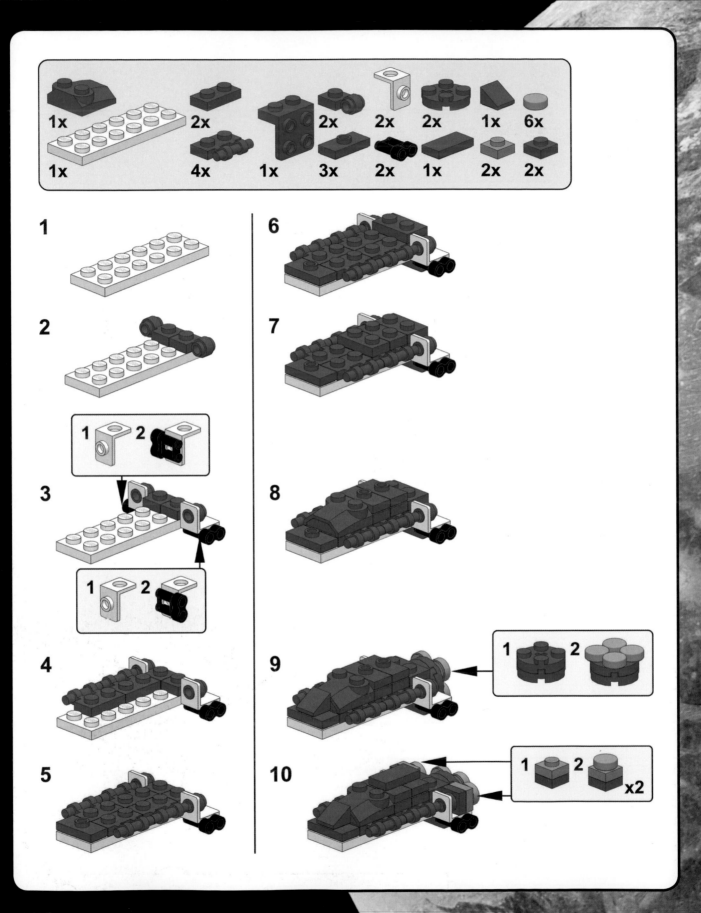

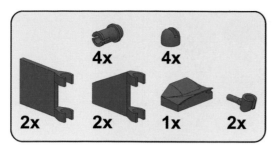

11

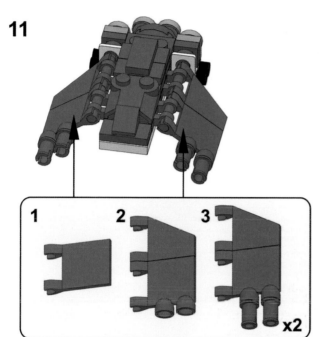

1　**2**　**3**

x2

12

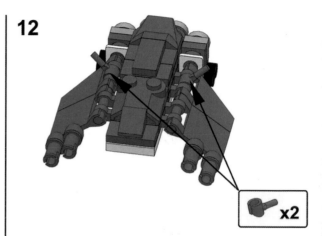

x2

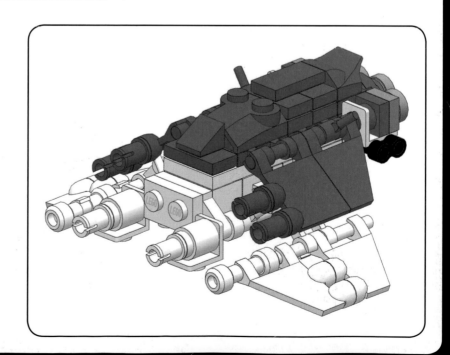

1

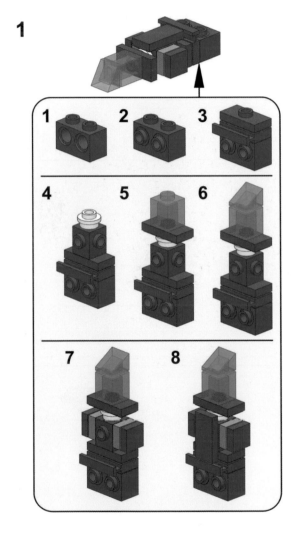

2

3

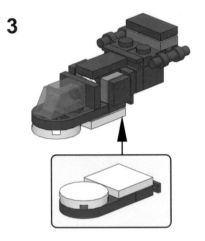

4

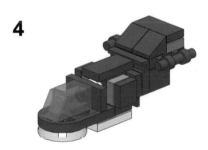

5

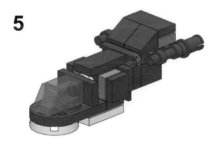

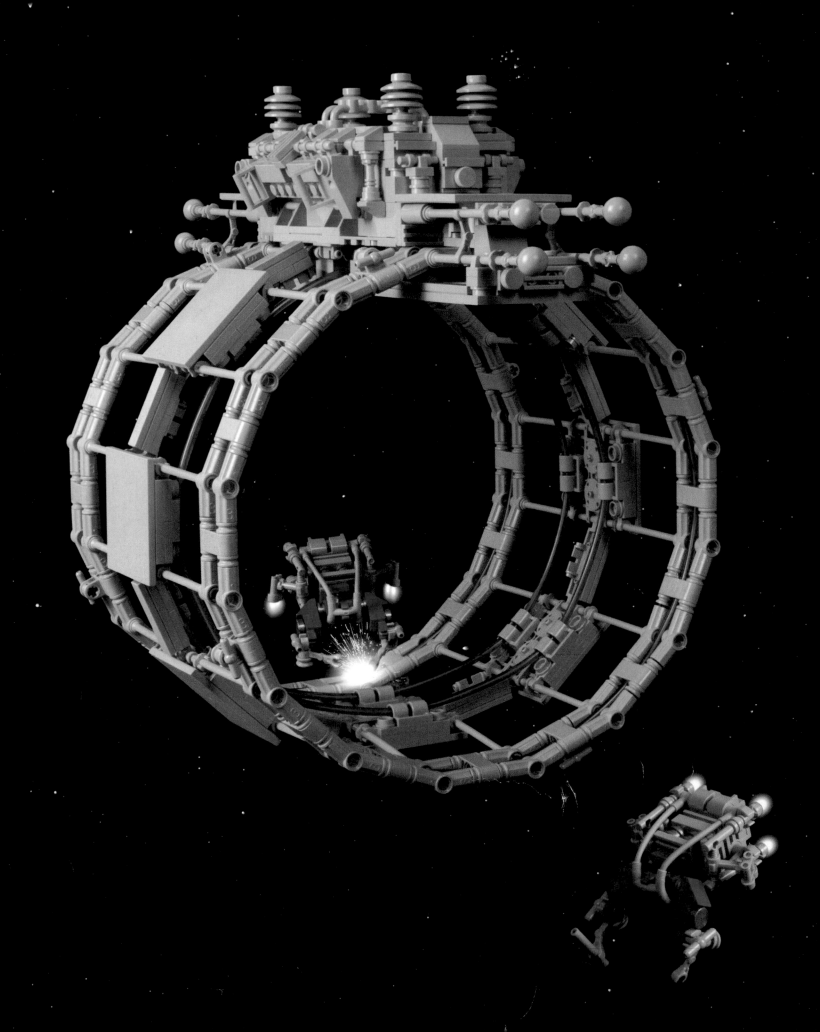

NEW FRONTIERS

"Just two small words represent centuries of research into artificial intelligence: I am."

—*Professor Dade*

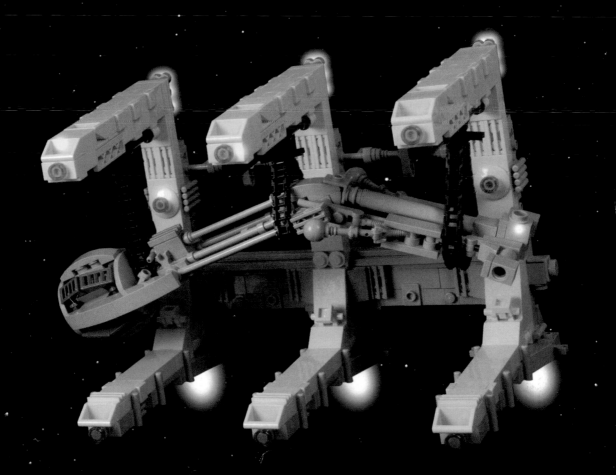

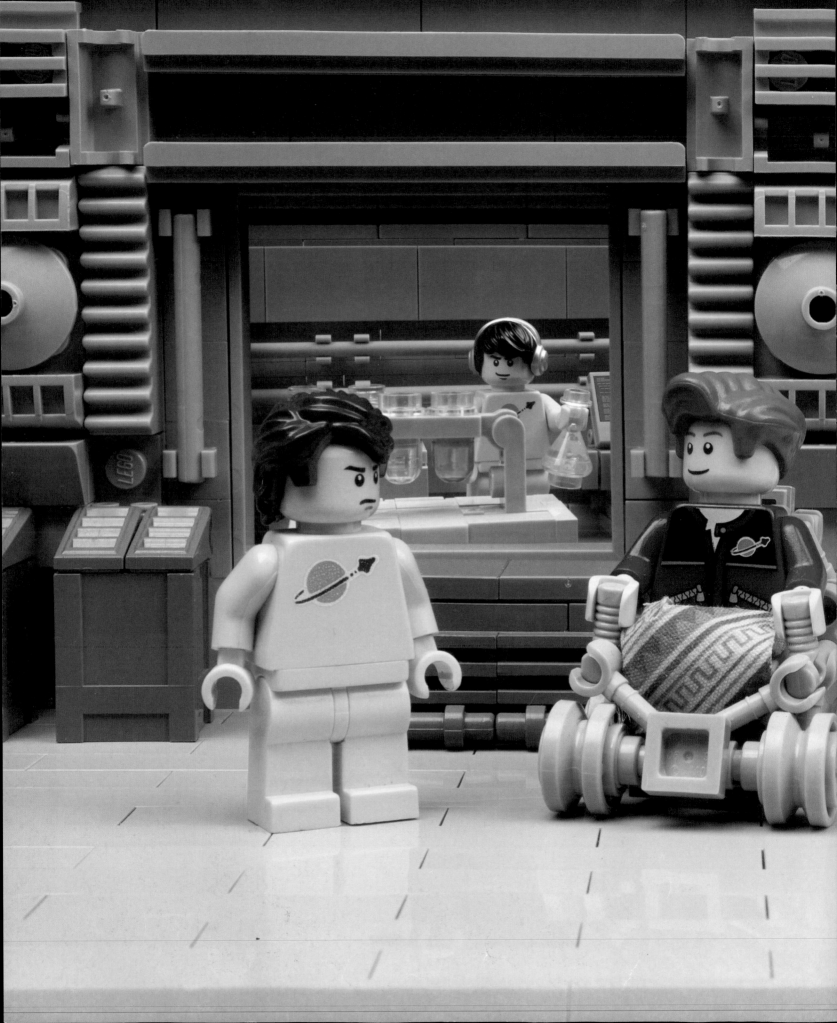

On Tranquility Base, teams of yellow-suited scientists carried out cutting-edge research. The finest scientific minds of the age were stationed on the lunar base, where they were encouraged to master their respective fields. Tranquility Base was regarded by many academics as the finest Federation posting.

Graduate scientists were allowed to pursue their passions, academic or otherwise. They could specialize in whichever field they favored with minimal interference from their superiors. The Federation greatly valued the constant stream of new technologies that originated from Tranquility Base. The scientists managed their own work schedules and were usually far more productive when left unsupervised. Every time a high-ranking officer attempted to get involved, projects failed.

The low levels of gravity and lack of atmosphere outside the lunar base enabled design teams to simulate conditions in deep space, resulting in greatly improved spacecraft. The most recent generation of ships had been developed on the Moon, and they were considered the pinnacle of Federation technology.

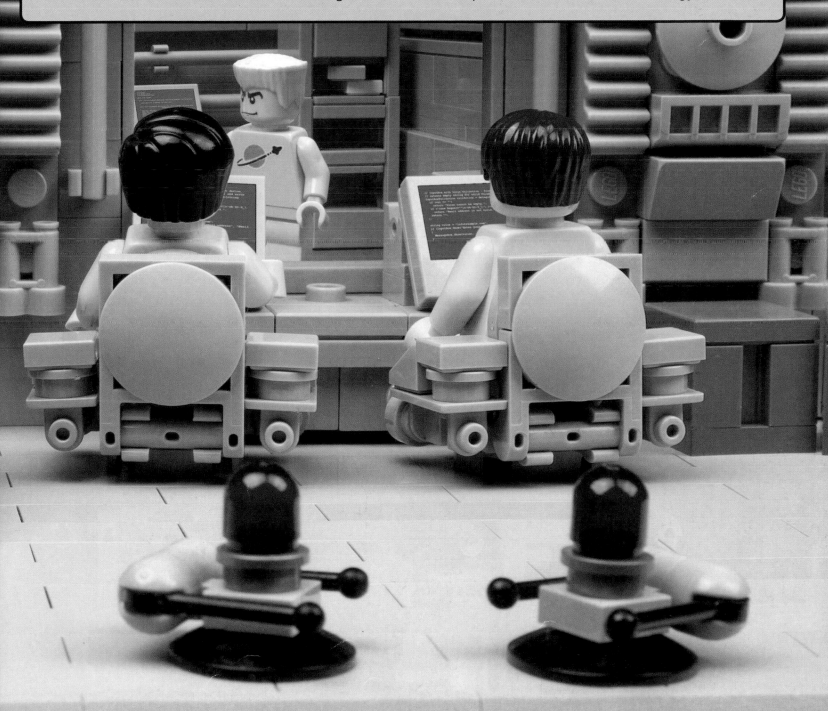

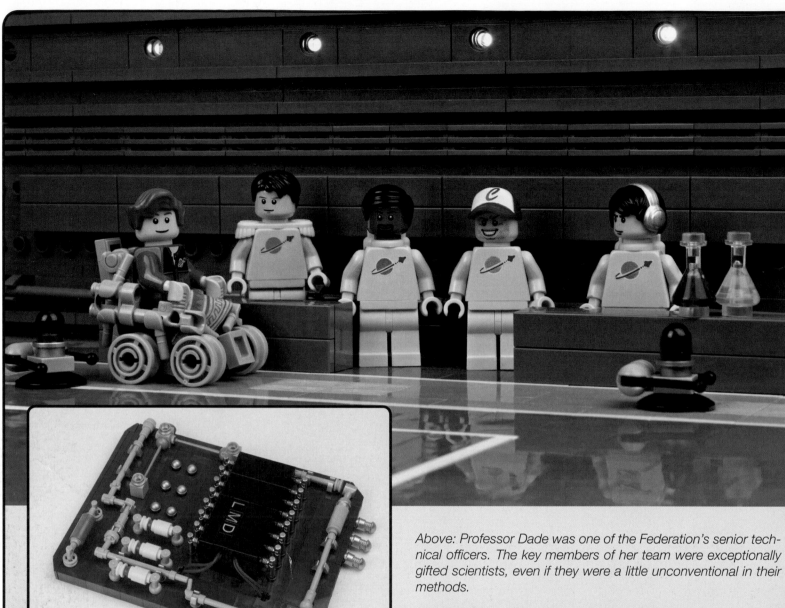

Above: Professor Dade was one of the Federation's senior technical officers. The key members of her team were exceptionally gifted scientists, even if they were a little unconventional in their methods.

Left: The LMD processor revolutionized the commercial cybernetics industry. Professor Dade's brilliant design was mass-produced by Anodyne Systems and fitted as a standard safety feature to all types of mechanoid.

Professor Dade was head of the cybernetics division on Tranquility Base, also serving as a mentor to several groups of scientists. During her distinguished career, Dade specialized in the study of cybernetic minds.

Professor Dade was responsible for an exhaustive set of operational and protocol updates. Networks and programming methods devised by Dade led to groundbreaking advances in the field of artificial intelligence. It had taken mankind centuries to create a machine that behaved like a human. At last, true artificial neural networks could be mass-produced, then easily programmed to behave in a way that was indistinguishable from a human mind.

Public opinion on robots had been overwhelmingly negative. Stories of fatalities involving defective, non-sentient robots were highly publicized in the media.

Once Professor Dade's updated matrices filtered down to the mass-produced machines on Earth, however, popular opinion rapidly changed. It was impossible to resist the charm of a robot fitted with an LMD processor.

Decades of superstition and mistrust turned into a consumer frenzy as millions of people on Earth purchased these new robots. The Federation contracted the manufacture to Anodyne Systems, a company originally founded by renowned philanthropist Sir Charles Anodyne to produce educational toys for the third world. Thanks to a popular marketing campaign, the *My Lovely Robot* series broke sales records. The company retooled their factories to cope with demand.

Despite the success of this new line of robots, Professor Dade had her reservations. She felt sorry for the robots—positronic minds were much too powerful for worker units. But the decision to use her LMD processor in consumer models was beyond her control. The manufacture of such companionable machines generated incredible revenue for the Federation.

She continued her work, adapting Blips to assist the scientific teams on Tranquility Base. Vast amounts of information were transferred between various laboratories and a central database by an army of the tiny robots. Professor Dade programmed a group of specially upgraded Blips to assist the teams with their intense data transfer and processing requirements.

Above: The star of the My Lovely Robot *advertising campaign was a modified HC series mechanoid.*

Below: Professor Dade continued to adapt the Blips, making them indispensable to the staff of the base.

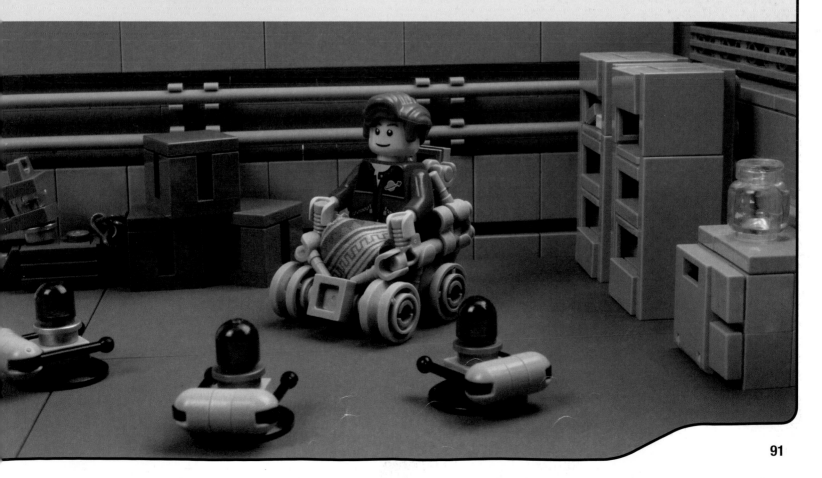

BLIPS

For the first few decades of Federation expansion, robots were rarely seen alongside humans. Mechanoids were primarily used for mining and mapping duties. The high levels of cosmic radiation they absorbed meant they could never return to areas frequented by human beings.

Despite advances in artificial intelligence, off-world personnel were generally wary of robots. There had been several unfortunate incidents over the years.

Federation robots were generally larger than the average human, built to a scale that suited their duties.

Smaller models such as the Blip were an exception. Professor Dade introduced a networked cluster of Blips to Tranquility Base. The machines had a surprisingly flexible user interface, and Dade established an advanced series of cybernetic protocols for them.

Blips performed a wide range of duties on the lunar base, from simple messaging to cleaning and security patrols. The robots also provided valuable companionship to some of the more reclusive scientists on Tranquility Base.

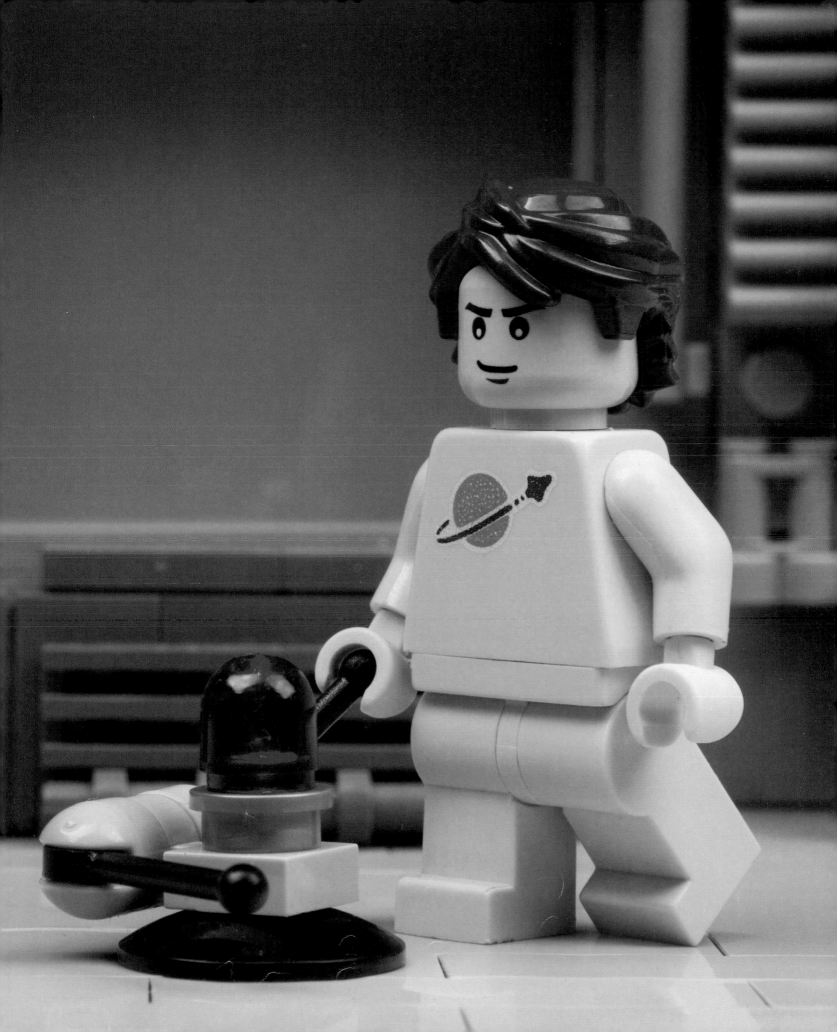

RELATIVE DIMENSION

The scientists on Tranquility Base were an odd mixture of characters. Some exuded an air of brilliance and enjoyed debates and discussions with their colleagues. Others were more distant, preferring to communicate using messaging devices or other machines.

The most reclusive scientists never made contact with their superiors or colleagues. Unsettled by conventional social interaction, they spent most of their time hiding in their laboratories, content among their charts and endless research.

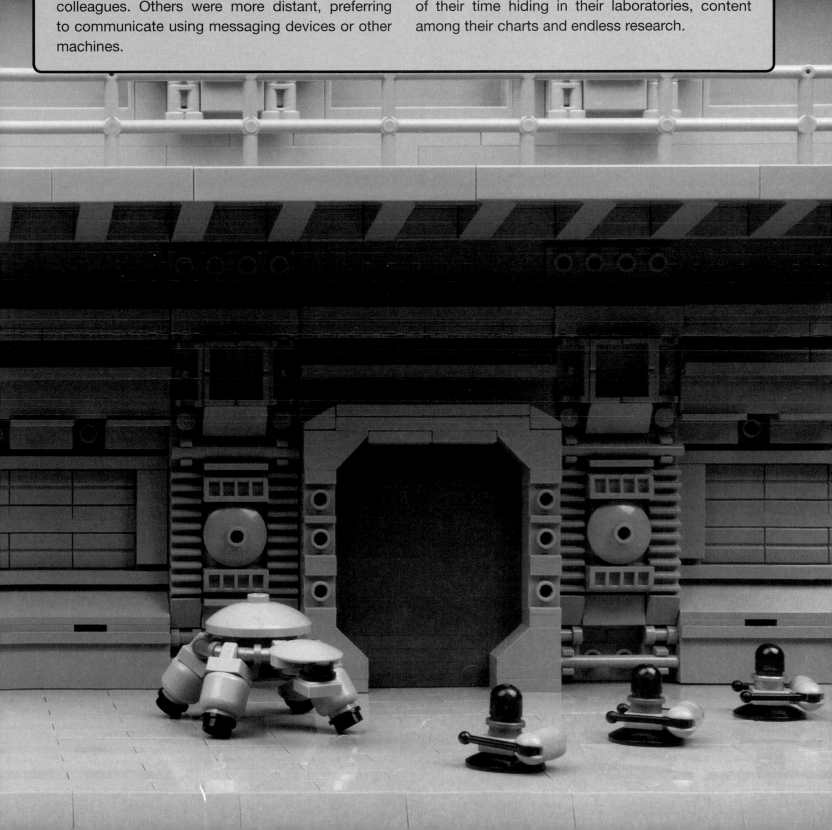

Tranquility Base was an ideal environment for Tom Golightly. He did his best work on his own, and his wishes for solitude were respected. He had a spacious workshop where he was allowed to develop his theories undisturbed.

Golightly grew up on Earth, and his high school dissertation on general relativity caught the attention of the Federation's talent spotters. A headhunter approached him on the eve of his 17th birthday and told him he was short-listed for a full-scholarship position on Tranquility Base. All he had to do was achieve the predicted high marks on his final exams, and the opportunity of a lifetime would be his.

Less than a week after receiving a set of results that exceeded even the Federation's high expectations, Golightly was shipped to the Moon to start his new career as a Federation scientist. He was allocated a well-equipped laboratory and granted priority funding for his work.

Over the years, he rose through the ranks, helping development teams with a variety of scientific innovations and eventually becoming a major.

Below: Major Golightly's research into conductive energy fields led directly to enhanced power systems on short-range Federation spacecraft.

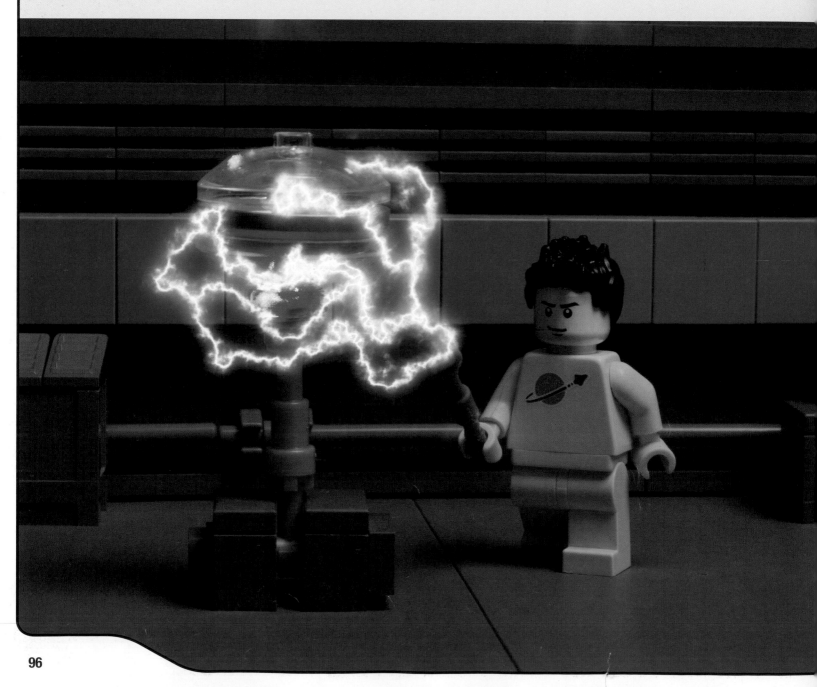

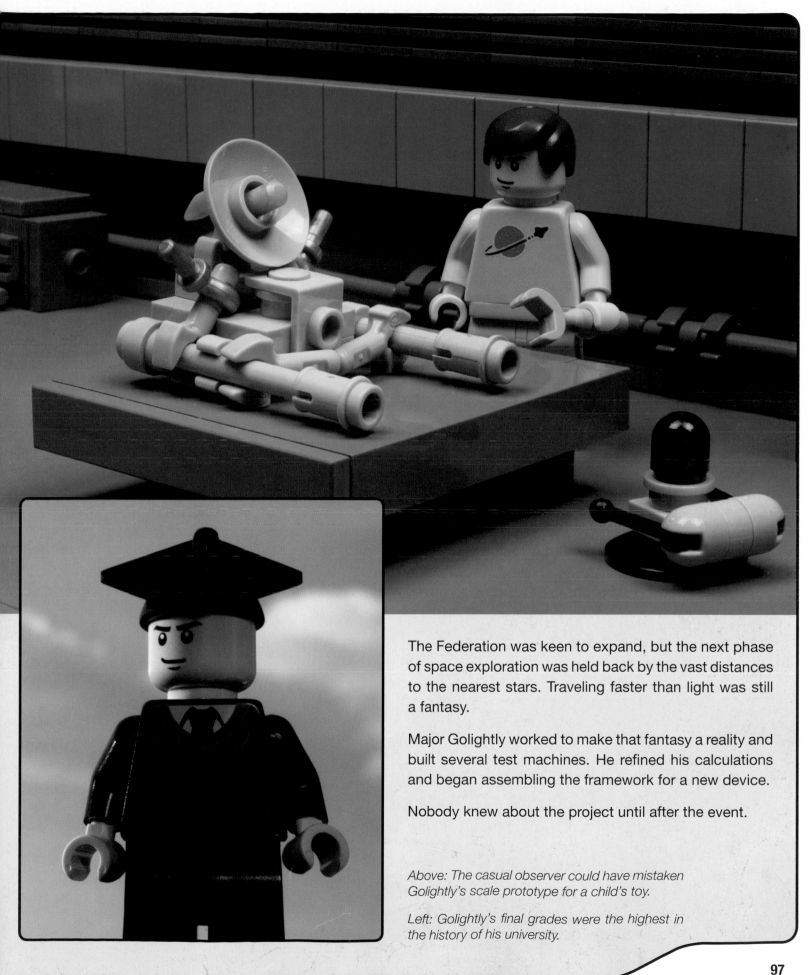

The Federation was keen to expand, but the next phase of space exploration was held back by the vast distances to the nearest stars. Traveling faster than light was still a fantasy.

Major Golightly worked to make that fantasy a reality and built several test machines. He refined his calculations and began assembling the framework for a new device.

Nobody knew about the project until after the event.

Above: The casual observer could have mistaken Golightly's scale prototype for a child's toy.

Left: Golightly's final grades were the highest in the history of his university.

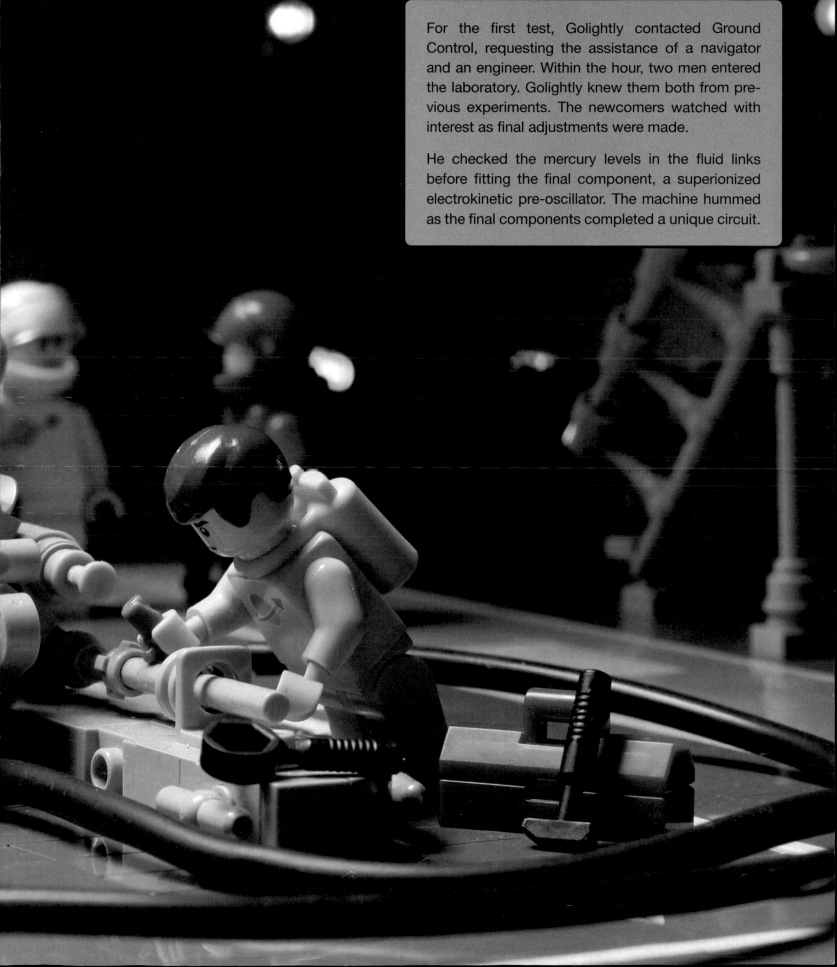

For the first test, Golightly contacted Ground Control, requesting the assistance of a navigator and an engineer. Within the hour, two men entered the laboratory. Golightly knew them both from previous experiments. The newcomers watched with interest as final adjustments were made.

He checked the mercury levels in the fluid links before fitting the final component, a superionized electrokinetic pre-oscillator. The machine hummed as the final components completed a unique circuit.

Golightly climbed into the device and invited the navigator and engineer to step aboard. He adjusted the controls. The lights across Tranquility Base dimmed as power was diverted to the workshop. The machine hummed louder. For the three men, the room seemed to grow dim and lose focus.

Golightly pulled the lever back farther. As the humming increased in volume, the room around them phased and then disappeared. They had been transported to an unknown point in space and time.

Emergency breakers tripped as the circuit broke. Ground Control repeatedly attempted to reestablish a communications link.

A team was dispatched to Golightly's workshop. The team entered the laboratory and found no trace of the three men. Major Golightly's computer terminal was still operational. His personal log contained clues regarding the fate of the three men.

Above: After the power surge, Ground Control repeatedly tried to make contact with Major Golightly. His circuit was dead. There was something wrong.

Below: The investigation team was perplexed. No trace of the major or his mysterious device remained.

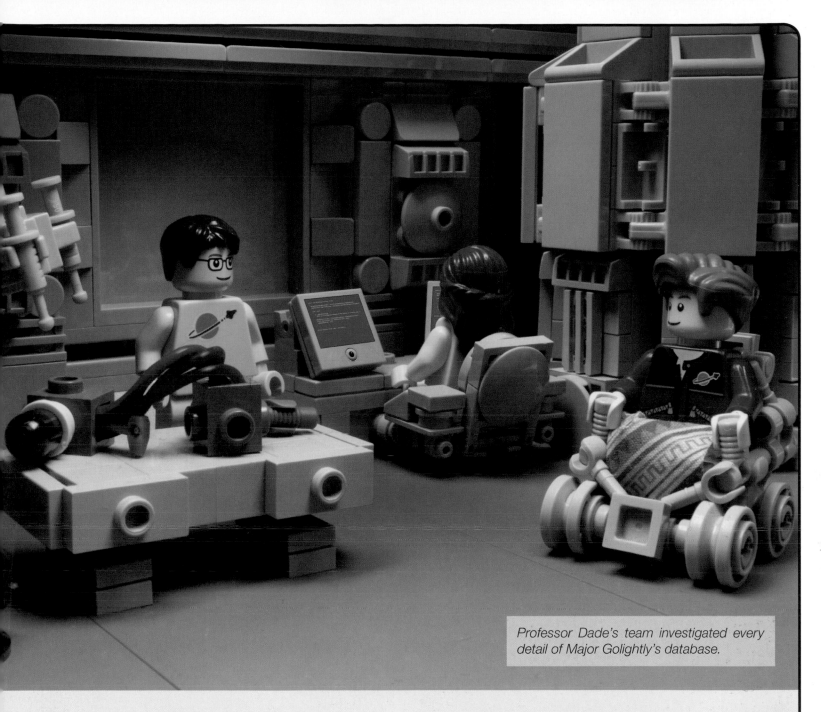

Professor Dade's team investigated every detail of Major Golightly's database.

Unfortunately, they were never seen again.

The last words from Major Golightly were transcribed by his helmet microphone. Shortly before the transmission ceased, he spoke of a most peculiar floating sensation. His computer was examined by Professor Dade and her team, who found a remarkable series of journal entries and instructions from one of her more introverted colleagues.

Major Golightly's extensive logs contained comprehensive theories and equations for a method of folding the very fabric of the universe. It would link fixed points for only a limited time, but the information would eventually provide the Federation with a means to circumvent the laws of physics and travel unimaginable distances in the blink of an eye.

One of the key discoveries in the database was a set of prototype instructions for building a large jump point. The energy requirements would be considerable, but the science was faultless.

Professor Dade had no trouble persuading the Federation Council to approve a new construction project.

THE GATE

The Gate was to be constructed in orbit around the Moon. The location would reduce journey time, and the orbit would be at a sufficient distance to avoid damaging the lunar colony if the machine's reactor malfunctioned.

After several years and considerable financial investment, the Gate was ready. The first brave pilot, Captain Elgram, piloted an experimental shuttle through the Gate, emerging light-years away. Elgram returned after a brief survey of the Altair System. The successful test flight confirmed Major Golightly's equations were faultless. His legacy would live on.

The Gate was successful in holding a portal open for a limited period, creating a stable wormhole large enough for a ship to fly through. The Federation stood on the threshold of a new age of expansion.

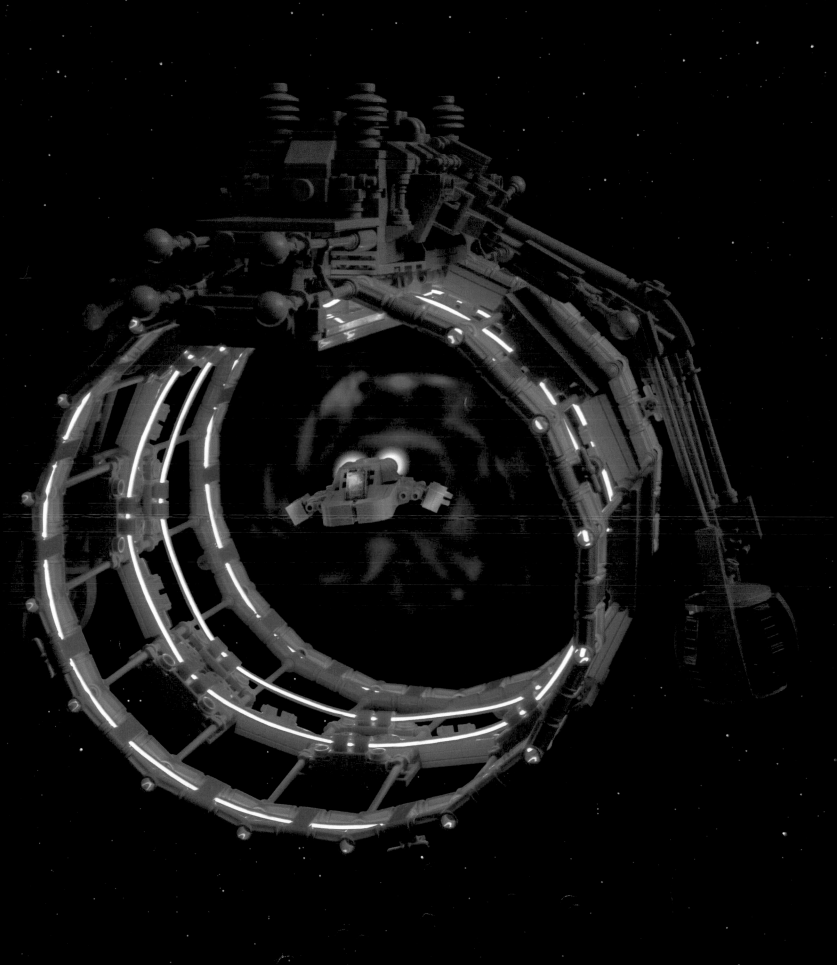

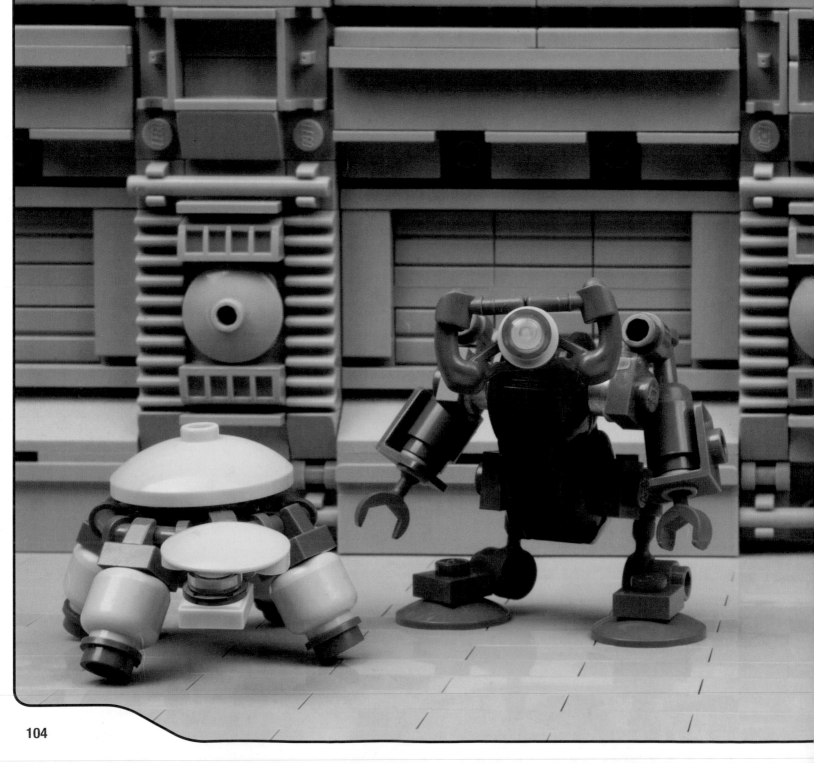

M364 TURTLE AND HC SERIES

Technological advances from the Tranquility Base laboratories led to the creation of a new generation of robots. Mass-produced by Anodyne Systems, mechanoids played a vital role in the Federation. Countless designs, upgrades, and variant machines worked tirelessly for the benefit of mankind.

M364 TURTLE

1x 1x 1x 11x 1x 2x 1x 1x
1x 1x 1x 1x 4x 4x 2x 2x

1

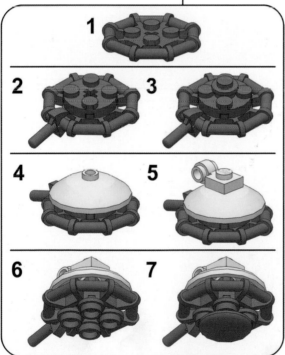

1

2 3

4 5

6 7

2

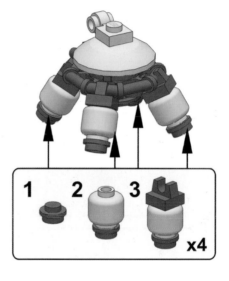

1 2 3

x4

3

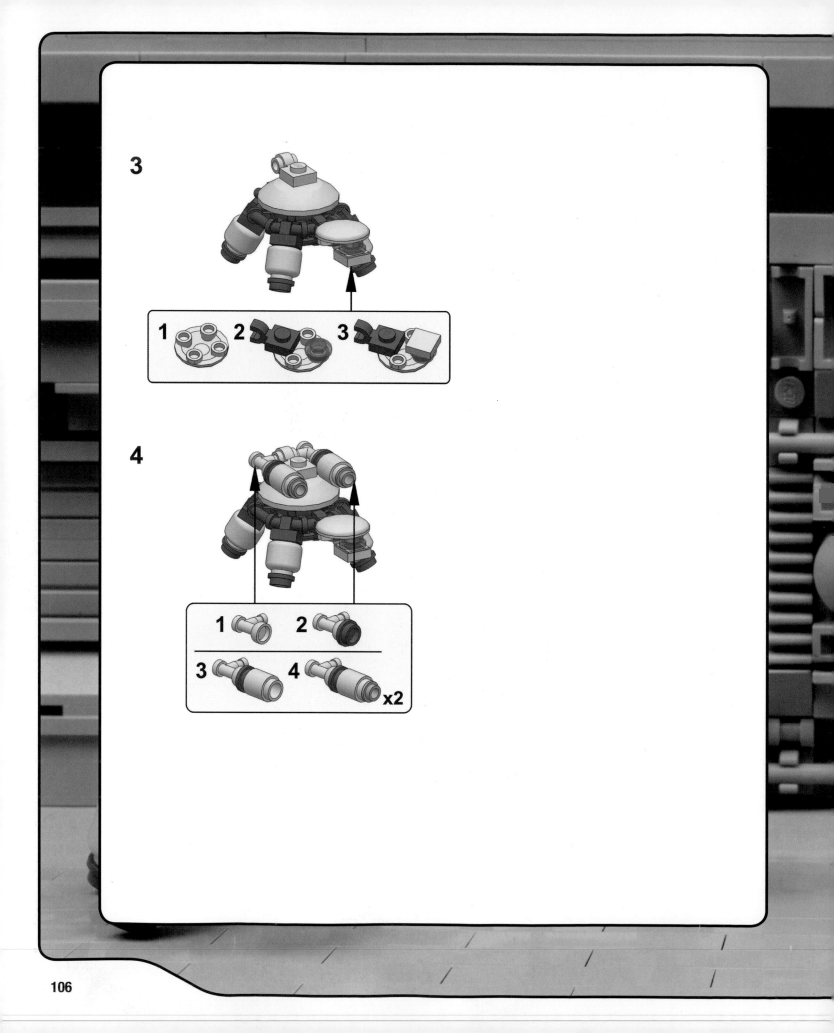

1 2 3

4

1 2
3 4 x2

HC SERIES

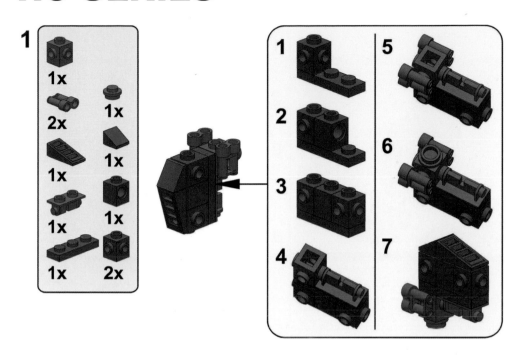

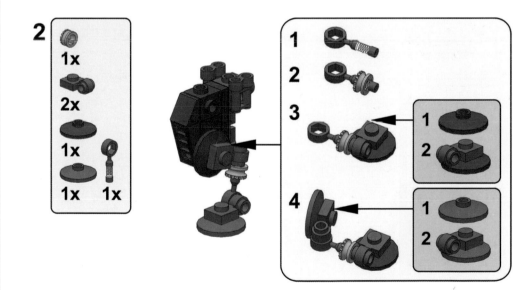

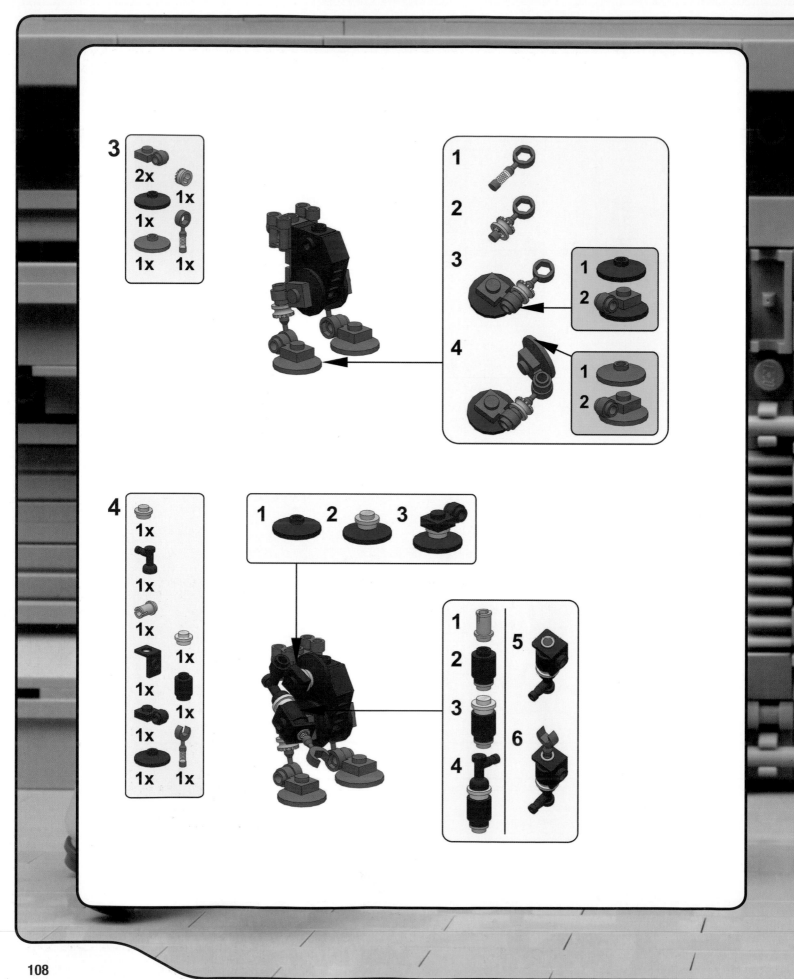

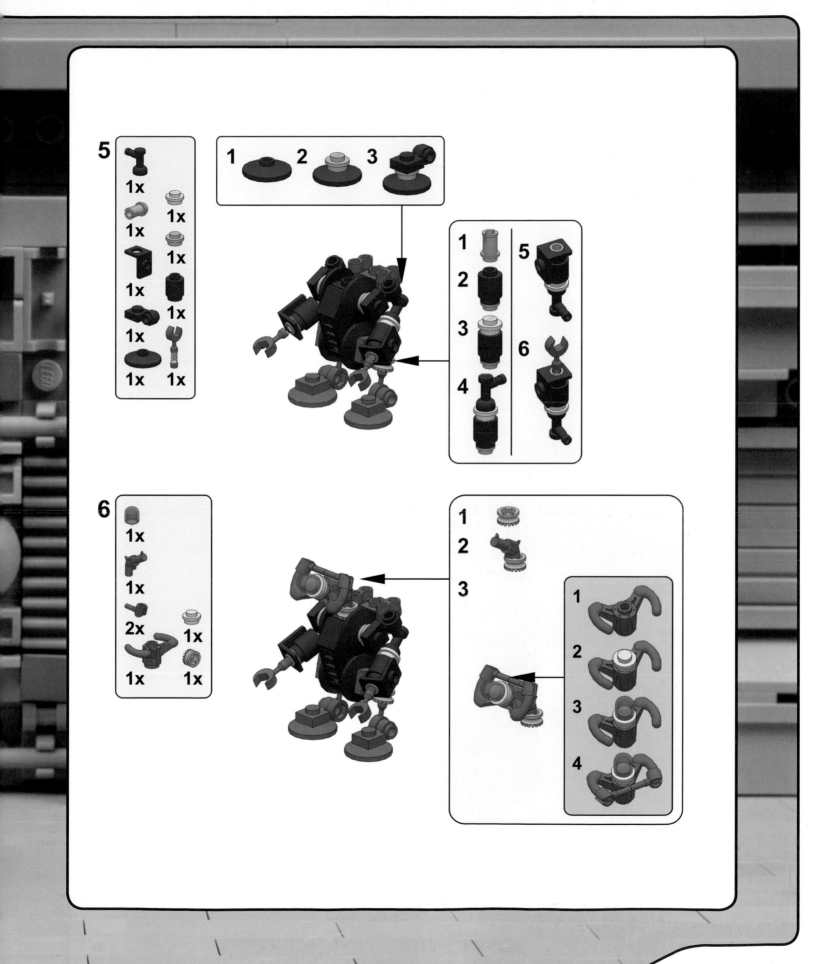

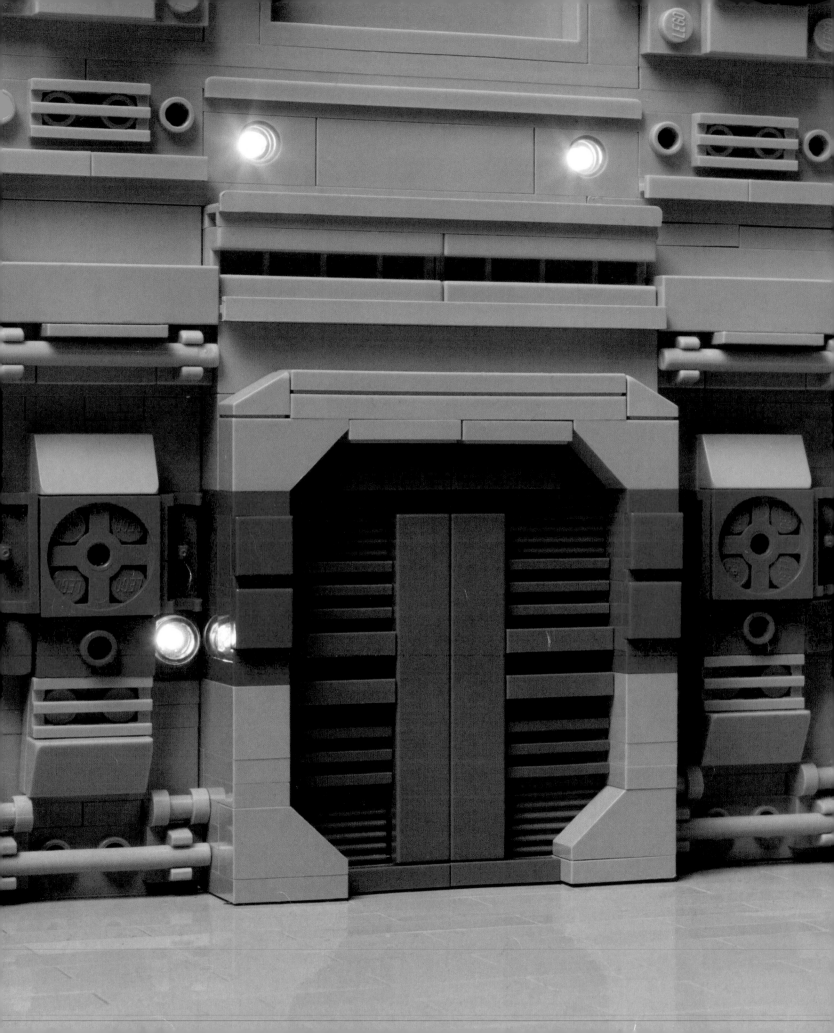

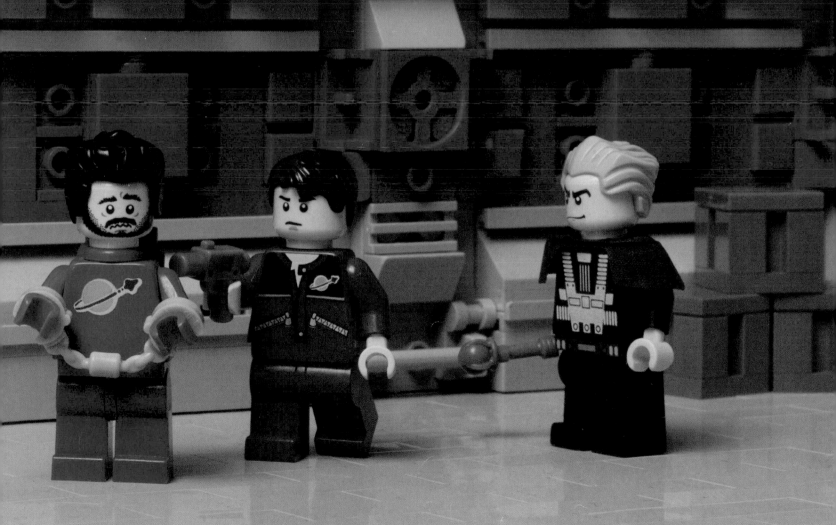

REALM OF SHADOWS

"The outer system is full of wonders."
—*Admiral Kazak*

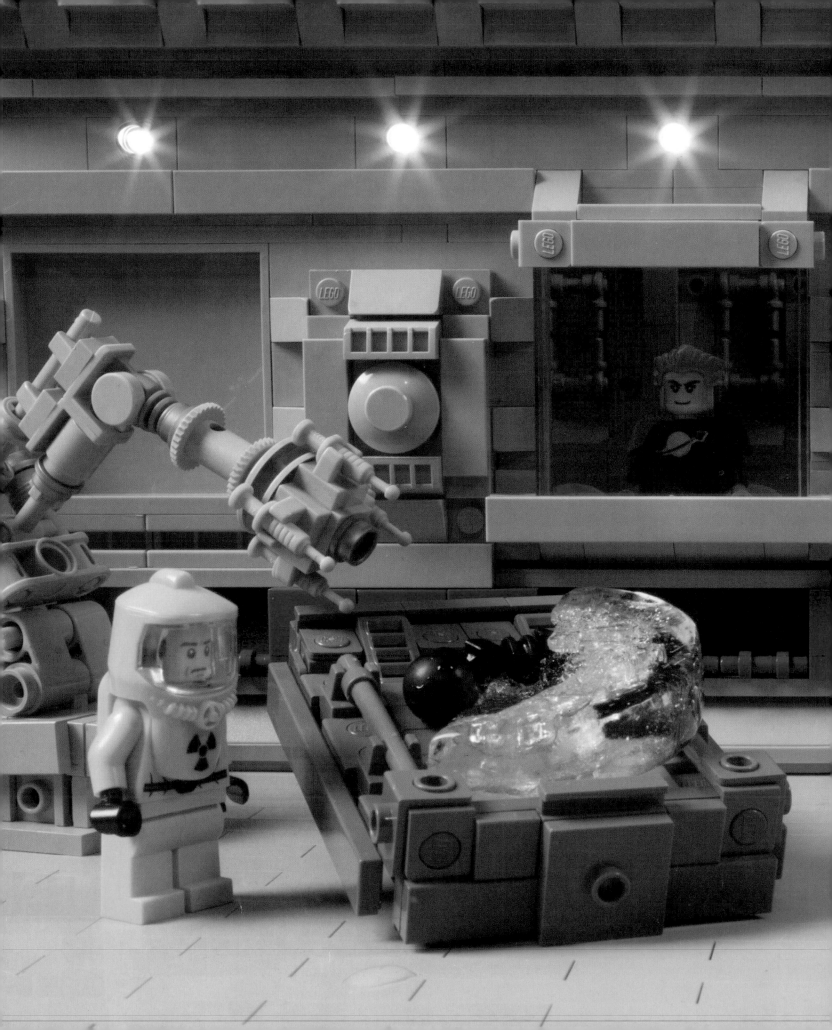

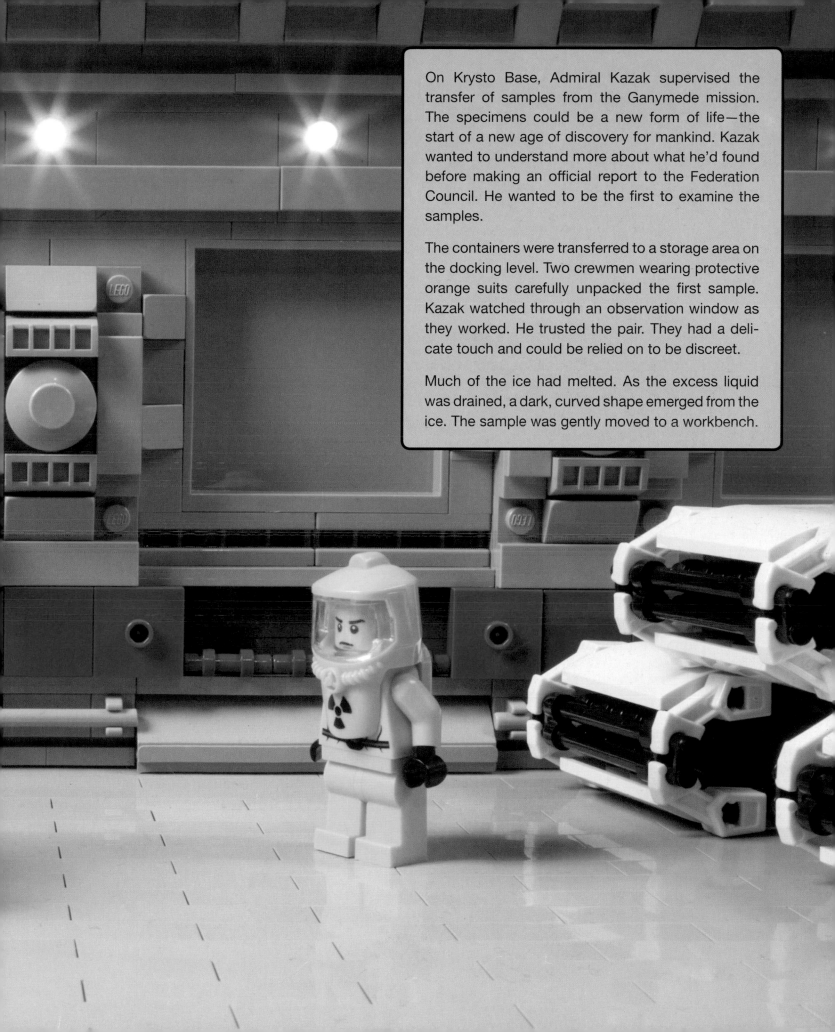

On Krysto Base, Admiral Kazak supervised the transfer of samples from the Ganymede mission. The specimens could be a new form of life—the start of a new age of discovery for mankind. Kazak wanted to understand more about what he'd found before making an official report to the Federation Council. He wanted to be the first to examine the samples.

The containers were transferred to a storage area on the docking level. Two crewmen wearing protective orange suits carefully unpacked the first sample. Kazak watched through an observation window as they worked. He trusted the pair. They had a delicate touch and could be relied on to be discreet.

Much of the ice had melted. As the excess liquid was drained, a dark, curved shape emerged from the ice. The sample was gently moved to a workbench.

A strange notion formed in Kazak's mind. Over the intercom, he instructed the crewmen to leave. He waited for the door behind them to close.

Without pausing to put on a protective suit, he entered the chamber. As he approached the table, he saw the strange form in the ice. It was rounded at one end, tapering to a point at the other.

The sample curled tightly around itself. The dark surface gleamed. It was impossible to tell if it was mechanical or organic. It looked like nothing he had seen before. Kazak laid his bare hand on the dark shape.

At the moment of contact, he was bathed in a green glow. He gasped as strange visions filled his mind's eye. A new understanding flooded through him as he was bombarded with images and information. Snapshots of unknown constellations whirled. Giant comets hurtled through the void, an endless journey across the cosmos.

A psychic barb hooked into Kazak's mind. He did not resist, teetering on the brink of insanity as he gazed upon an unknown galaxy from the perspective of a different life-form. He was on a comet, moving at incredible speed. A celestial body grew from a distant speck into the familiar topography of Ganymede.

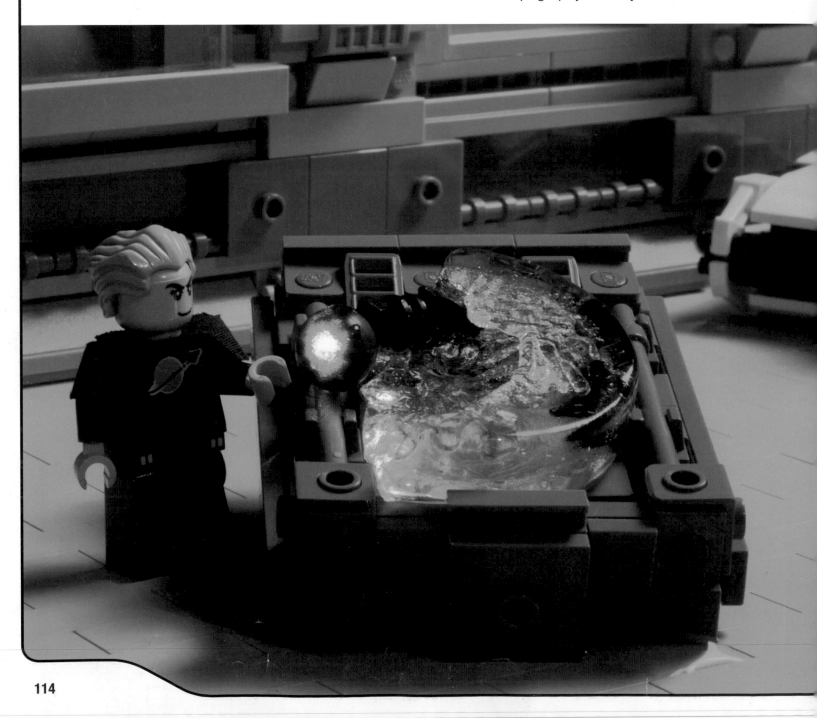

As Kazak's senses returned, the worm moved again, sliding free of the remaining ice. The worm floated into the air and hovered above the workbench. Droplets of water fell. It flew gracefully around the chamber, completing a gentle circuit of the room before returning to Kazak.

He looked into the green eye of the creature. The story had been told. The telepathic link was complete.

Kazak sent a message to Station Control, assuring them everything was fine. He told them he needed more time to examine the samples and asked for a security detail to be permanently stationed outside the chamber. He opened the rest of the cases.

Kazak spent long periods locked away with the strange creatures.

Opposite: First contact with alien life turned out to be a bizarre psychic meeting of minds.

Below: The worms developed quickly, growing and changing each day.

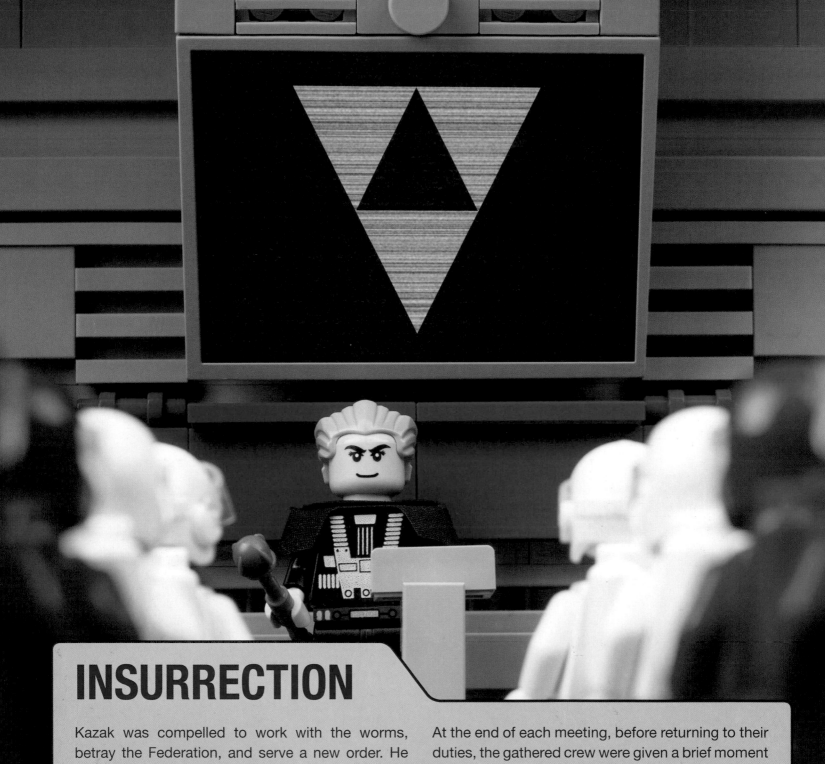

INSURRECTION

Kazak was compelled to work with the worms, betray the Federation, and serve a new order. He would have to be careful. Krysto Base was far from the main colonies, but the worms told him it was not distant enough. A twisted plan began to take shape.

Krysto Base personnel were instructed to attend special meetings. They gathered in small groups, and the admiral informed them of a new mission: They were to leave Krysto Base, relocating to the abandoned Federation outpost on Hyperion. Once there, they would prepare for the next phase.

At the end of each meeting, before returning to their duties, the gathered crew were given a brief moment of contact with one of the worms.

The creatures spread their influence around the station, alerting Kazak to those who might resist. Those deemed most likely to reject the new order were rounded up and unceremoniously ejected into space.

An independent research ship, the *Lucky Penny*, docked at Krysto Base. Refueling after a long mission studying the rings of Saturn, the small crew was glad to have a change of scenery. The moment they boarded Krysto Base, they were taken to an isolation chamber. The chief medical officer, Dr. Spaltro, explained there had been a viral outbreak onboard the station, and they would need to be inoculated and quarantined. One by one, he injected the crew, and one by one, they slipped away.

Kazak renamed the ship *Tyrant*. The massive cargo holds inside the vessel were sealed and pressure tested. Vast banks of analytical equipment were stripped away and discarded. The outer hull was repainted with a special bonded coating, making the ship almost impossible to detect with standard sensors.

Opposite: Kazak outlines his mysterious plans to the crew of Krysto Base.

Below: Kazak's newly outfitted flagship, Tyrant

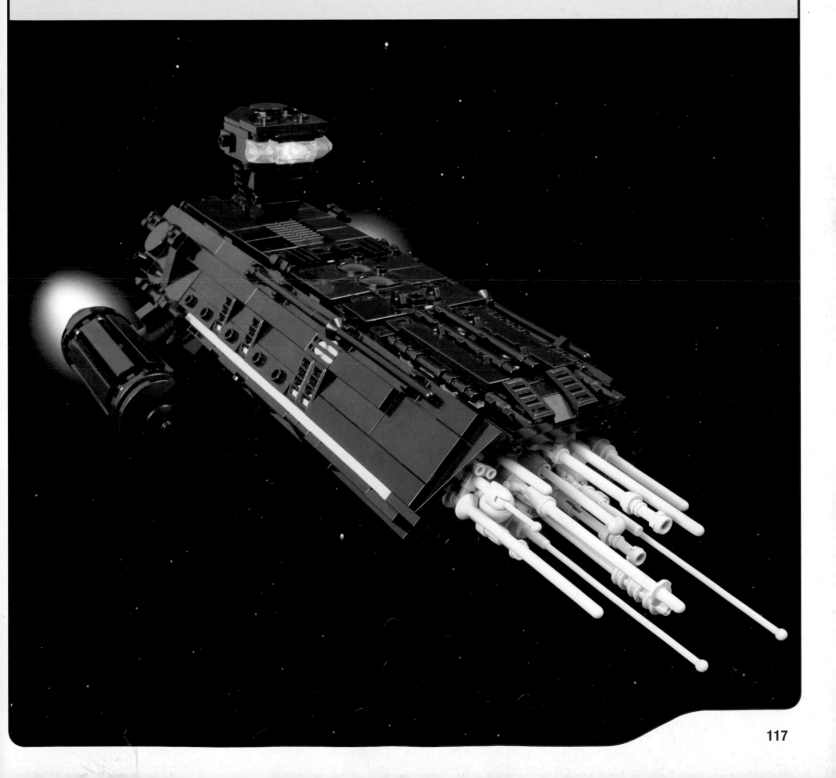

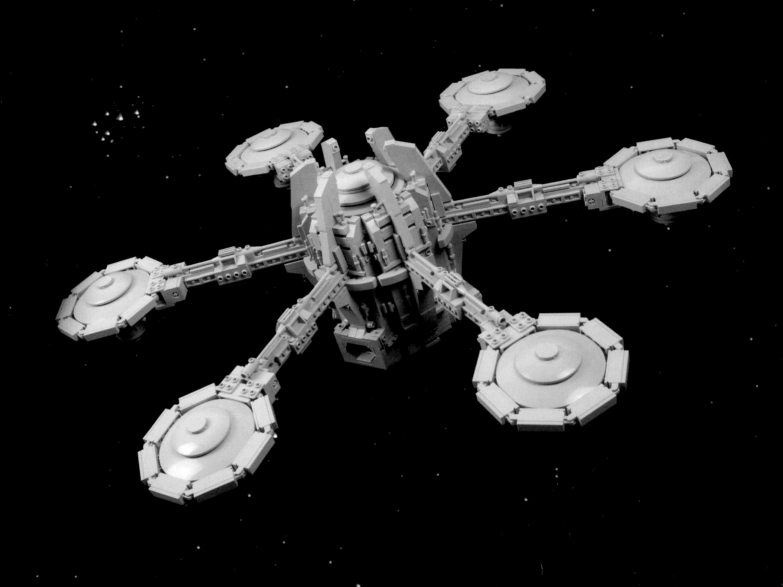

The Federation never expected that one of its own admirals might act against it. Kazak carefully controlled Krysto's communications with the Core Systems and made sure any who might disrupt his plans were taken care of discreetly. He remained unchallenged as he redirected ships and supplies. He had full security clearance and enough high-level command codes to achieve his aims. The once loyal Federation admiral was a transformed man. He was a willing agent of the worms and, so too, were hundreds of his personnel.

Once preparations were complete, Kazak gave the order. Hundreds of Krysto Base personnel boarded the *Tyrant*. Their last days were spent emptying the base of any supplies or equipment that might prove useful on their new mission.

Krysto Base engineers spent the final hours before departure sabotaging the base control network, setting a trap for those who might come looking for clues to where Kazak's army had fled. Kazak made a last check of the lower levels before boarding the ship. He took his place on the bridge of the *Tyrant* and gave the order for the ship to leave.

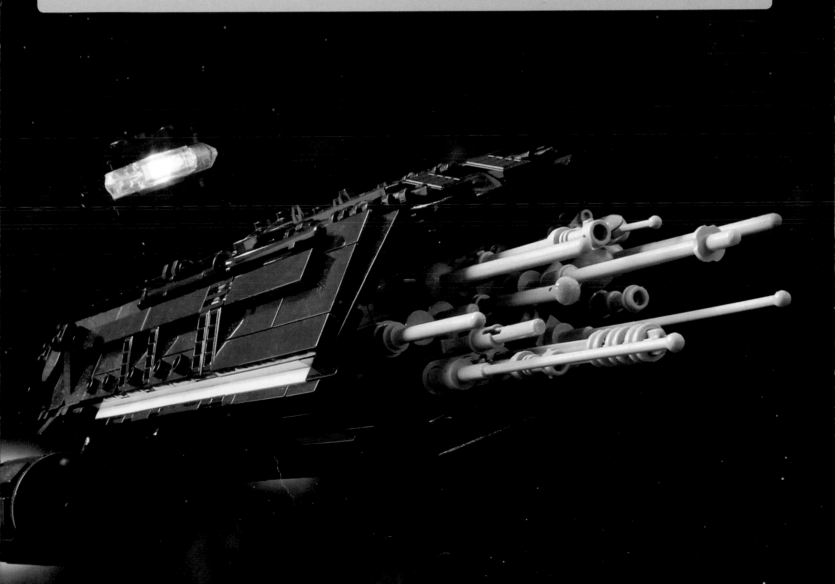

The *Tyrant* charted a course to Hyperion. On Krysto Base, an automated beacon transmitted a continuous safe signal to the Core Systems.

After several months, the *Tyrant* reached Hyperion. Personnel were transferred to Omega Base, where they began a new life away from Federation eyes. The abandoned outpost perfectly suited Kazak's needs.

As a precaution, he set up a series of satellites that orbited Hyperion and scanned for Federation probes. Most of Omega Base was underground, a vast network of tunnels and hangars. Kazak's people settled into their new home.

The area around Hyperion would eventually become known as the Realm of Shadows.

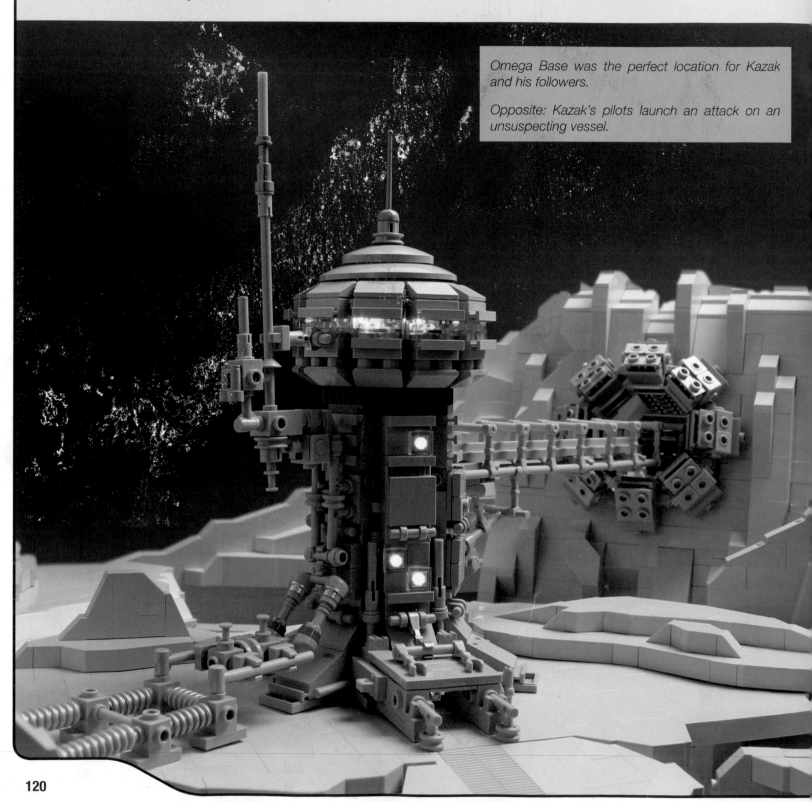

Omega Base was the perfect location for Kazak and his followers.

Opposite: Kazak's pilots launch an attack on an unsuspecting vessel.

SPACE PIRATES

A squadron of Kazak's elite pilots remained near Krysto Base. They were ordered to patrol the shipping lanes approaching the region.

Kazak instructed them to target specific vessels. The crews were captured and given no choice but to surrender and join Kazak's regime. Those who resisted were ejected into space.

Several ships were captured and taken to the new stronghold on Hyperion. Krysto Base continued to broadcast the all-clear code. The Federation was still unaware anything was wrong.

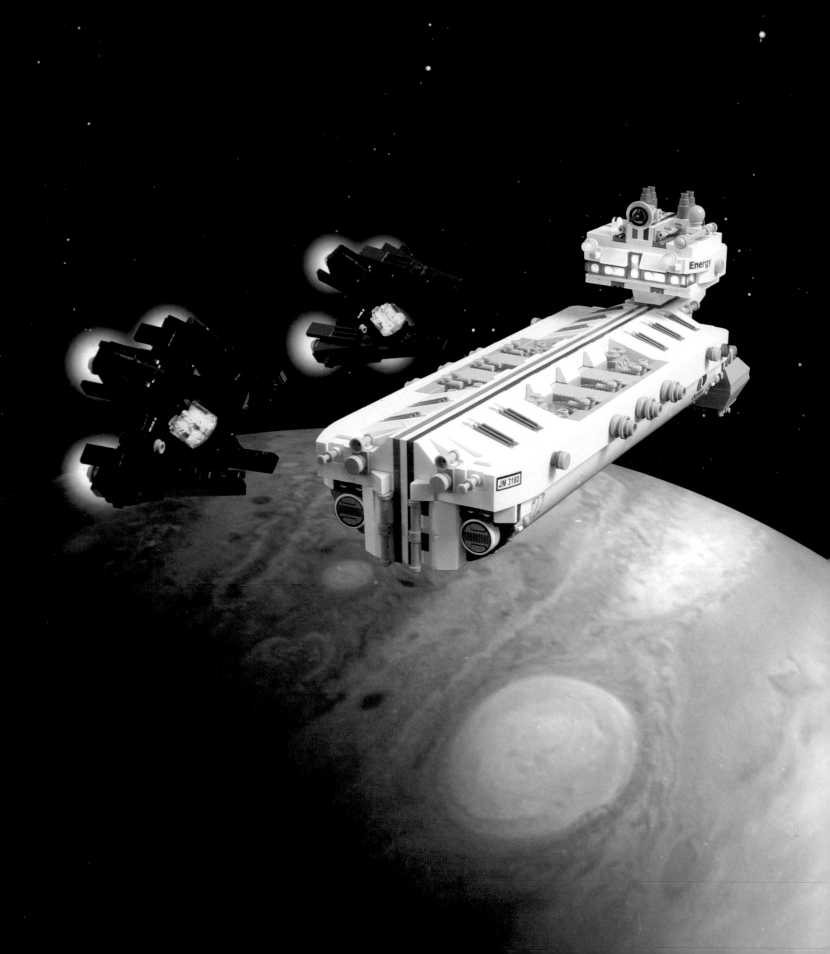

Hijacking a tanker with a payload of Helium-3 was the final piece of Kazak's plan. The precious gas was slow to mine and process, but it was a crucial source of power for fusion engines. The valuable cargo on the *Octania* would ensure Kazak's ships stayed fueled for lengthy missions and would keep systems operational on Omega Base for decades.

Kazak was familiar with the ship's delivery route. At regular intervals, *Octania* refilled the massive fuel reservoir inside Krysto Base. Kazak's pilots were told exactly when to expect the vessel. They waited behind asteroids as the tanker approached.

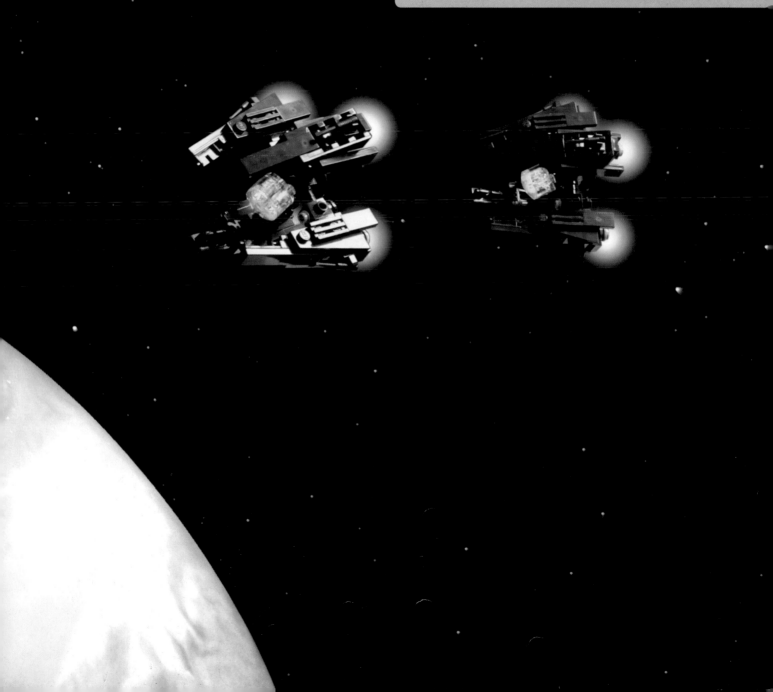

In an audacious attack, the *Octania* was hijacked and stolen. Once the ship reached Omega Base, Kazak and his people had everything they needed for prolonged survival in their new home.

When the *Octania* failed to return to the Moon, the alarm was raised. Other ships had disappeared in recent months. Something was wrong in the outer system. Attempts to contact Krysto Base were unsuccessful. Unthinkable as it seemed, someone was acting against the Federation's interests. The Federation Council authorized the deployment of security patrols along the shipping lanes and began to prepare a heavily armed investigative team for a mission to Krysto Base.

The cargo ships captured by Kazak's men had been carefully selected based on their inventories. Mining gear and excavation rigs were retooled by Kazak's engineering teams. Federation Walkers and other hardware formed the core of his dark attack force. The machines were fitted with a range of fearsome weapons.

Soon Kazak had an army of war machines at his disposal.

Below: The processing plant on Omega Base was put to work converting equipment.

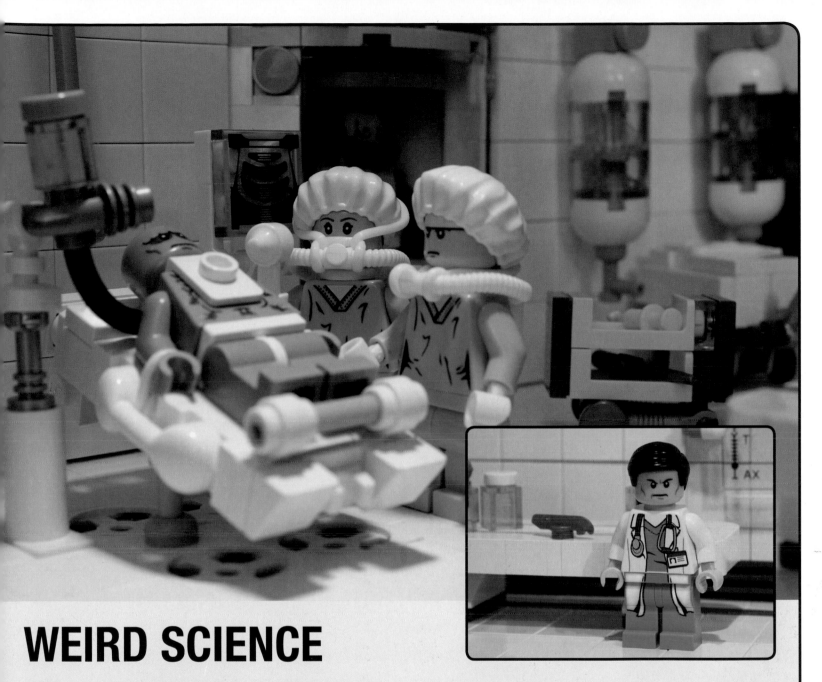

WEIRD SCIENCE

On Hyperion, Kazak and his men lived in a place of darkness and strange technology. The worms had influenced them all, and an alien mind-set pervaded their thoughts.

In the depths of Omega Base, Dr. Spaltro practiced unusual, experimental medicine. On Krysto Base he had been a proud, upstanding member of the Federation's medical division. When Kazak introduced him to the worms, everything changed.

In the medical bay, the doctor was able to realize his increasingly bizarre dreams. His ambition reached new heights, and he went about his work with newfound passion. His scientific breakthroughs were as terrible as they were incredible.

When three of Kazak's soldiers were killed transferring cargo between ships, it was not the end of their service. Dr. Spaltro was able to bring the dead men back to life, but at a terrible price. They were grotesque mannequins, amalgamations of rotting flesh and robotic augmentation. The doctor's first experiments haunted the lowest corridors of Omega Base. The unfortunate souls were given a new, wretched form of existence.

Above: Dr. Spaltro practiced unusual forms of medicine.

Top: The procedures carried out by Dr. Spaltro's medical team were unorthodox in the extreme.

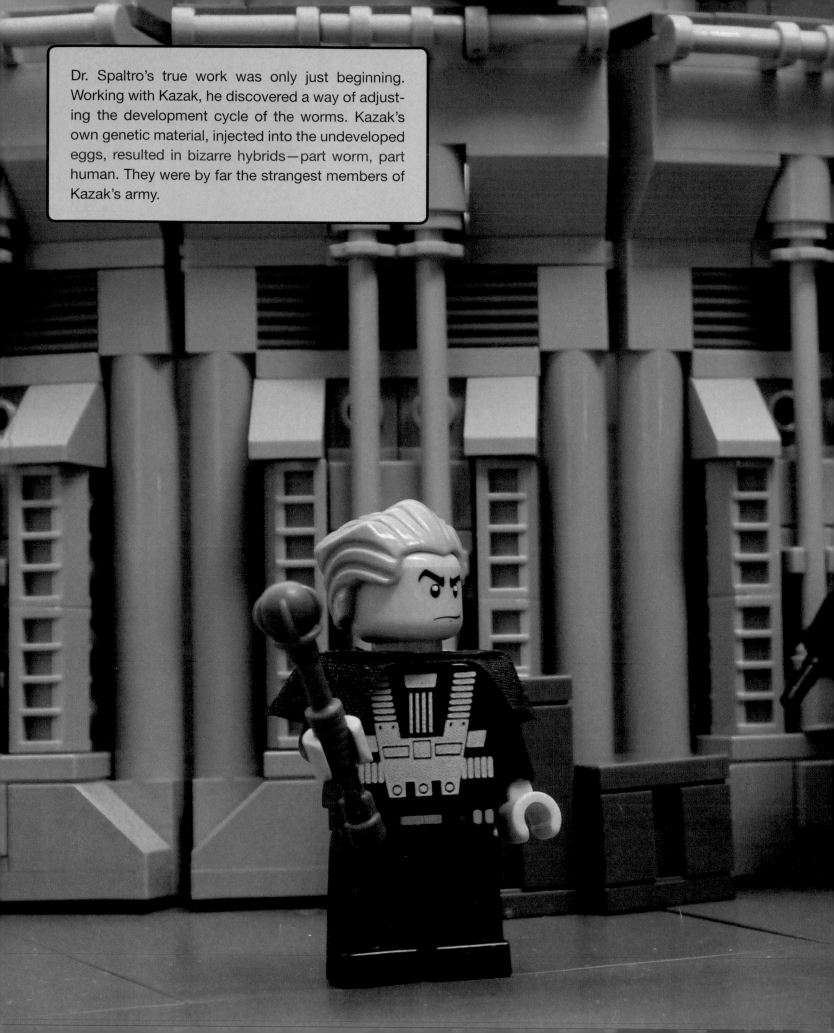

Dr. Spaltro's true work was only just beginning. Working with Kazak, he discovered a way of adjusting the development cycle of the worms. Kazak's own genetic material, injected into the undeveloped eggs, resulted in bizarre hybrids—part worm, part human. They were by far the strangest members of Kazak's army.

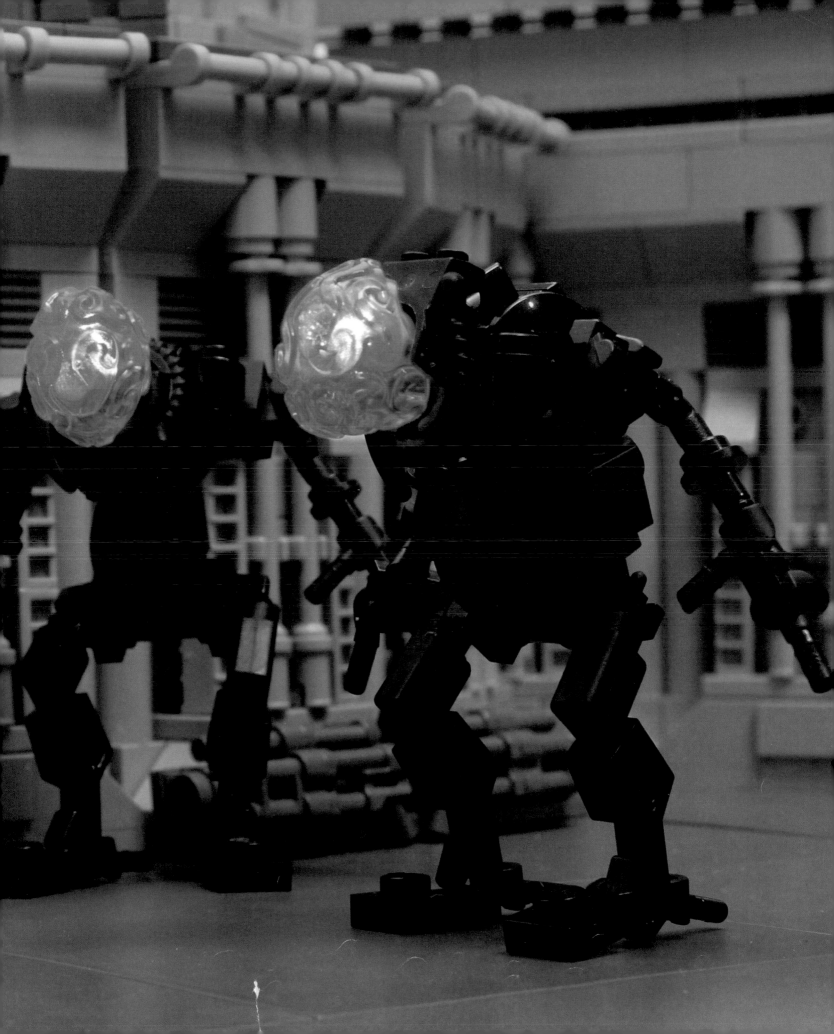

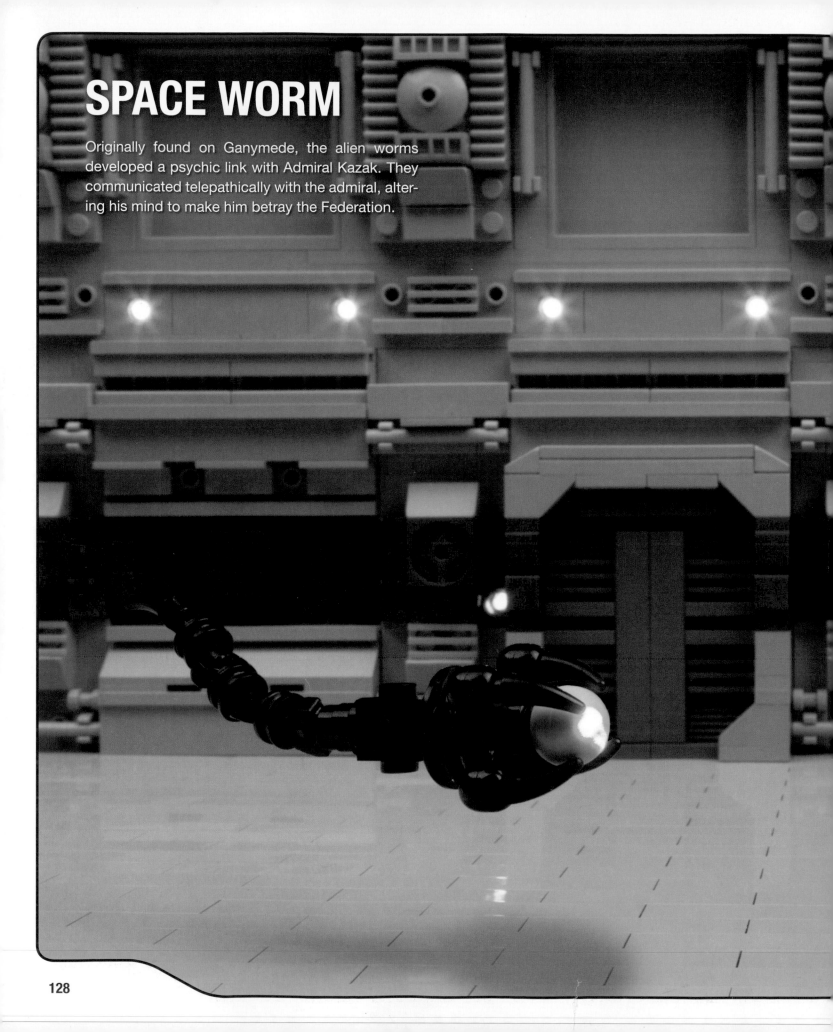

SPACE WORM

Originally found on Ganymede, the alien worms developed a psychic link with Admiral Kazak. They communicated telepathically with the admiral, altering his mind to make him betray the Federation.

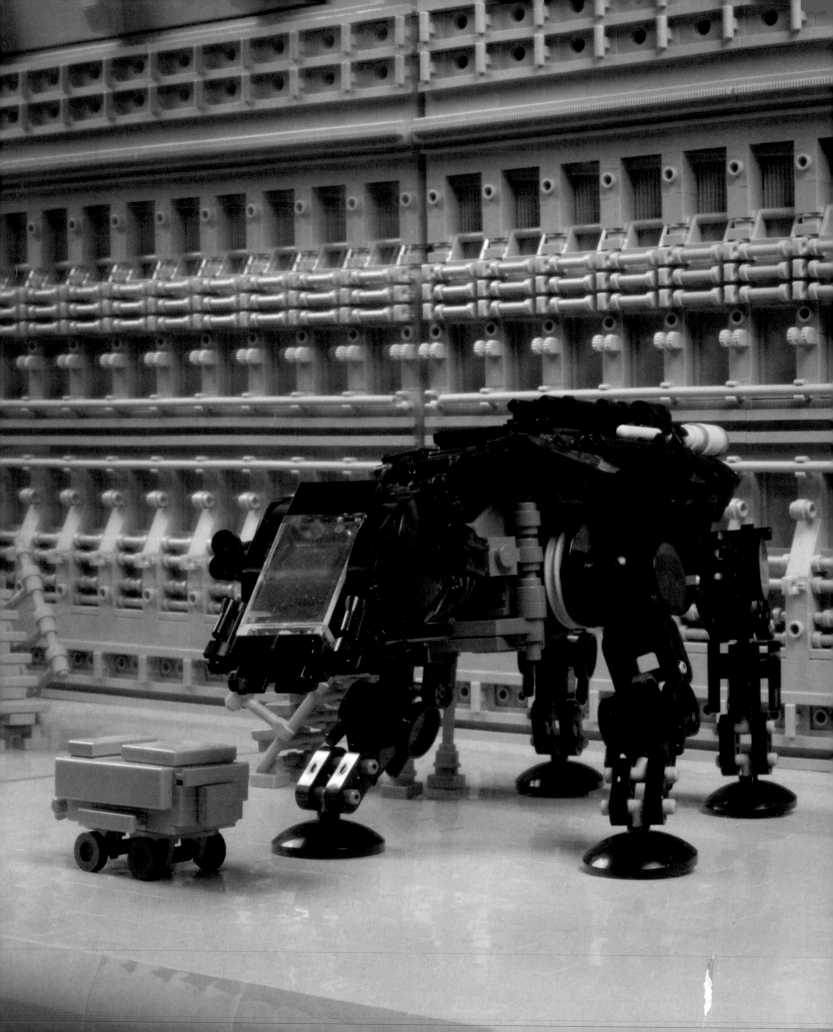

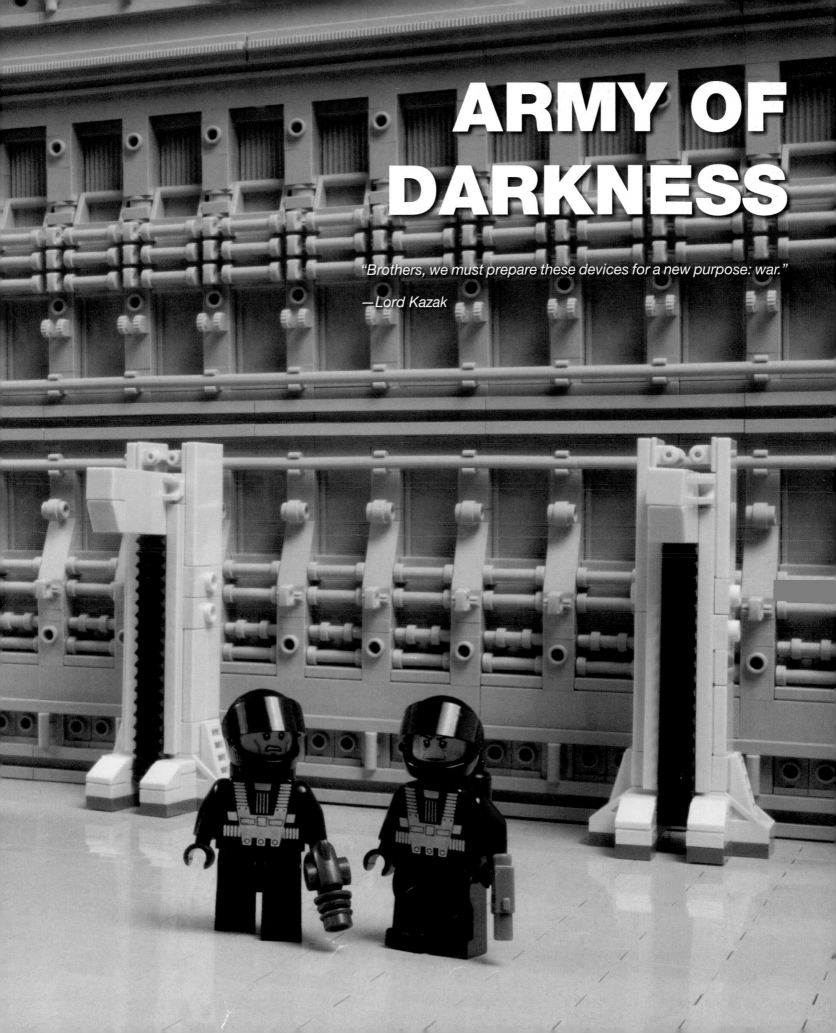

ARMY OF DARKNESS

"Brothers, we must prepare these devices for a new purpose: war."
—Lord Kazak

BT-15 JETBIKE

Powerful but highly maneuverable commercial vehicles, the BT-15 Jetbikes are fitted with a forward-facing pulse laser, stealth coating, and a remarkably quiet propulsion system. Teams of riders would often practice their skills in the spacious hangars beneath Omega Base.

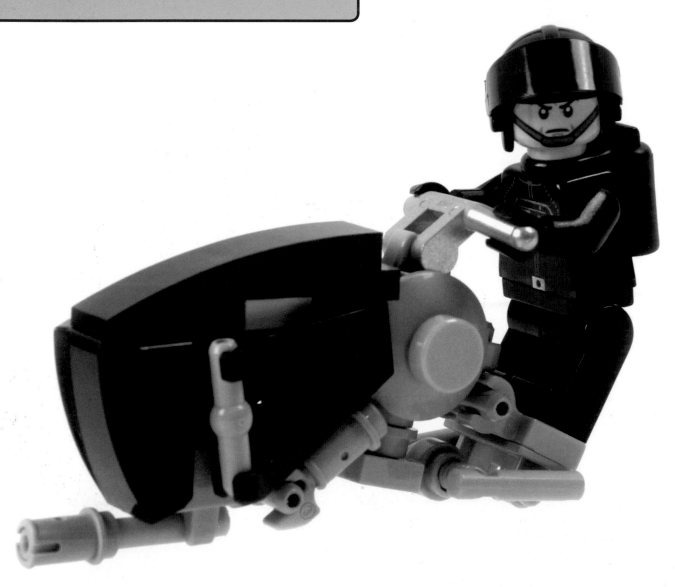

BT-33 ONYX GUNSHIP

The *Onyx* is a small, one-man assault craft with advanced stealth technology to make it invisible to long-range scanners. Originally used as a short-range runabout to transport equipment from base to base, the ship was heavily refitted for tactical strike missions.

Federation technology was ruthlessly stripped from the vessel, leaving space for a single pilot, improved weaponry, and an experimental propulsion drive. Powerful beam weapons replaced banks of scientific equipment, making the *Onyx* one of the most formidable ships in Kazak's strike force.

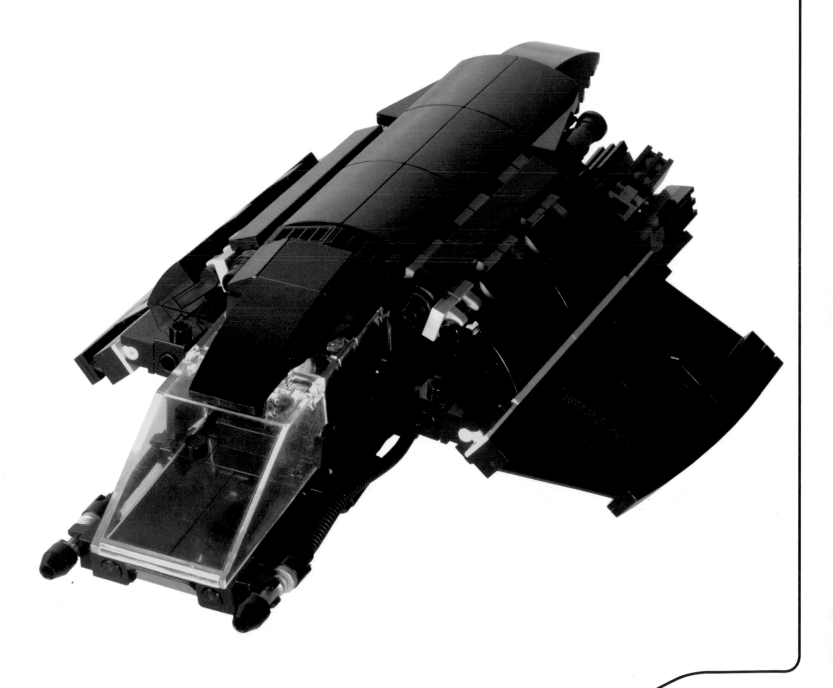

BT-23 OBSIDIAN SCOUT

A modified low-altitude racing vehicle, the *Obsidian Scout* is designed to provide fast support to ground troops, relaying telemetry to the orbital command ship. The armored hull plating provides excellent protection for the pilot.

Below: The Scout *retains the original racing engine within a modified armor-plated housing designed to protect the vehicle from sustained laser and small arms fire.*

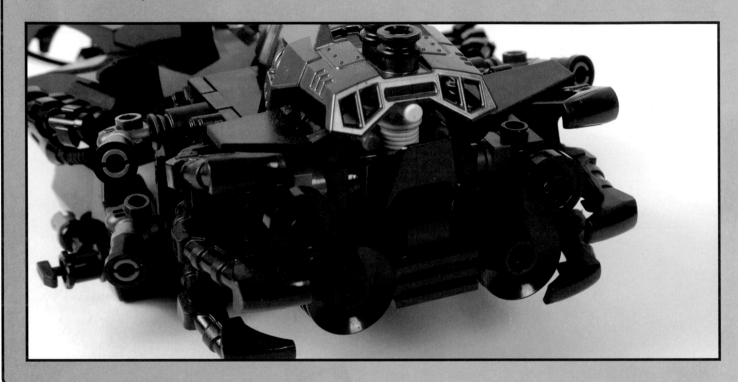

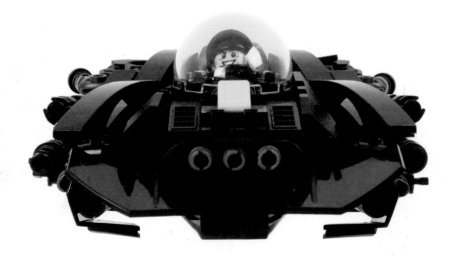

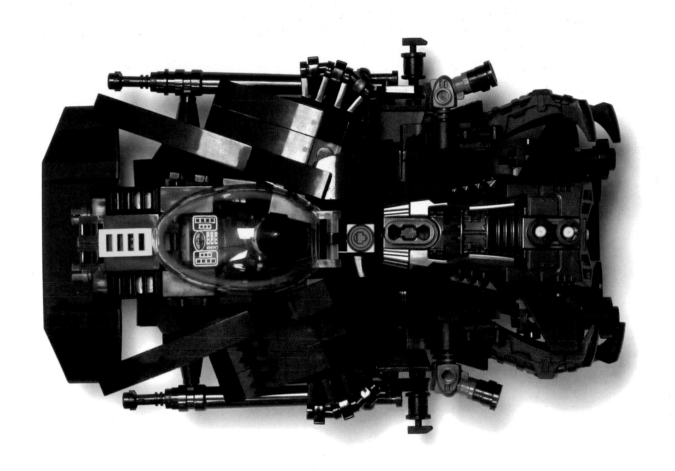

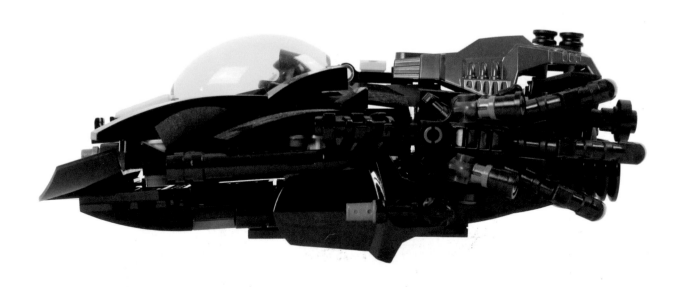

BT-19 HOPPER

A variant of the Federation Sentinel, Hoppers are designed for patrol and reconnaissance duties. A powerful transceiver system makes them ideal for long-range missions, such as perimeter patrol and covert surveillance.

These bipedal machines are able to cope easily with varied terrain and gravity conditions, and they are armed with a pair of deadly forward-facing beam weapons.

Right: Dual titanium spring shock absorbers on each leg provide support for fast movement over rough terrain.

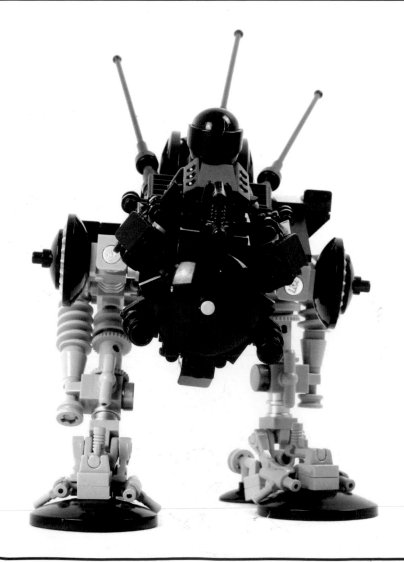

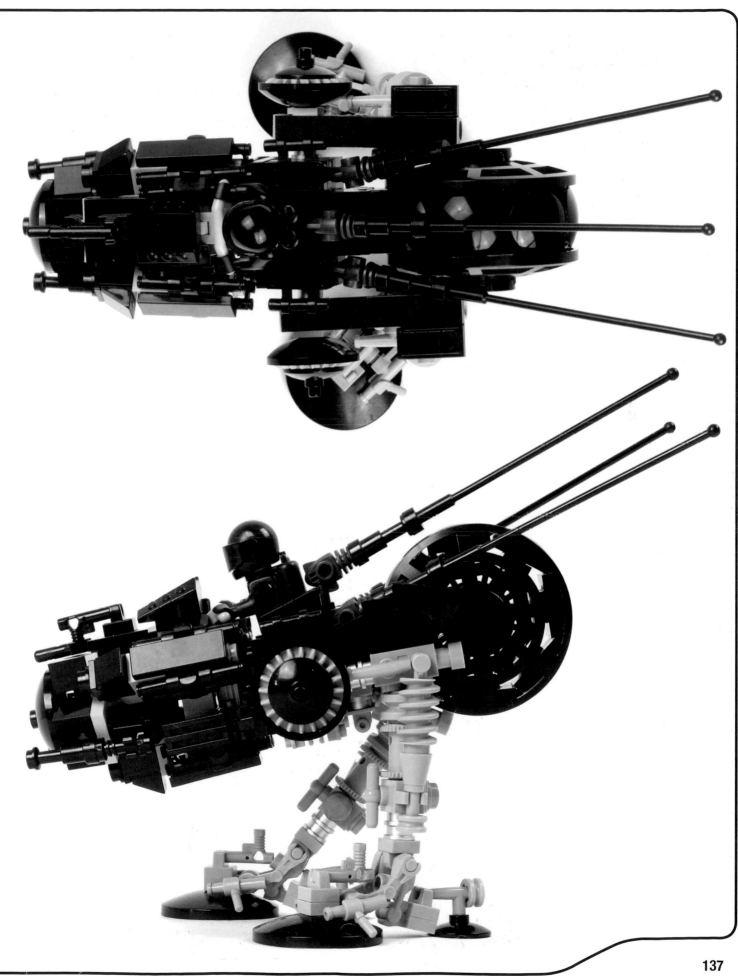

BT-21 INTERCEPTOR 'ERYNIS'

A squadron of *Interceptors* was originally assigned to Krysto Base for defense and debris clearance. Designed by Optimal Control Laboratories, *Interceptors* patrolled the space lanes and protected incoming transport ships from rogue asteroids and other space debris. The handful of *Erynis* pilots remained loyal to their commanding officer when new orders were issued.

Right: An experimental array of thrusters replaced Standard Federation thrusters for more responsive handling.

BT-27 OCTRAX

The *Octrax* is a tough, compact landing craft. Designed to withstand repeated drops in a variety of gravities and atmospheric conditions, the drop ship has proved itself repeatedly.

Aside from a coating of black, sensor-jamming paint, the *Octrax* is almost unchanged from its original design. Six identical ships are assigned to the command ship, *Tyrant*.

TROOPERS

Kazak's warriors wore black flight suits, designed to provide maximum protection in the harsh outer system.

These special uniforms were based on modified ICE technology. They protected the warriors from low temperatures and cosmic radiation and allowed them to survive prolonged periods in the vacuum of space.

The suits were temperature controlled, pressurized, and computer augmented, providing extended life support in hostile environments.

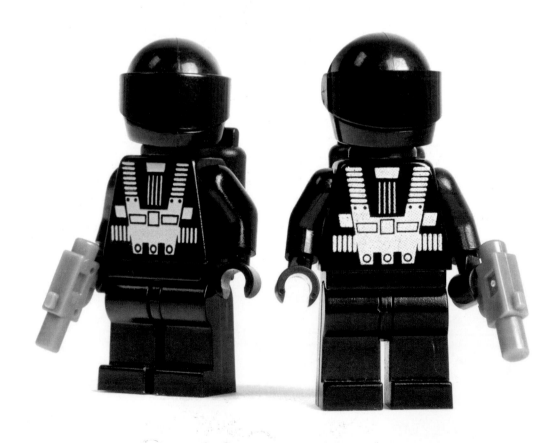

HYBRIDS

With the help of Dr. Spaltro and the medical team, Kazak found a method of altering the development cycle of newly spawned worms.

Some of the creatures had rudimentary limbs, and the medical team encouraged further mutations. After months of careful cultivation, worms with the form of humans took their first steps.

The hybrids contained genetic material from Kazak. Their developing minds were different from other worms. They grew at an accelerated rate, and within months they approached Kazak and asked to join his army. He loved the hybrids greatly and was reluctant to put them in harm's way, but they were intelligent creatures, keen to prove themselves as part of the dark force.

DARK ROBOTS

A selection of mechanoids was stolen from hijacked freighters to become part of Kazak's army, but recent protocol developments made it a challenge to turn the sentient machines into warriors. Kazak needed the robots as part of his attack force, but the machines were unwilling to harm humans.

The LMD chip was extracted and studied. The ethical subroutines embedded in the chip's firmware were difficult to bypass, but Kazak's engineers were dedicated.

The robots were equipped with experimental weaponry and field-tested against drones on the surface of Hyperion.

Left to right: Survey Robot, Tactical Crusader, HC Series Variant, Heavy Crusader

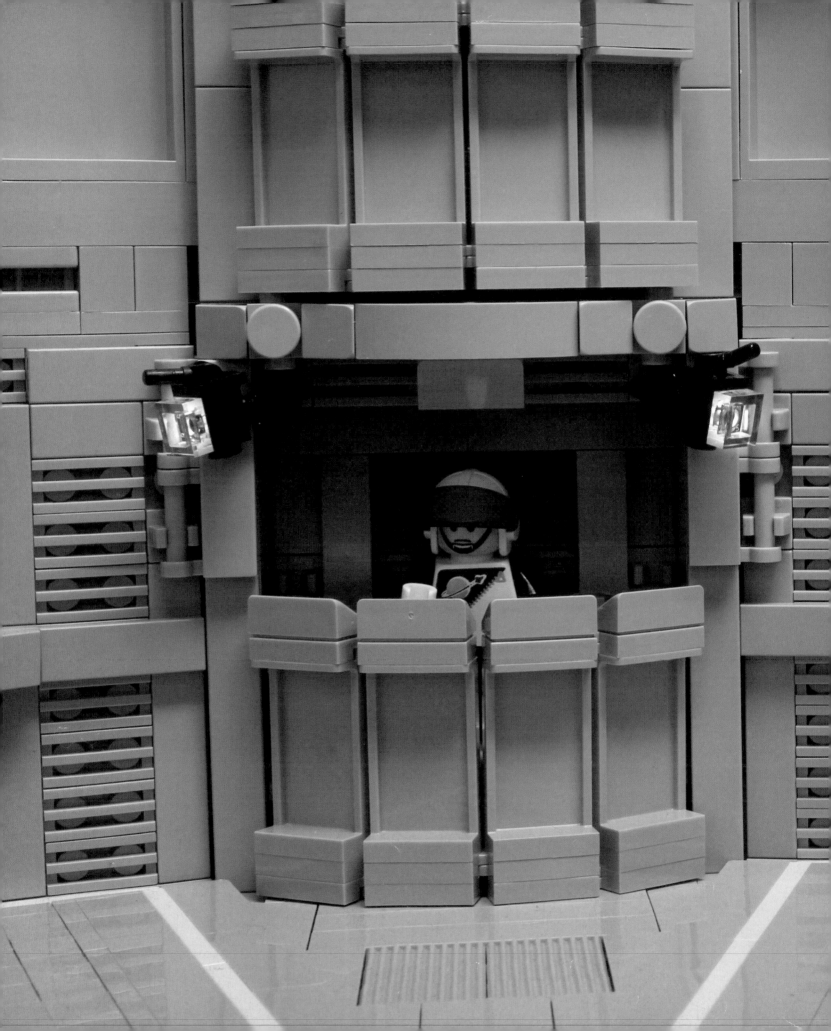

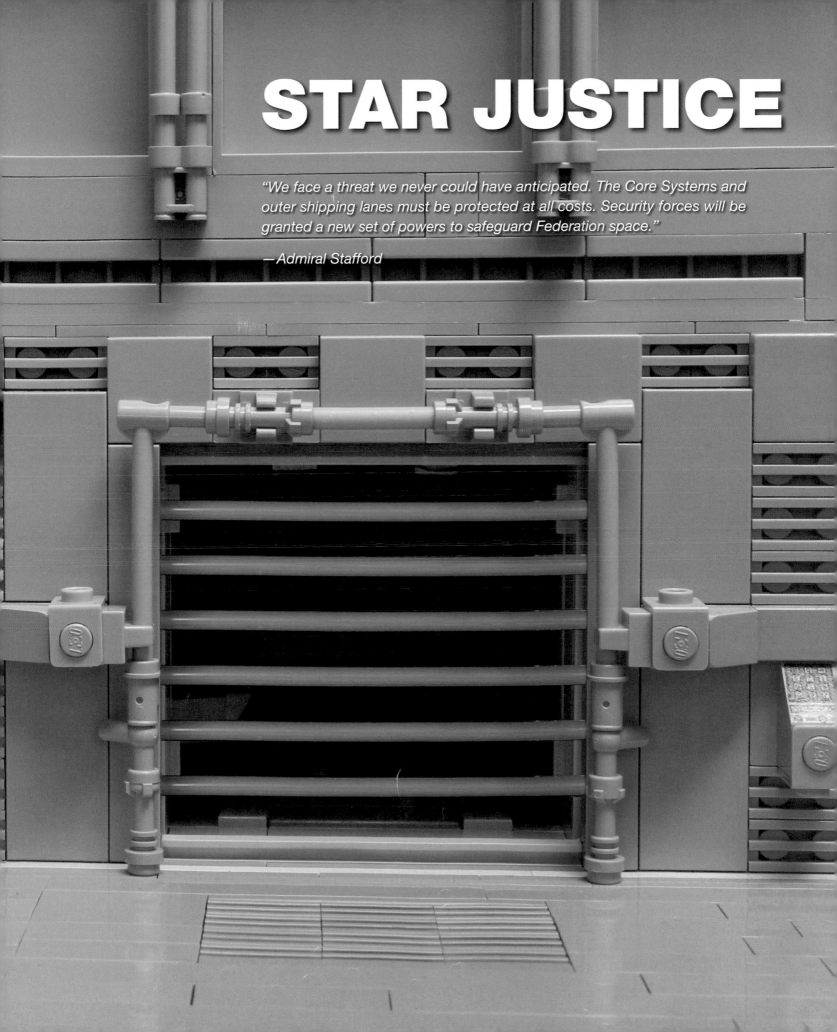

STAR JUSTICE

"We face a threat we never could have anticipated. The Core Systems and outer shipping lanes must be protected at all costs. Security forces will be granted a new set of powers to safeguard Federation space."

—Admiral Stafford

Security became a major concern along the shipping lanes. Local agencies kept the peace on individual outposts, but police ships were not equipped for interplanetary travel and could not be used for long-haul escort duties. Short-range vessels offered no protection for ships traveling through the outer system.

Journeying beyond the asteroid belt became a gamble. Ships had always been armed, but standard pulse weapons were designed to blast apart meteors and provided little defense against Kazak's heavily armed pirates.

The Federation Council convened to find a solution for the continuing problems in the outer system. They set up a far-reaching justice network using modified *Viper* escort ships to provide protection along the shipping lanes. Soon, previously unseen classes of heavily armed police ships patrolled the skies.

With rigorously trained pilots, cutting-edge ships, and a thirst for justice, the newly founded Federation Peacekeeping Department (FPD) fought to return law and order to the outer system.

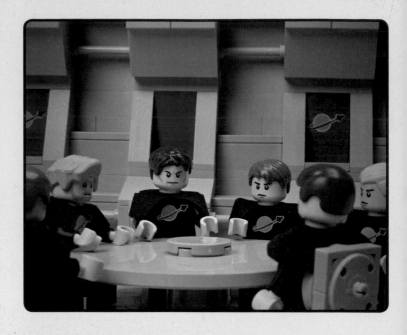

Above: The Federation Council debates the best way to respond to the threat from Kazak's strike force. They spent days speculating about his motivations.

Below: Armed Viper *escort ships ensured that cargo freighters reached their destinations without incident.*

Opposite: The FPD command ship docks with Krysto Base.

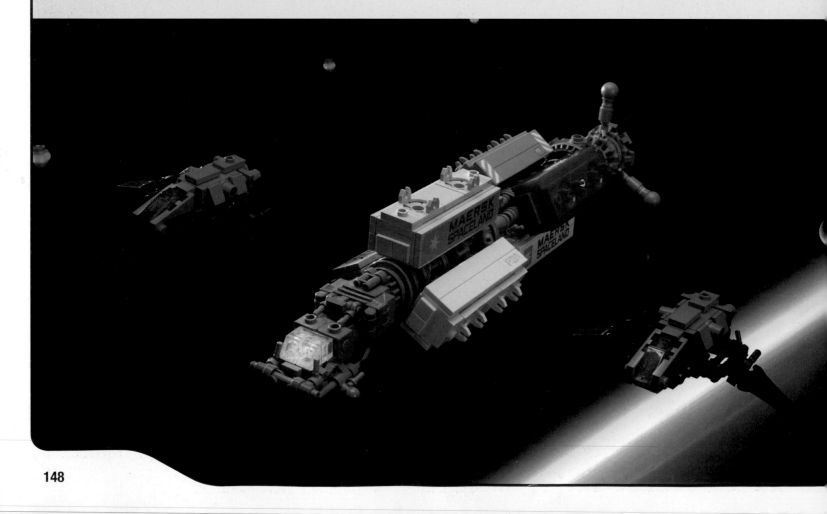

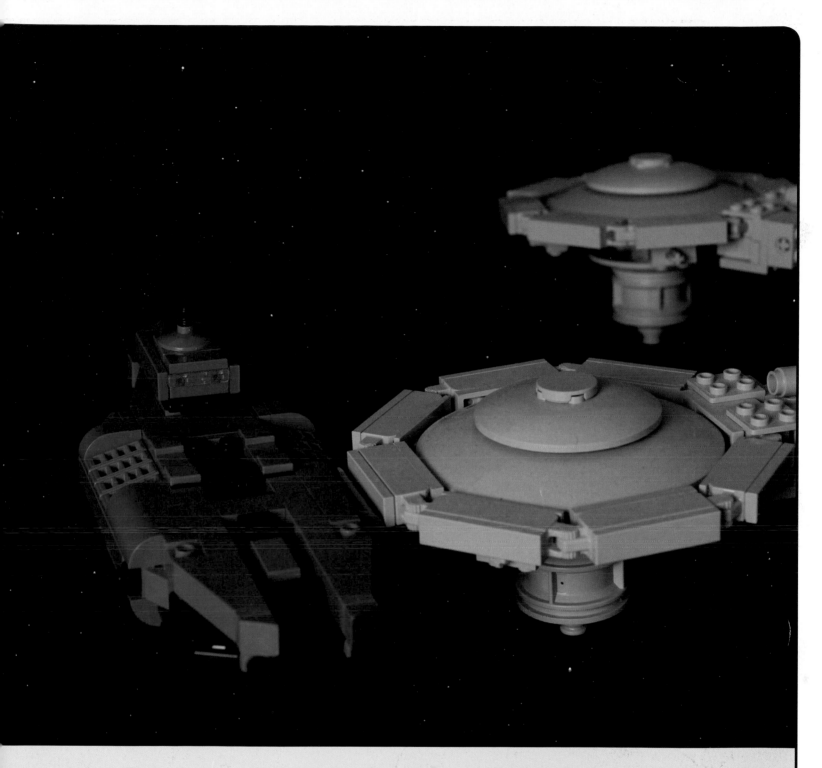

One of the first FPD actions was an investigative mission to Krysto Base, where a number of supply vessels had gone missing. A command ship was dispatched from Earth and reached the base after several weeks.

It was immediately clear that something was wrong, despite months of normal broadcasts. The station was in complete darkness, and there was no response to the ship's transmissions.

As it drew closer, the command ship adjusted its heading to deploy a squad of armed Exo Suits into the lower loading bay. The giant machines lumbered into the darkness.

The command ship then moved to the docking level of Krysto Base. The docking ring was aligned, sealed, and pressurized. After painstakingly bypassing the security protocols, FPD teams gained access to the operations level of Krysto Base.

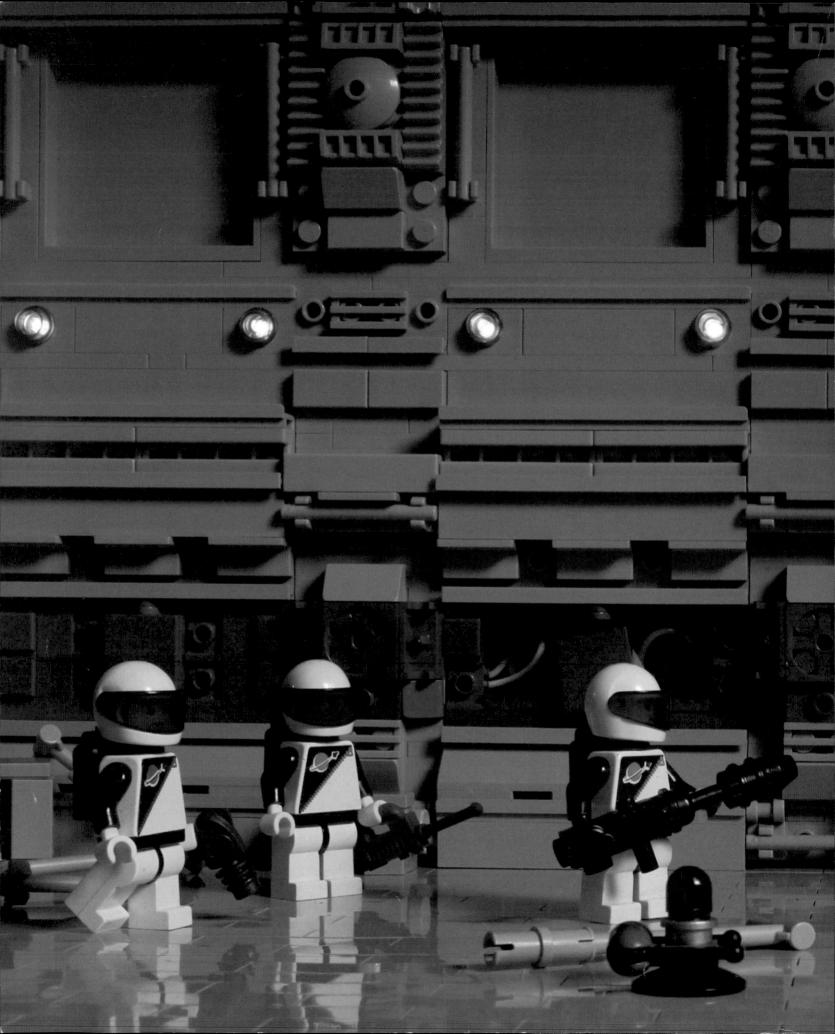

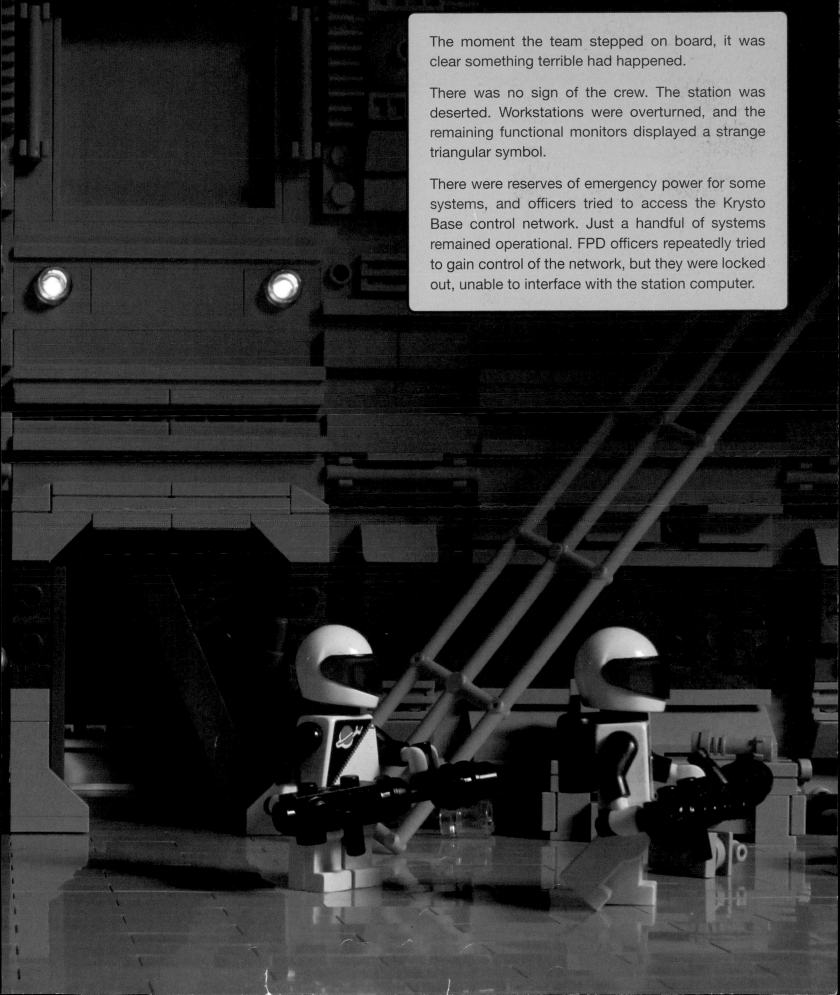

The moment the team stepped on board, it was clear something terrible had happened.

There was no sign of the crew. The station was deserted. Workstations were overturned, and the remaining functional monitors displayed a strange triangular symbol.

There were reserves of emergency power for some systems, and officers tried to access the Krysto Base control network. Just a handful of systems remained operational. FPD officers repeatedly tried to gain control of the network, but they were locked out, unable to interface with the station computer.

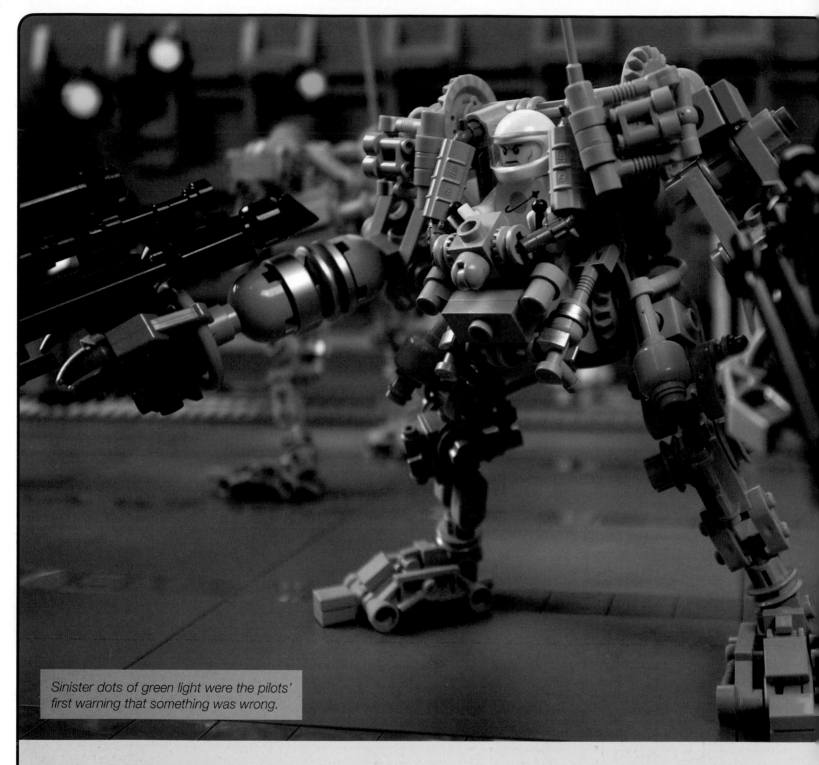

Sinister dots of green light were the pilots' first warning that something was wrong.

With the ops team unable to take control of the station's environmental controls, the squad of Exo Suits lumbered through the lower level in darkness, making their way to the main hold. The Exo Suit operators scanned the area. According to the last inventory filed with Federation headquarters, this section of Krysto Base should have been full of supplies and equipment. It was empty. The Exo Suits moved to the center of the hold.

From the darkness, a green glow appeared. It was joined by another. And another. The pilots drew their machines closer into a defensive formation as multiple green orbs appeared, floating all around them. They raised their weapons, while the squad leader reported an emergency situation on the lower levels.

Kazak had booby-trapped Krysto Base.

The news caused panic on the docking level. As the transmission came through, one of the officers found a bypass setting that reset the emergency lighting relays. The cargo hold was suddenly illuminated, revealing the nightmare that surrounded the squad.

The creatures moved closer, and the Exo Suit pilots had little time to react before they were attacked from all sides by a swarm of robotic worms.

Right: The officers on the docking level attempt to bypass Kazak's sabotage.

Below: Dozens of worms swarm toward the squad.

Overleaf: The pilots fought bravely but were quickly overwhelmed by the sheer number of creatures.

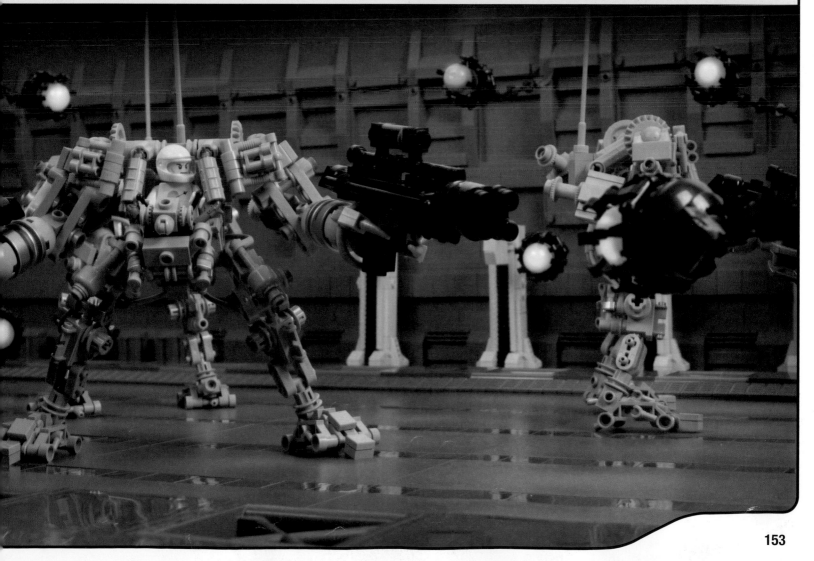

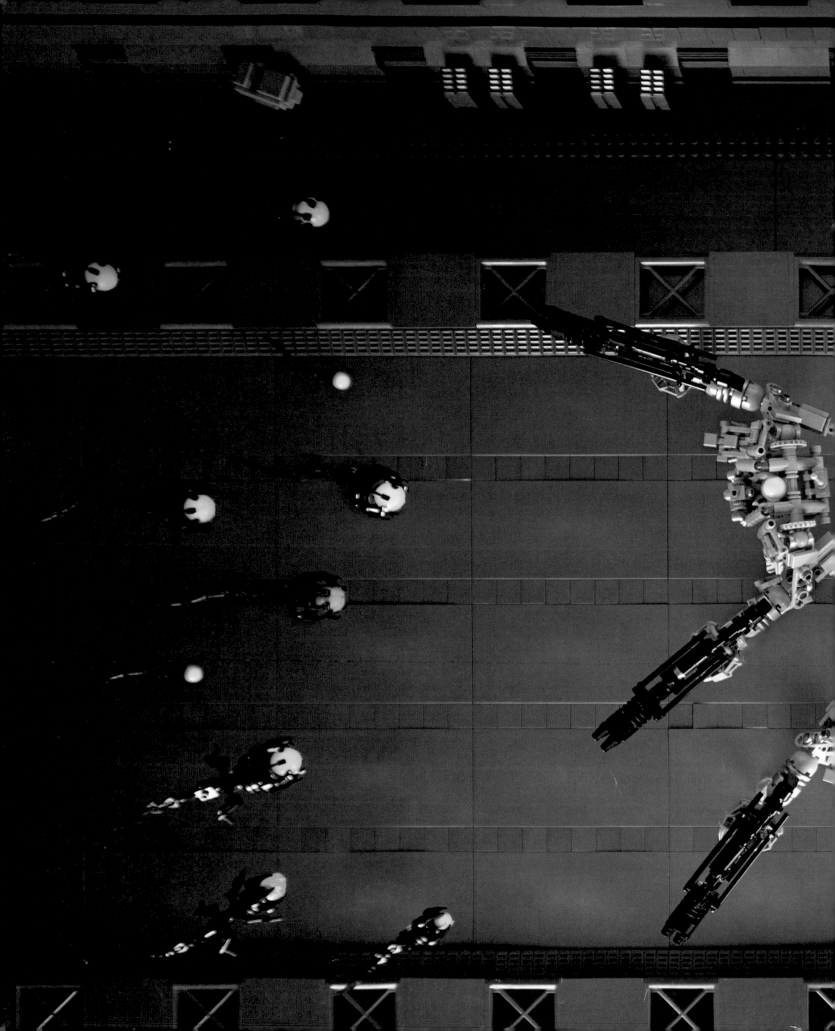

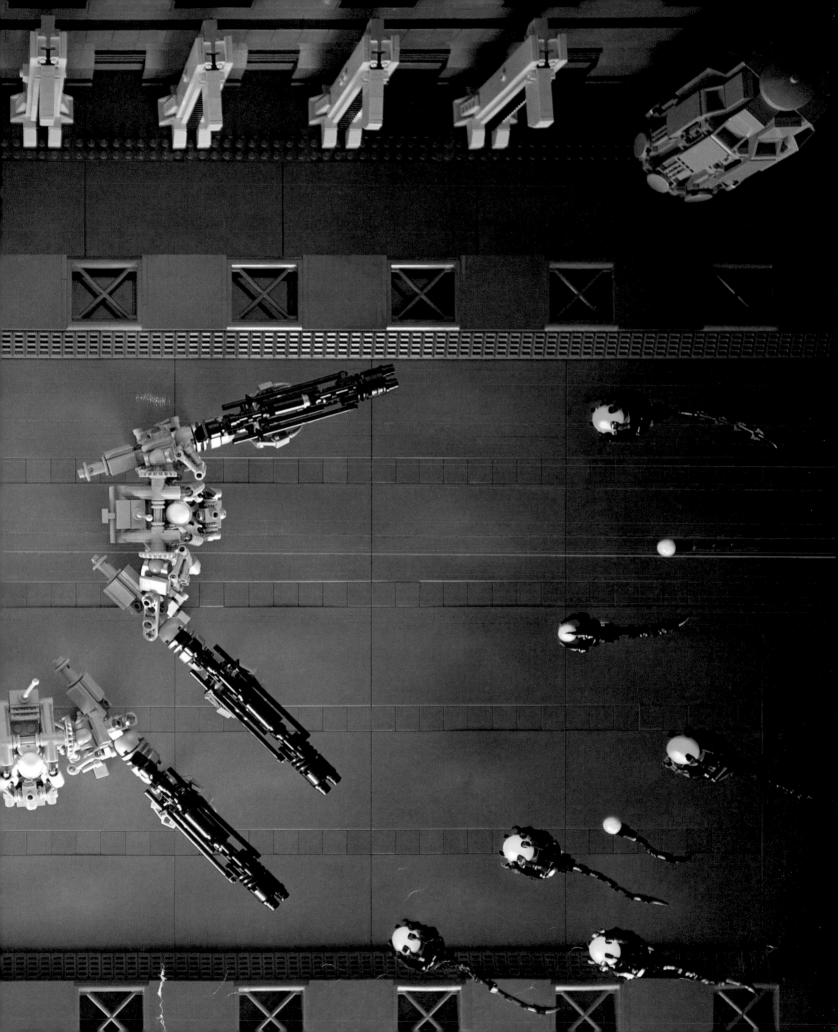

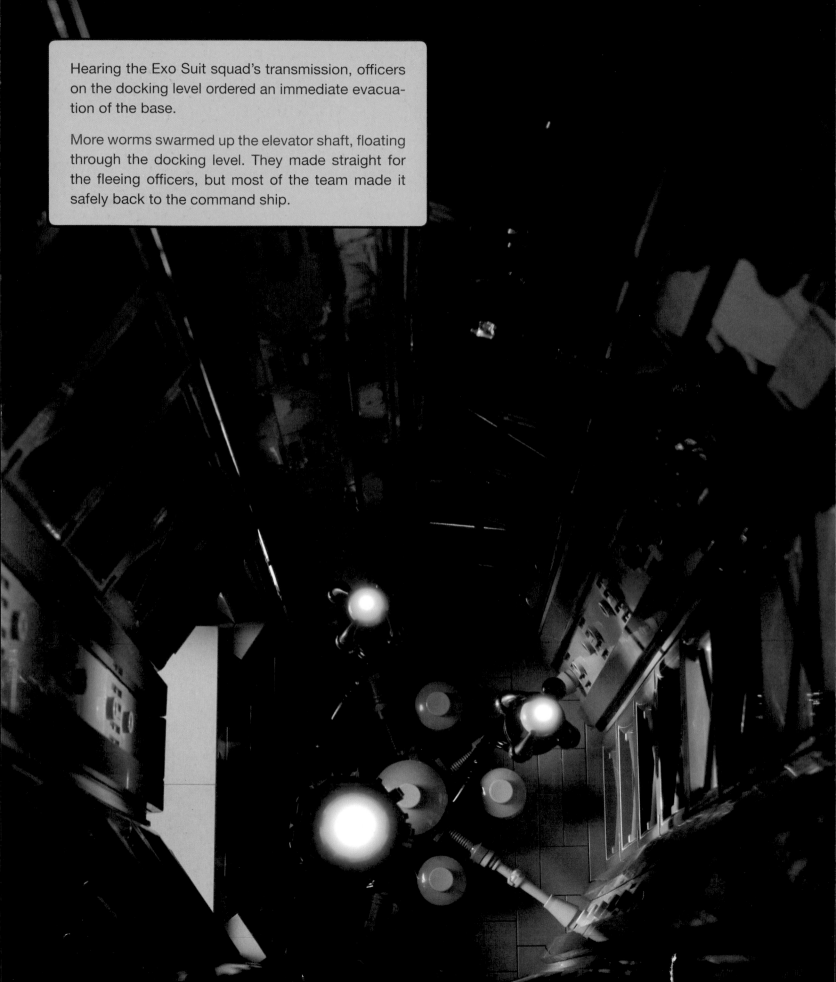

Hearing the Exo Suit squad's transmission, officers on the docking level ordered an immediate evacuation of the base.

More worms swarmed up the elevator shaft, floating through the docking level. They made straight for the fleeing officers, but most of the team made it safely back to the command ship.

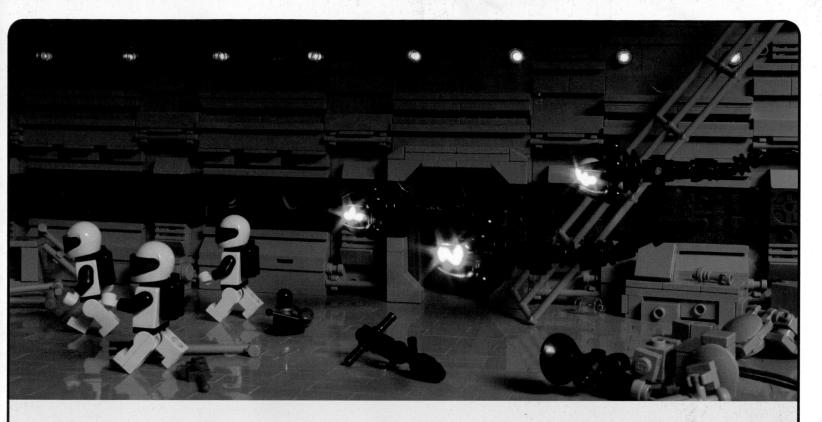

Captain Johnson was the last to board, diving through the docking tube with worms in close pursuit. The creatures smashed against the connecting door as it closed. The command ship detached from Krysto Base and retreated to a safe distance.

The command ship remained close to Krysto Base as it sent a report. The Federation Council reviewed the harrowing FPD security footage and gave the order to destroy the space station. Such terrifying creatures would only bring chaos to the Core Systems.

Officers onboard the command ship trained the ship's weapons on the station's external thrusters. As Krysto Base rotated, the command ship blasted each one away. The space station's orbit began to decay. Over several hours, the space station was pulled closer to Ganymede. The enormous moon eventually claimed the base and the terrible creatures within.

Above: The FPD team had no choice but to flee the worms.

Below: Officers on the command ship disable the thrusters on Krysto Base.

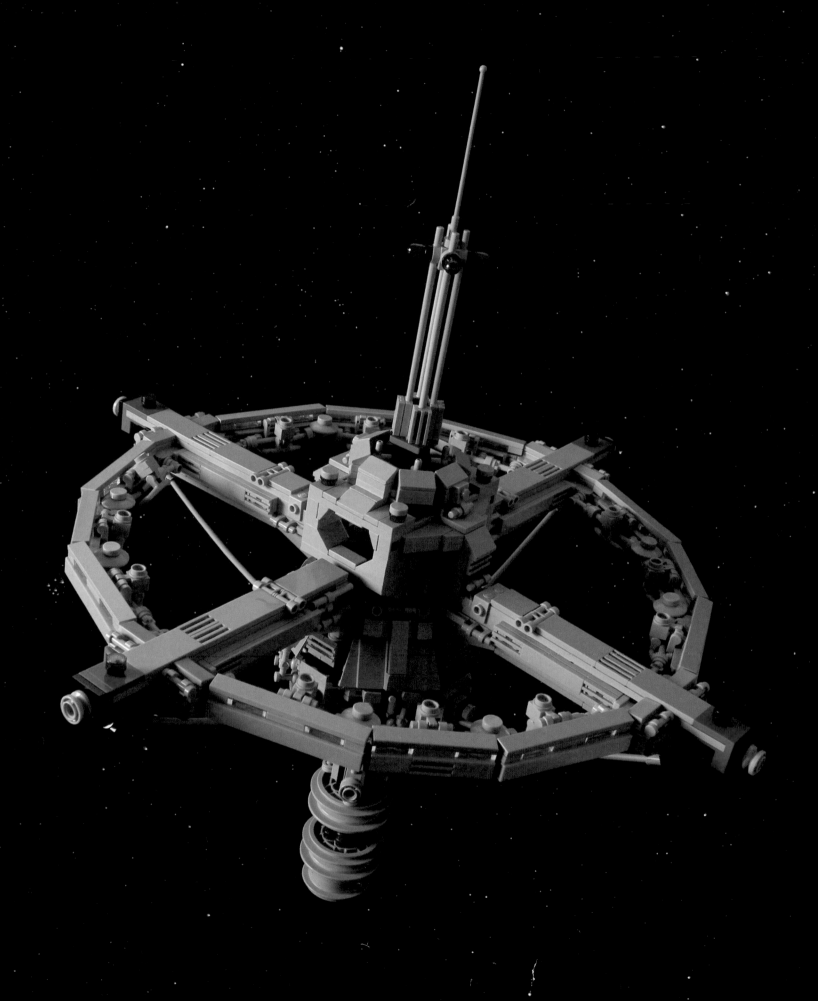

JUSTICE STATION

Not knowing where the creatures came from or where they might strike next, the Federation established a new jovian orbital base, Justice Station. Escort patrols along shipping lanes increased.

FPD patrol ships managed to disable a squad of Kazak's *Interceptors* and capture several pilots. The prisoners were detained in Justice Station and seemed content to keep their own counsel. During questioning, they revealed nothing to their captors. When messages from their families were played, the prisoners showed no emotion. They acted unconcerned and even belligerent when presented with arguments against their actions. The prisoners held on to an inner fury at their captors.

A peacekeeper mission to Omega Base was deemed too risky. It was feared Kazak's soldiers would be well prepared to defend the territory around Hyperion. Surveillance probes were dispatched to Hyperion and destroyed every time they approached. Kazak had rigged some kind of defensive network around the moon, which made gathering intelligence almost impossible.

Opposite: Justice Station was the first of many outer system peacekeeping facilities.

Below: Kazak's pilots were incarcerated while they waited for judgment from the Federation Council. Their sentences would be harsh.

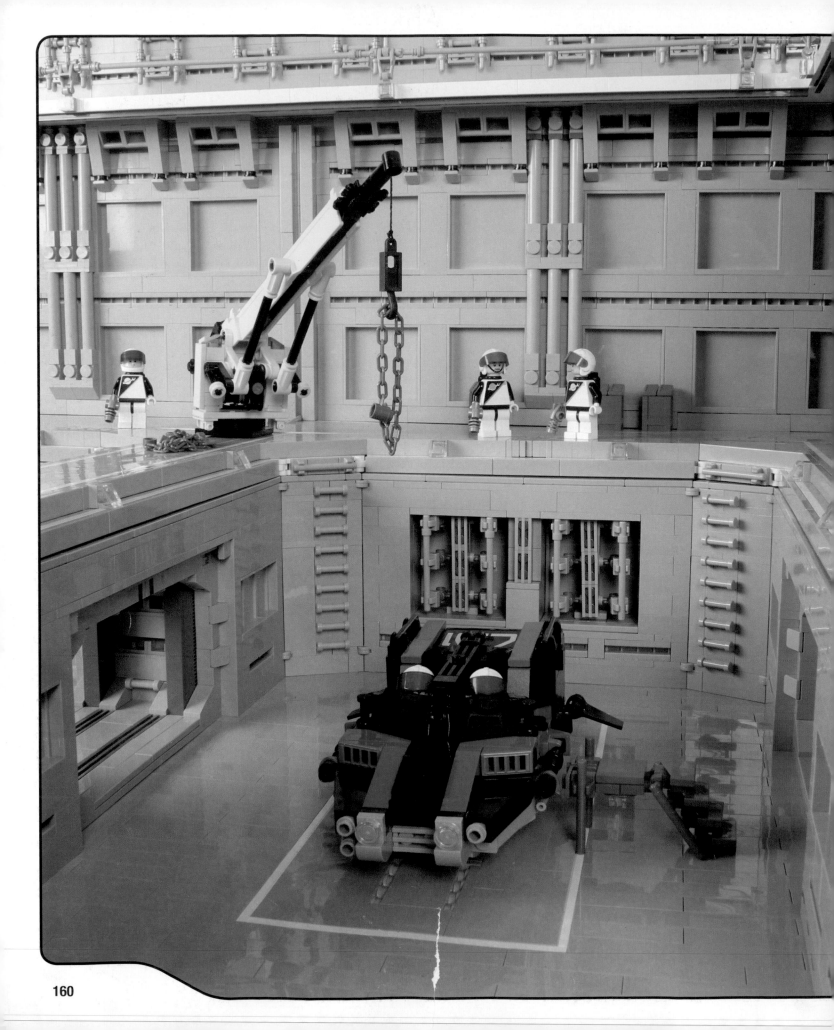

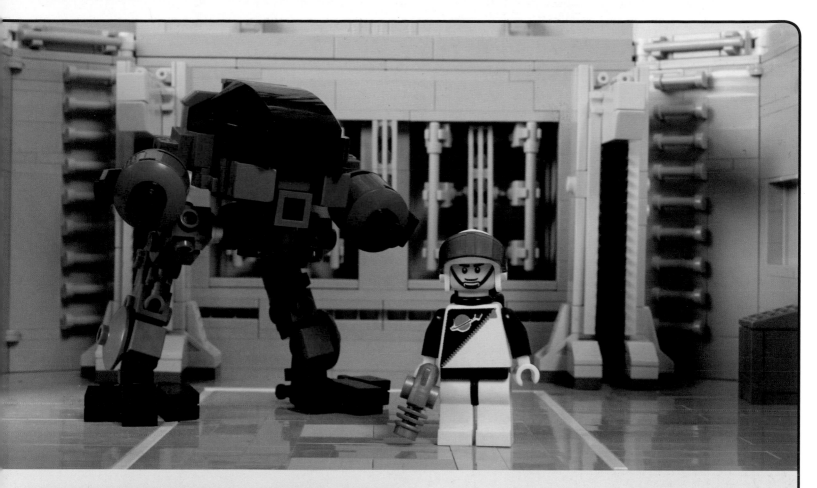

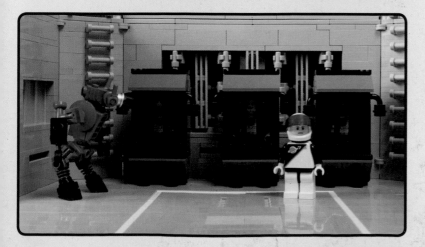

Above: The corridors of Justice Station were patrolled by both FPD officers and Enforcer droids.

Left center: The station's internal docking bays were designed to allow Vipers to refuel on long escort missions.

Left below: Prisoners are transferred to the station in secure holding pods. With a classic design that predated the FPD, the pods were not intended for a comfortable journey.

Opposite: A Patrol Speeder undergoes maintenance in one of the station's repair bays.

SP-78 VIPER ESCORT

The most commonly seen FPD escort ship, the *Viper* is a highly adaptable vessel. Several variants are in service, and optional wings can easily be fitted for atmospheric or low-orbital patrol duties. A high-capacity fuel tank means long-range missions are possible.

The *Viper* is one of the more recent designs from Tranquility Base laboratories. Integrated weapons, propulsion, life support, and navigation systems make it a highly capable ship for its size.

Right: The Viper's bidirectional thrusters allow for improved handling in close-quarter dogfights.

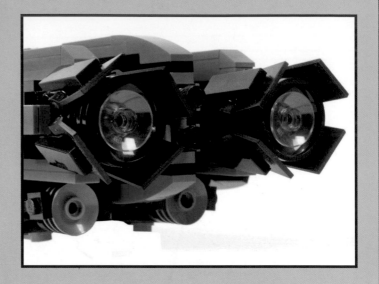

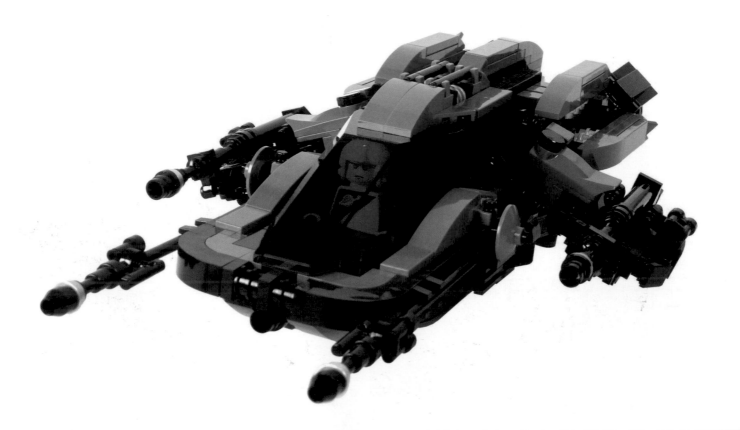

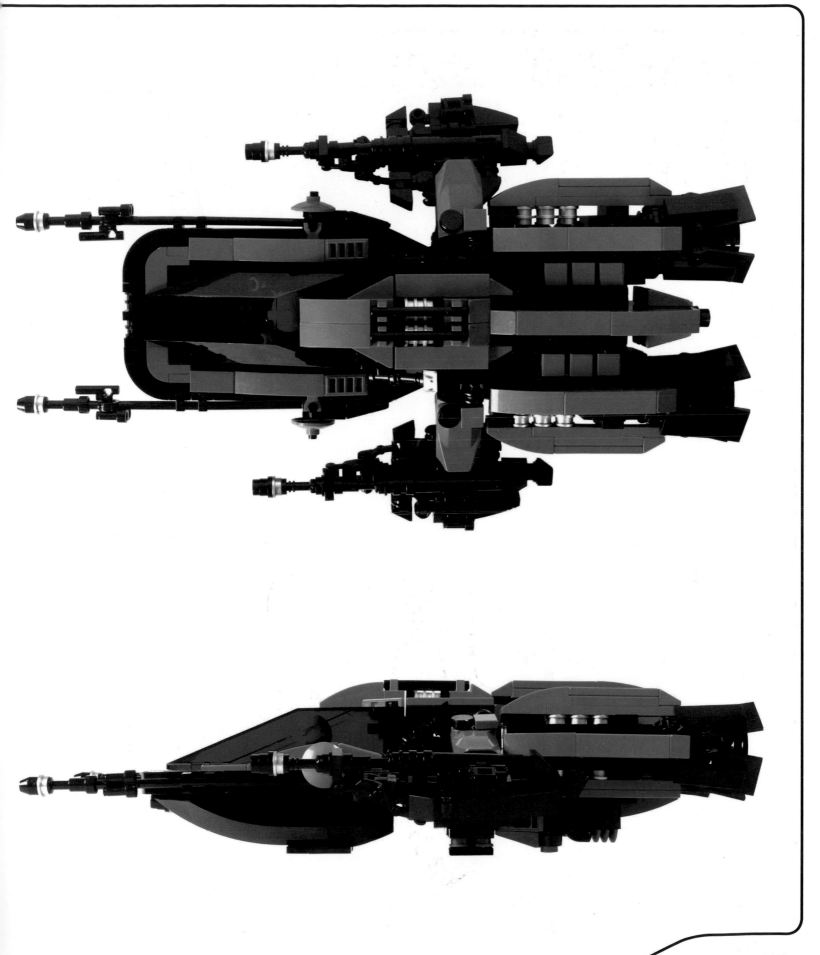

SP-67 PATROL SPEEDER

Designed for prolonged low-altitude flight, the *SP-67* is an effective and reliable reconnaissance craft. An array of sensors fitted to the underside of the vehicle make it ideal for surveillance missions.

The *SP-67* is a modified version of a commercial design, crewed by a pilot and a navigator.

Right: Often visible from the surface of planets, the SP-67 is clearly marked as a police vehicle to reassure colonists and deter criminals.

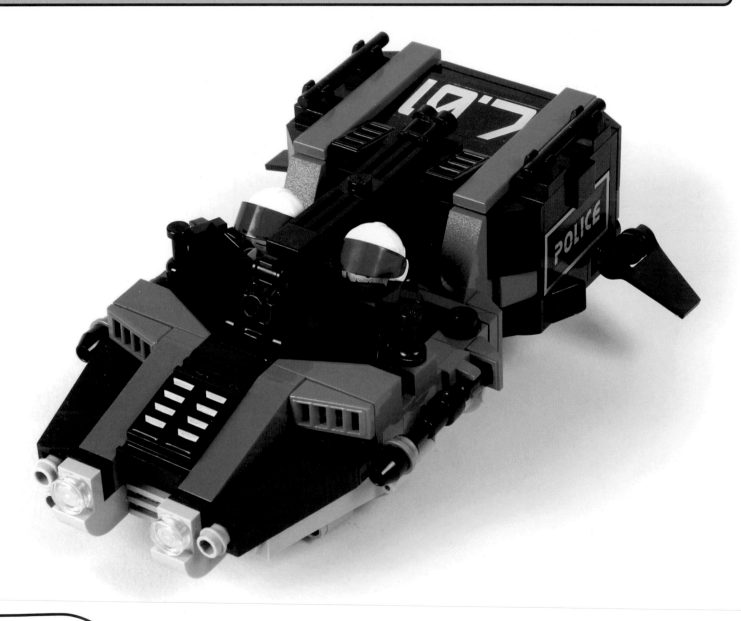

SP-13 JETBIKE

Based on a commercial design used on Earth, the SP-13 is a high-speed, low-altitude one-man vehicle. The compact design and efficient propulsion system make the Jetbike a popular choice among FPD personnel. The SP-13 can be adapted for various gravity conditions, and it is commonly used for surface patrol duties.

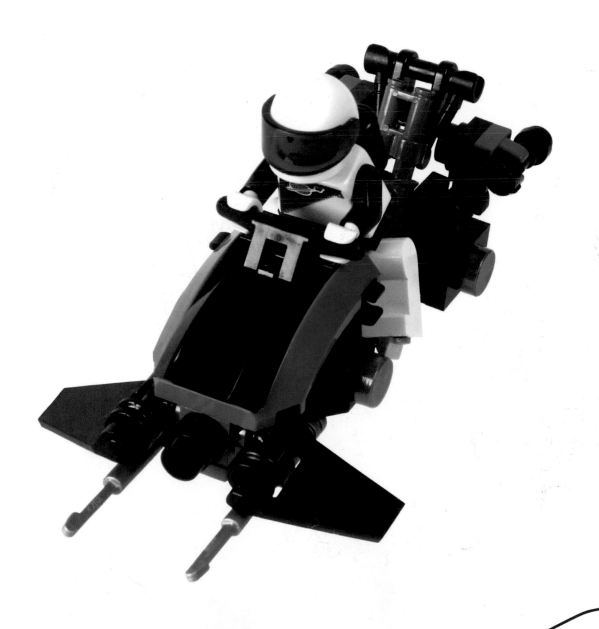

VIPER ESCORT VARIANT

The FPD *Viper* is a high-performance escort vessel developed by a top secret team in the Tranquility Base laboratories. The *Viper* was commissioned in response to the hostile activity in the outer system.

With powerful energy weapons, multiple configurations, and an impressive range, the *Viper* out-performs most other ships of its class. Squadrons of *Vipers* patrol the shipping lanes, keeping order in the outer system.

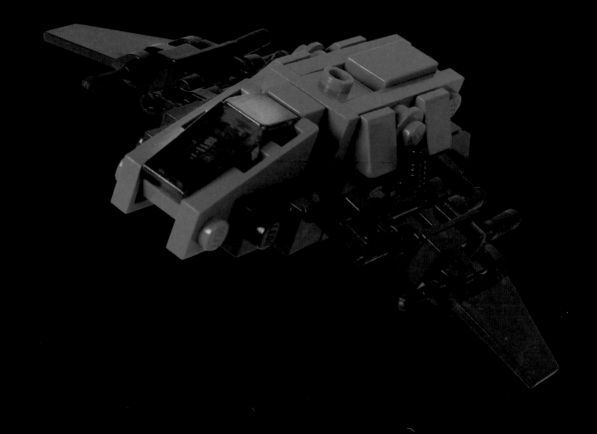

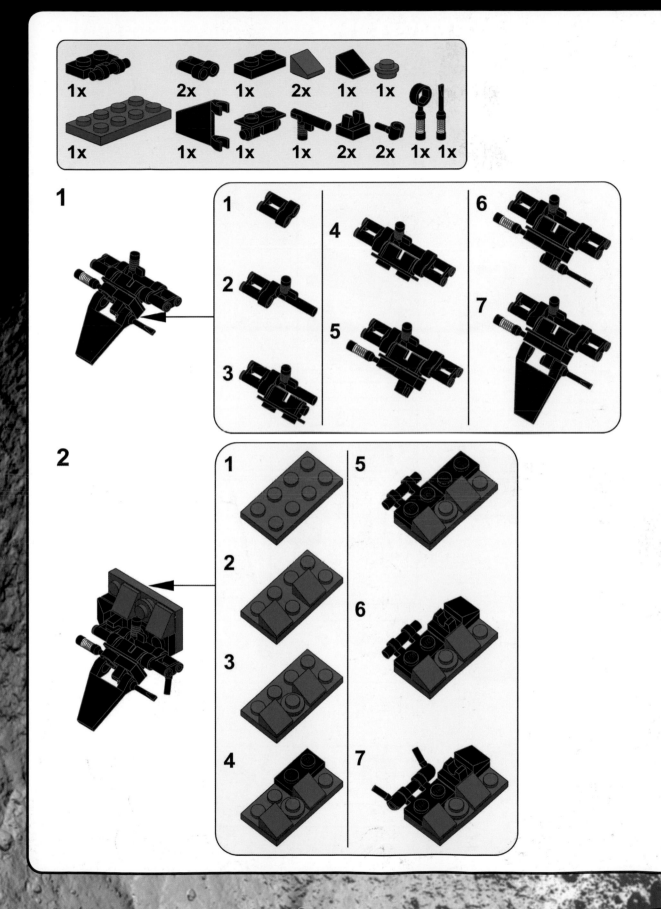

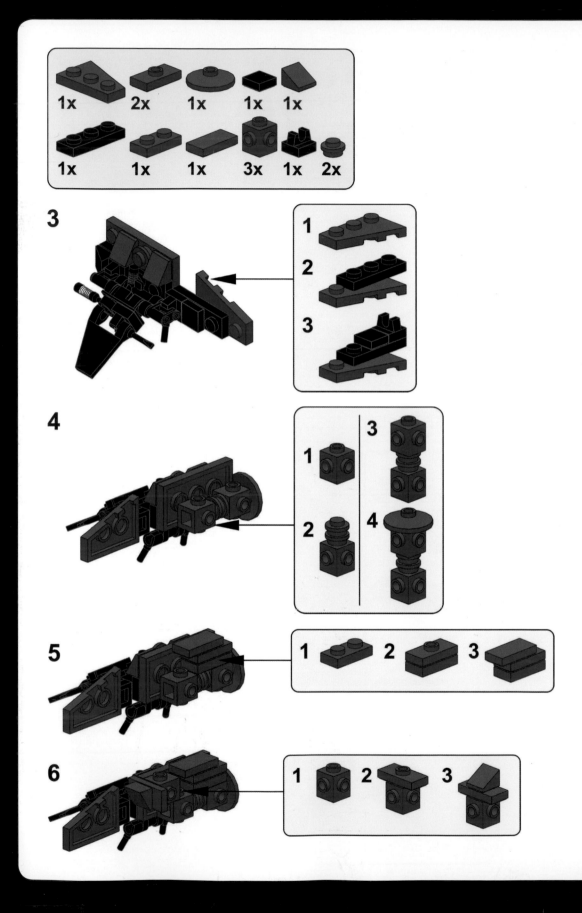

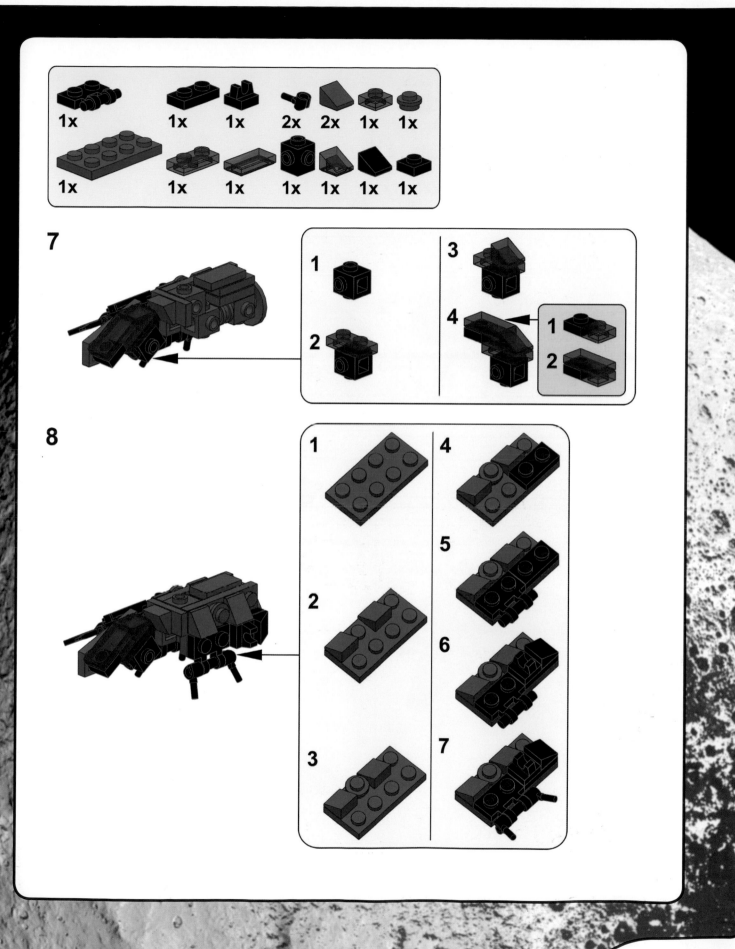

9

10

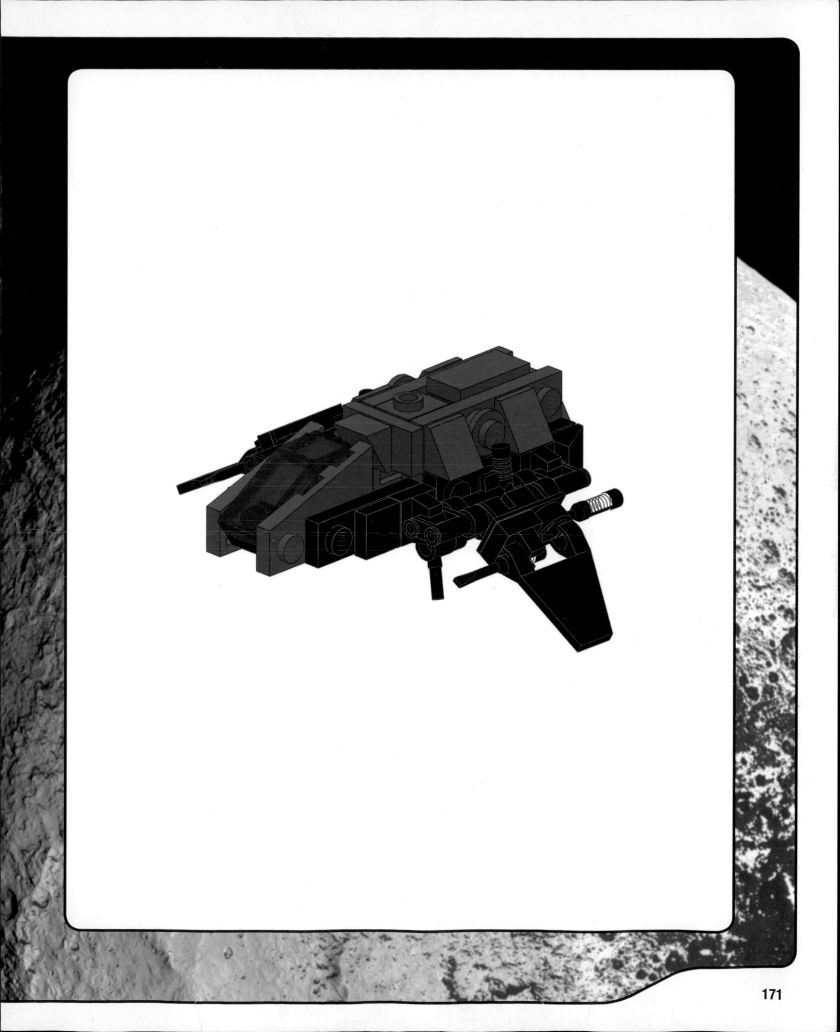

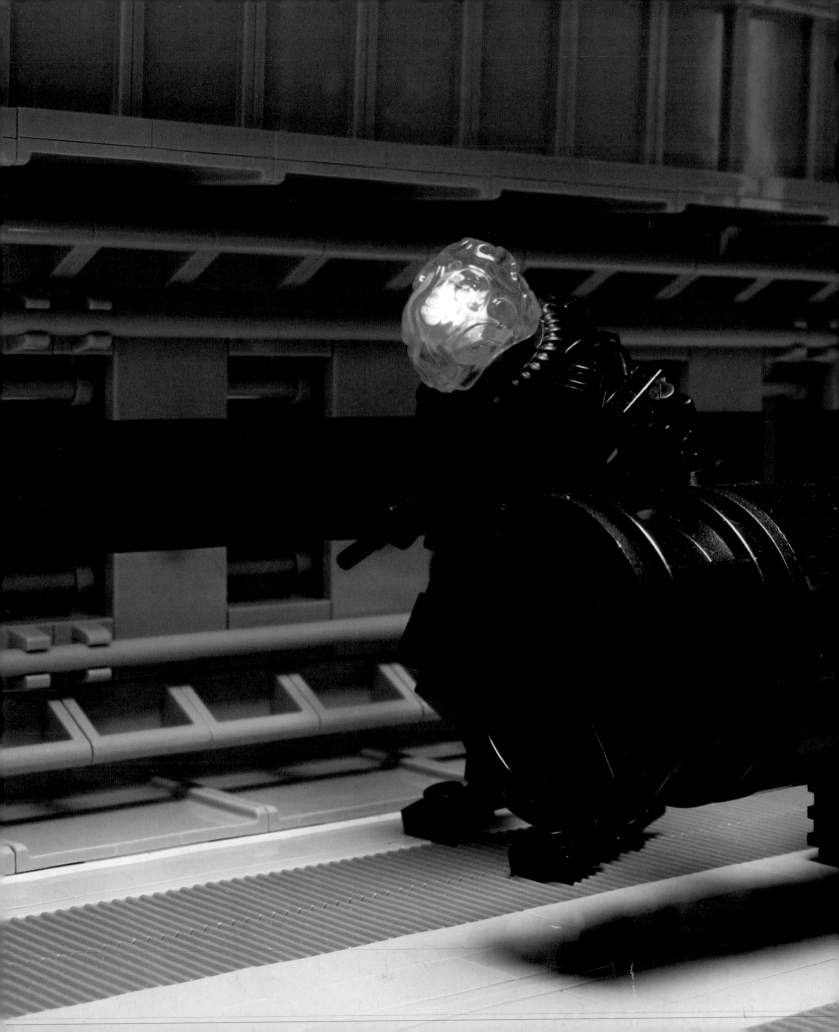

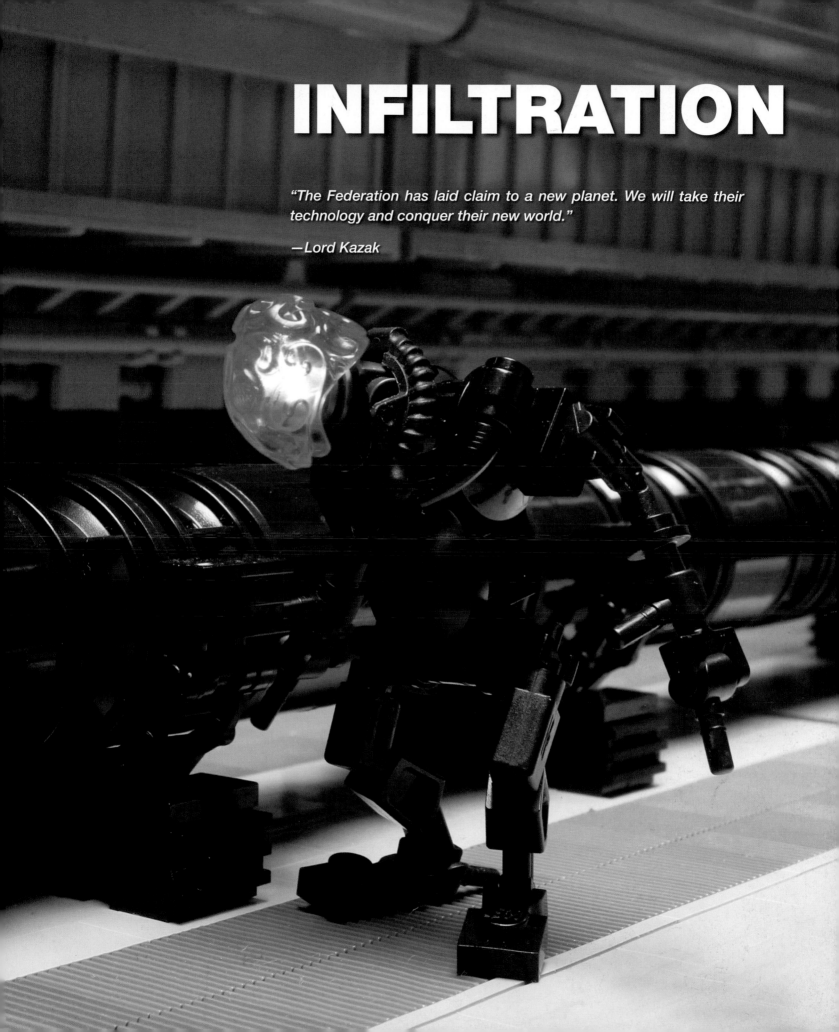

INFILTRATION

"The Federation has laid claim to a new planet. We will take their technology and conquer their new world."

—*Lord Kazak*

While the FPD attempted to police the space lanes, Federation scientists turned their attention to new frontiers. The potential for expansion through the Gate, which had been made possible by Major Golightly's groundbreaking advancements, had yet to be fully explored.

Decades ago, an unmanned probe from Earth had passed through the Altair system, 16.7 light-years away, and left a marker beacon in its wake. When the Gate was activated, it locked onto the beacon, creating an exit point in orbit around Altair's third planet, Panduro.

This world was perfect for colonization. Panduro had a similar gravity to Earth and was situated in the habitable zone, eight light-minutes from Altair, roughly the same distance between Earth and the Sun. The planet was barren and devoid of life and the atmosphere unbreathable, but Federation scientists were confident it could be changed. Specialist engineers traveled through the Gate and watched as mechanoids began the adaptation procedure. Squadrons of robots set up the towers that would process the atmosphere. The transformation began.

Above: The probe passes close to Panduro on its journey through the Altair system.

Below: The Gate's field generators were the largest ever produced by the Federation.

Opposite: The Gate's massive fusion chamber was maintained by a specialized robot.

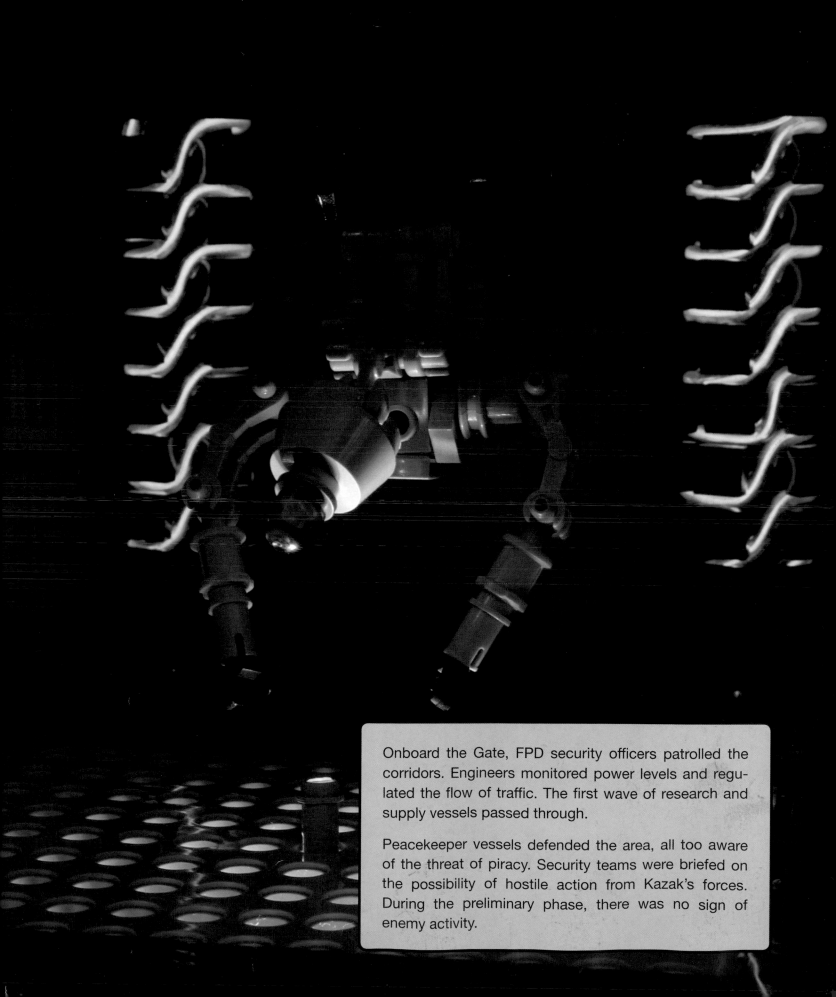

Onboard the Gate, FPD security officers patrolled the corridors. Engineers monitored power levels and regulated the flow of traffic. The first wave of research and supply vessels passed through.

Peacekeeper vessels defended the area, all too aware of the threat of piracy. Security teams were briefed on the possibility of hostile action from Kazak's forces. During the preliminary phase, there was no sign of enemy activity.

Gate technicians worked hard to master the calibration procedure. Aligning new destination parameters was a gamble, and without precise coordinates, colonists could end up stranded in deep space. Any adjustment might permanently sever the link to the Altair system. It was vital that the new world be fully established before the Gate was reset. After decades of planning and hard work, the Gate was used to transfer personnel, supplies, and equipment to the Altair system.

Between operational phases, the Gate was powered down and engineers were transferred to Tranquility Base. Only a handful of security officers remained aboard. They patrolled the corridors and maintenance conduits.

One of the officers, Captain Johnson, had been present during the ill-fated Krysto Base mission. During the evacuation, he had been the last of his team to make it safely back to the command ship. The worms had almost taken him down, one of them brushing the back of his neck as he fled the stricken base.

Johnson had been plagued by strange, disturbing dreams since his return.

Below: Captain Johnson checks the operational status of the energy core chamber.

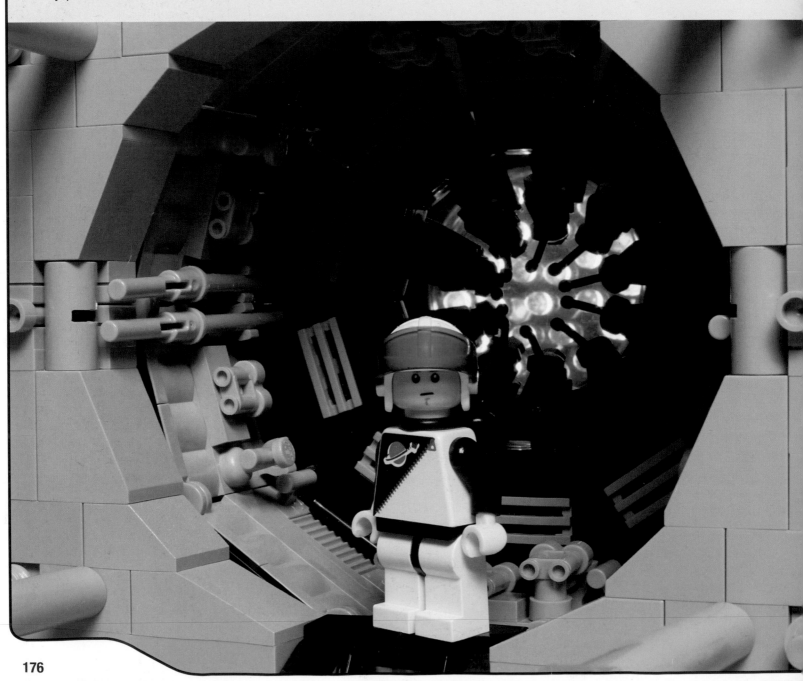

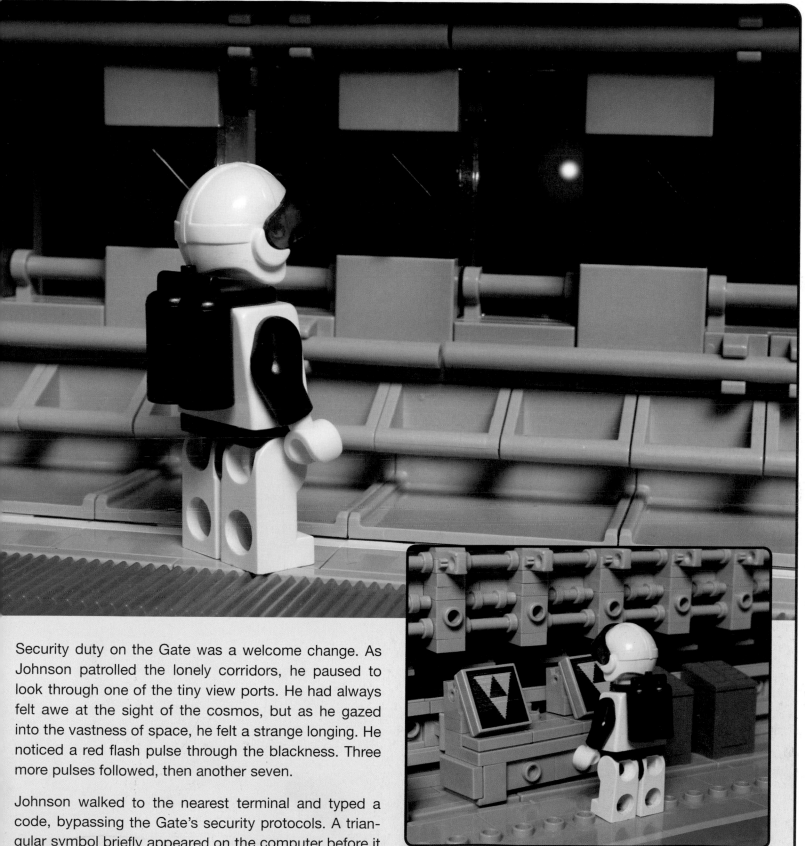

Security duty on the Gate was a welcome change. As Johnson patrolled the lonely corridors, he paused to look through one of the tiny view ports. He had always felt awe at the sight of the cosmos, but as he gazed into the vastness of space, he felt a strange longing. He noticed a red flash pulse through the blackness. Three more pulses followed, then another seven.

Johnson walked to the nearest terminal and typed a code, bypassing the Gate's security protocols. A triangular symbol briefly appeared on the computer before it reverted to the standard Federation screen. He made his way to the monitoring station and told his colleague to take the evening off.

Top: A mysterious light catches Johnson's eye.

Above: The computer monitors flash an unfamiliar symbol.

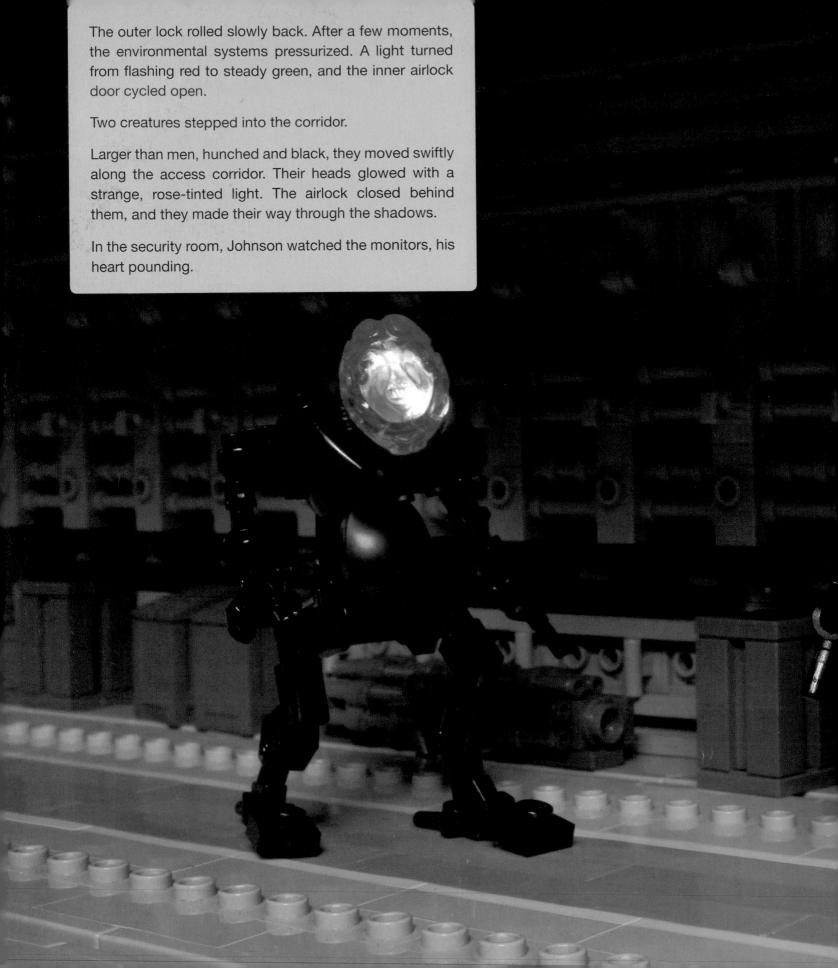

The outer lock rolled slowly back. After a few moments, the environmental systems pressurized. A light turned from flashing red to steady green, and the inner airlock door cycled open.

Two creatures stepped into the corridor.

Larger than men, hunched and black, they moved swiftly along the access corridor. Their heads glowed with a strange, rose-tinted light. The airlock closed behind them, and they made their way through the shadows.

In the security room, Johnson watched the monitors, his heart pounding.

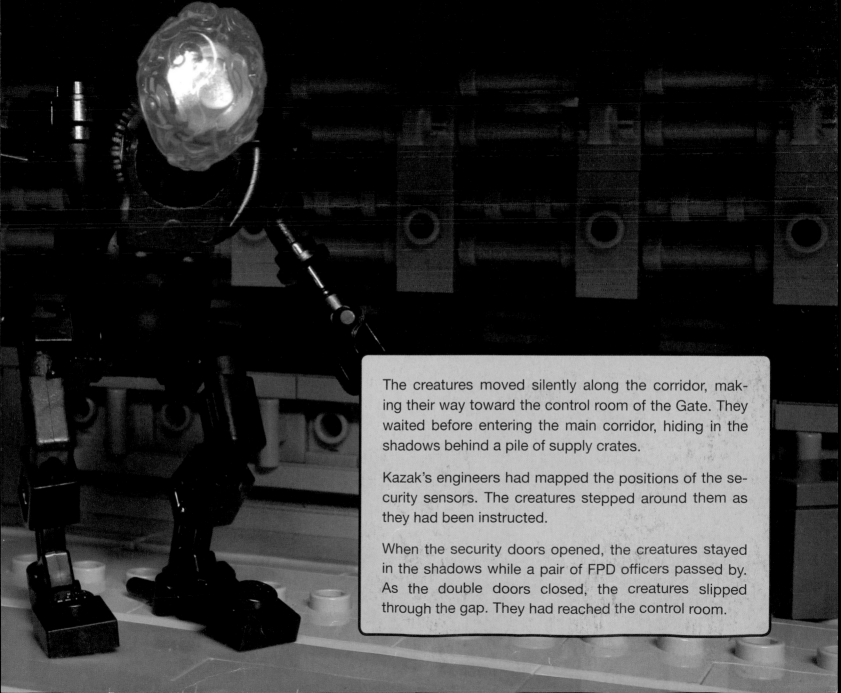

The creatures moved silently along the corridor, making their way toward the control room of the Gate. They waited before entering the main corridor, hiding in the shadows behind a pile of supply crates.

Kazak's engineers had mapped the positions of the security sensors. The creatures stepped around them as they had been instructed.

When the security doors opened, the creatures stayed in the shadows while a pair of FPD officers passed by. As the double doors closed, the creatures slipped through the gap. They had reached the control room.

With the security protocols disabled, the hybrids were able to establish a remote uplink.

The room was empty, and one of the creatures entered an activation code into the pad with a massive finger. Network security protocols had already been bypassed, and a remote uplink was established. The second creature sent a telepathic communication to Kazak, and they watched the monitor as the dark wedge of the *Tyrant* approached the Gate. The screen filled with inscrutable codes and numbers as Kazak's technicians on the *Tyrant* uploaded a virus to the Gate's mainframe. The Gate could now be controlled remotely.

There was enough residual power in the Gate's fusion reactor for a single jump. For less than 20 seconds, the giant rings glowed a bright blue. It was timed perfectly. The *Tyrant* passed through the Gate and into the Altair system.

The creatures observed the monitors as the uplink erased all evidence of the *Tyrant*'s passage. They left the control room, their mission almost complete.

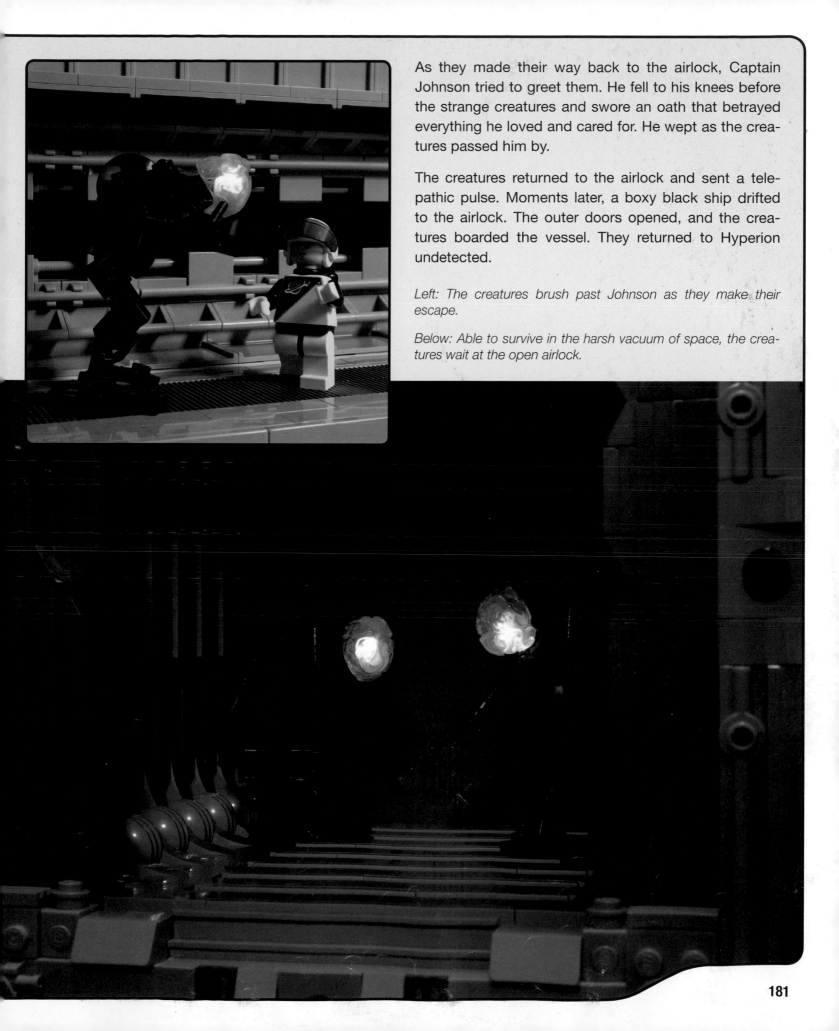

As they made their way back to the airlock, Captain Johnson tried to greet them. He fell to his knees before the strange creatures and swore an oath that betrayed everything he loved and cared for. He wept as the creatures passed him by.

The creatures returned to the airlock and sent a telepathic pulse. Moments later, a boxy black ship drifted to the airlock. The outer doors opened, and the creatures boarded the vessel. They returned to Hyperion undetected.

Left: The creatures brush past Johnson as they make their escape.

Below: Able to survive in the harsh vacuum of space, the creatures wait at the open airlock.

COMPUTER TERMINAL

Standard computer terminals allow access to the Federation network. With the appropriate security clearance codes, any part of the Federation database can be accessed.

Advanced ergonomic seating provides a comfortable working experience. Similar terminals can be found on every Federation outpost.

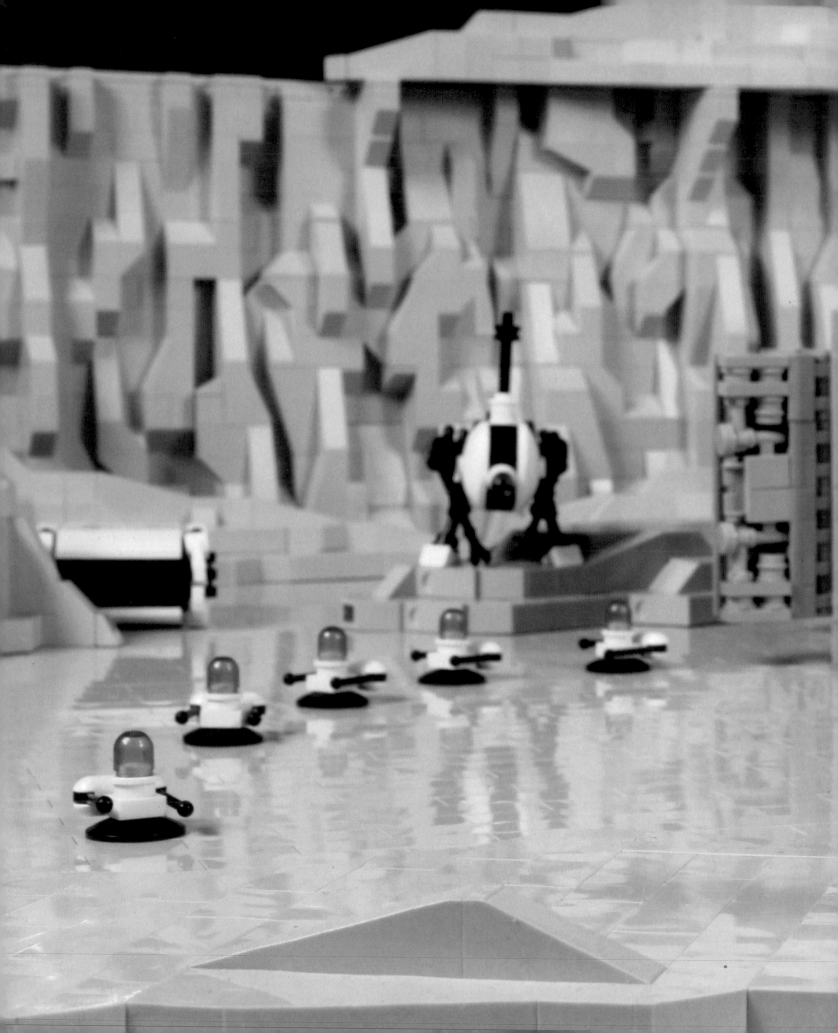

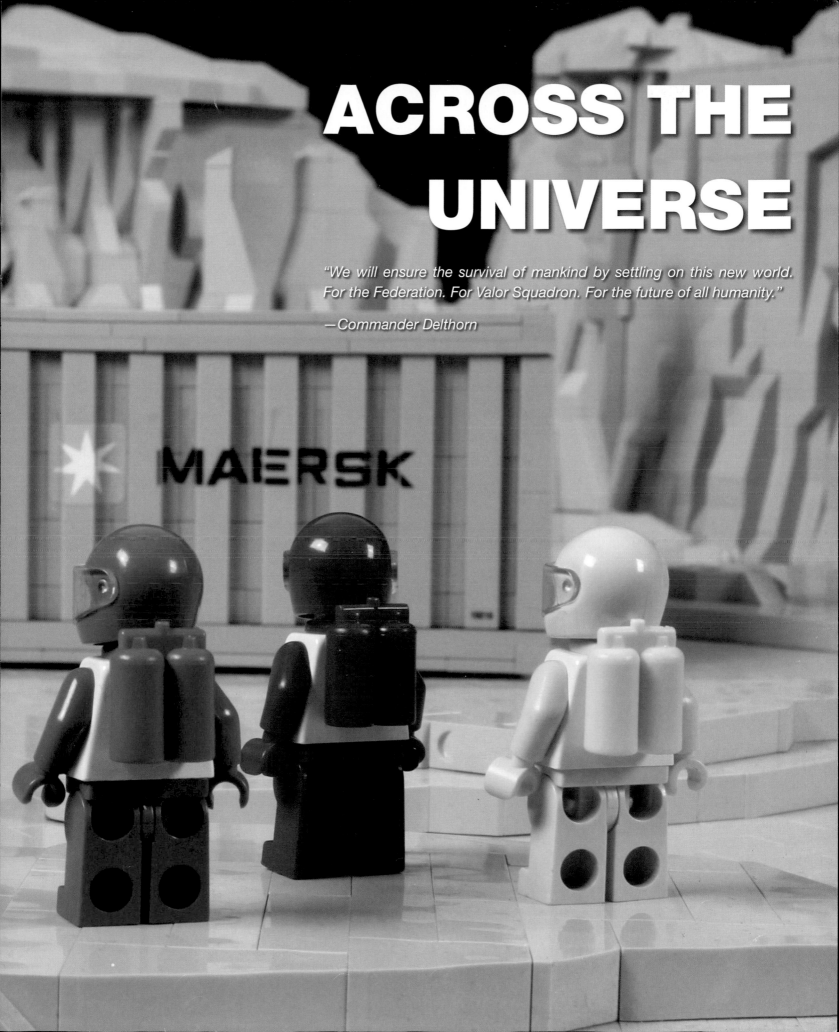

ACROSS THE UNIVERSE

"We will ensure the survival of mankind by settling on this new world. For the Federation. For Valor Squadron. For the future of all humanity."

—Commander Delthorn

The Federation allocated considerable resources to the transformation of Panduro. The distant world represented a future where humanity would be safe, even in the event of a catastrophe in the Core Systems.

The first structures were ugly, windowless outposts, designed to provide a safe haven for the small teams of engineers who oversaw the adjustment of Panduro's atmosphere.

The outposts were soon flanked by other buildings, as the new society grew at a rapid pace.

Preliminary groundwork was done by mechanoids. There was water on the planet, and pumping stations were erected to bring aquifers from the depths to the surface.

Robotic teams mapped the area, laying the foundation for a system of supply lines. The beginnings of the transport network etched lines across the barren plains.

Atmospheric processors scrubbed the poisonous air, gradually reducing carbon dioxide levels and increasing the oxygen percentage in tiny increments. It was a lengthy process, but the air slowly became less toxic to the colonists.

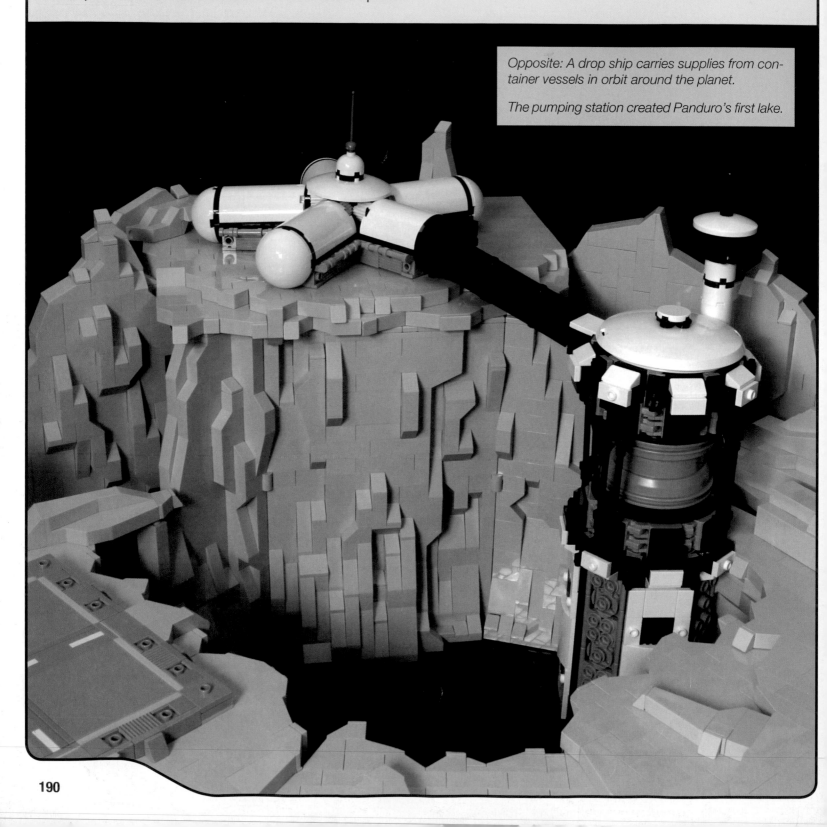

Opposite: A drop ship carries supplies from container vessels in orbit around the planet.

The pumping station created Panduro's first lake.

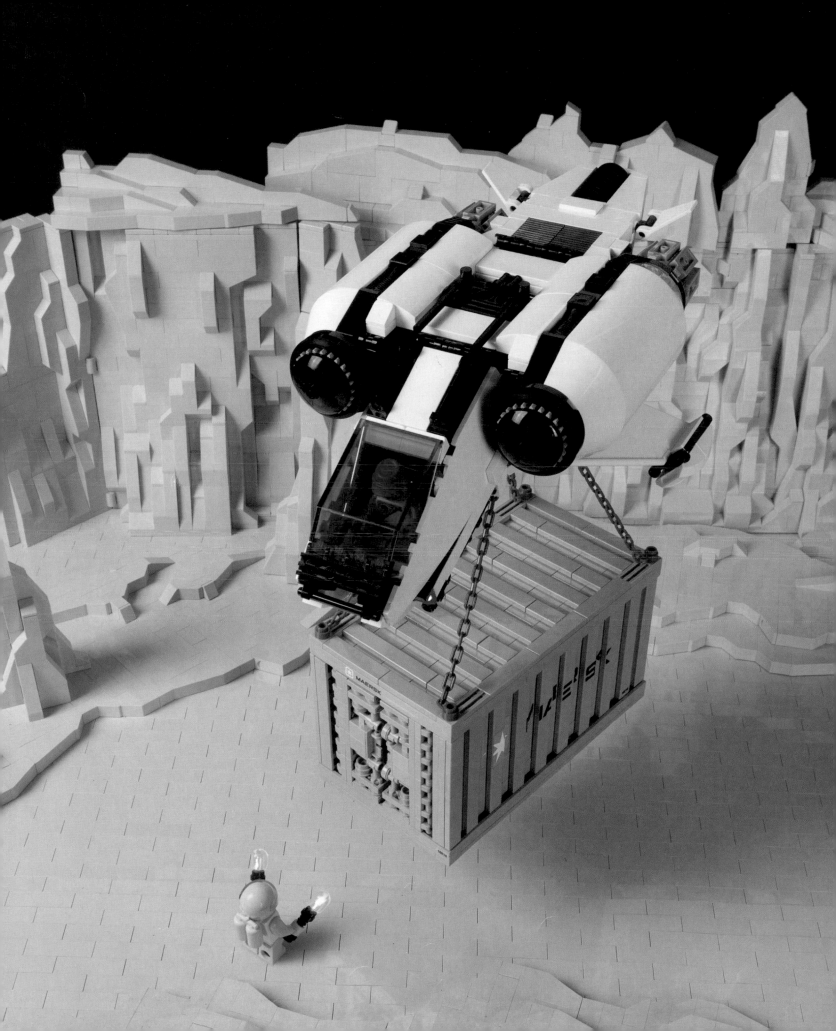

VALOR SQUADRON

With the preliminary phase of development complete, a second wave of Federation engineers journeyed through the Gate, ready to help build a future on Panduro. The team was known as Valor Squadron. Each member had been carefully selected for physical stamina and high intelligence. If mankind was to settle on this new world, the founders would need every advantage available.

Heading up Valor Squadron, Commander Delthorn kept a watchful eye over his teams as they performed their duties. In the early phase of their mission, he had assigned pilots to patrol the Gate. However, security at the other end was tight, so after a few months he decided to reassign the pilots to more practical duties on the planet. He needed every available pair of hands on the surface working toward a habitable world.

The Gate seemed like a miracle to the colonists on Panduro. These planetary engineers may have been able to adjust atmospheric lapse rates with field generators and grasp the delicate science of localized weather control, but instantaneous travel across the cosmos was far beyond their understanding. They knew their link back to Earth was fragile. If the Gate was damaged, they would be isolated for decades. Fortunately, the Gate remained operational, with transports providing essential supplies.

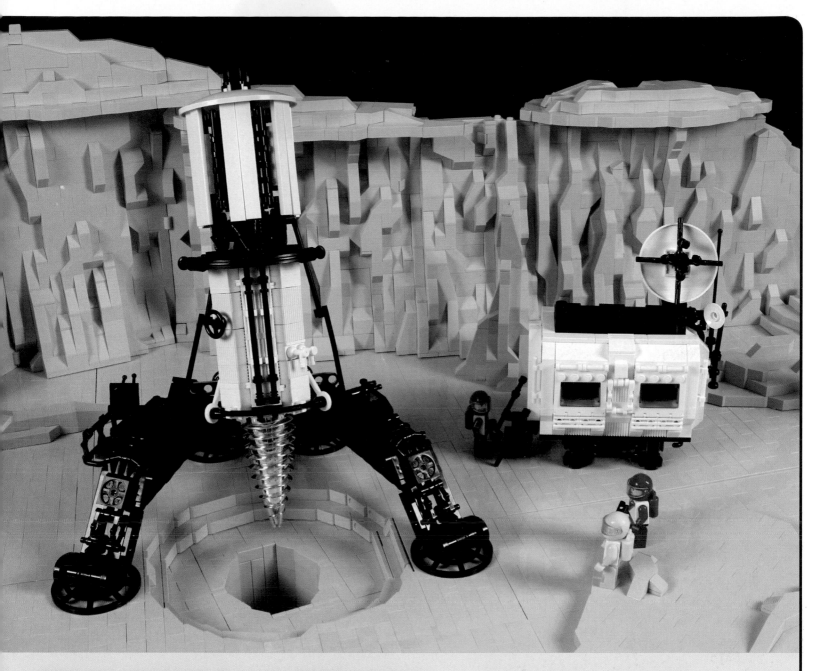

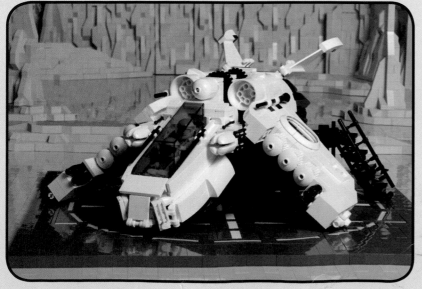

Opposite: Valor Squadron oversaw the deployment of robotic teams.

Above: Valor Squadron begins excavations on the planet's surface.

Left: An FT-875 Interceptor prepares for takeoff from a makeshift landing pad.

FT-162 HOVER BIKE

Hover Bikes are used for perimeter patrol duties on Panduro. The bikes rarely venture beyond the Valor Base perimeter. Running on low-capacity batteries, they require frequent charging, which limits their range.

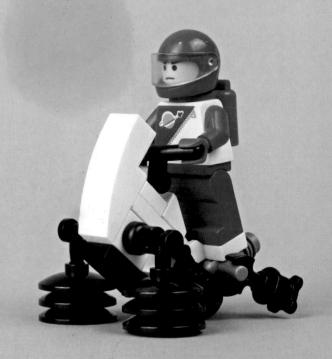

FT-925 ROVER

The FT-925 is a six-wheeled carrier vehicle used in the construction of new colony outposts. Its low center of gravity and independent suspension enable it to transport the heaviest of loads across the rocky plains of the frontier world.

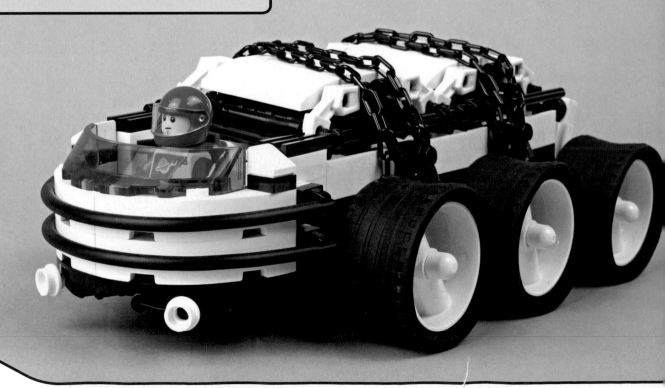

FT-875 INTERCEPTOR

The *Interceptor* is a compact, powerful shuttle. It is fitted with protective plating and a variety of sensors. The ship is heavily armed and equipped with a sophisticated onboard targeting system.

Valor Squadron uses these shuttles for security patrols and escort duties. Although Panduro is the Federation's most remote outpost, experience with Kazak's forces has taught Federation forces to take no chances.

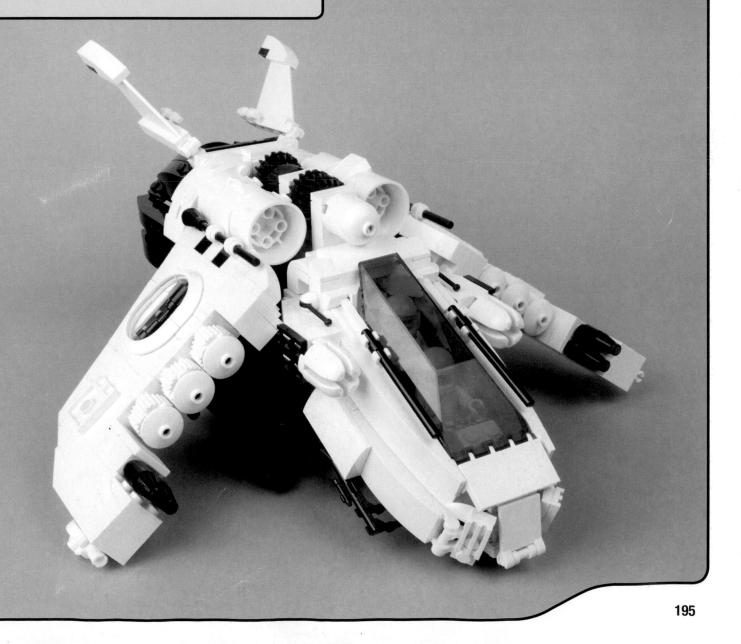

VALOR SQUADRON ROBOTS

Adept at terraforming duties, Valor Squadron robots work closely with their human counterparts, ready to assist engineering teams with a wide variety of mission requirements.

From perimeter patrol to construction, the latest generation of Federation mechanoids serves as an essential part of the primary phase workforce.

Left to right: Junior, Crusader, Proteus, Proteus Alpha, Federation Survey Robot, Neo Dog F1-D0

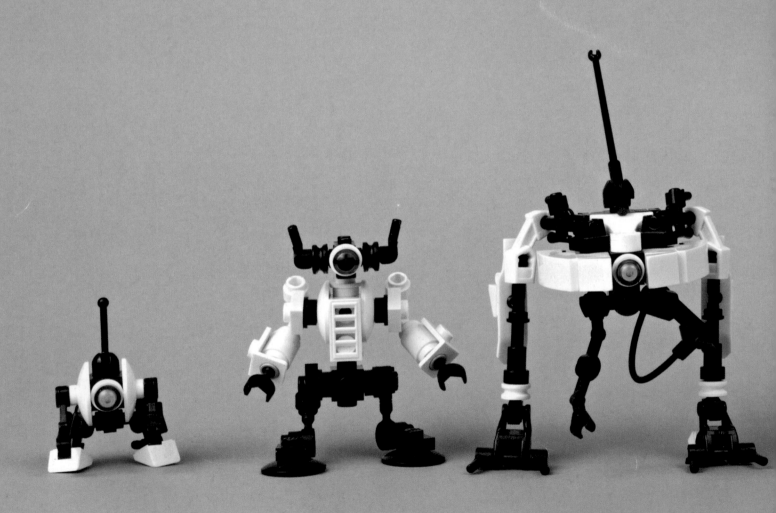

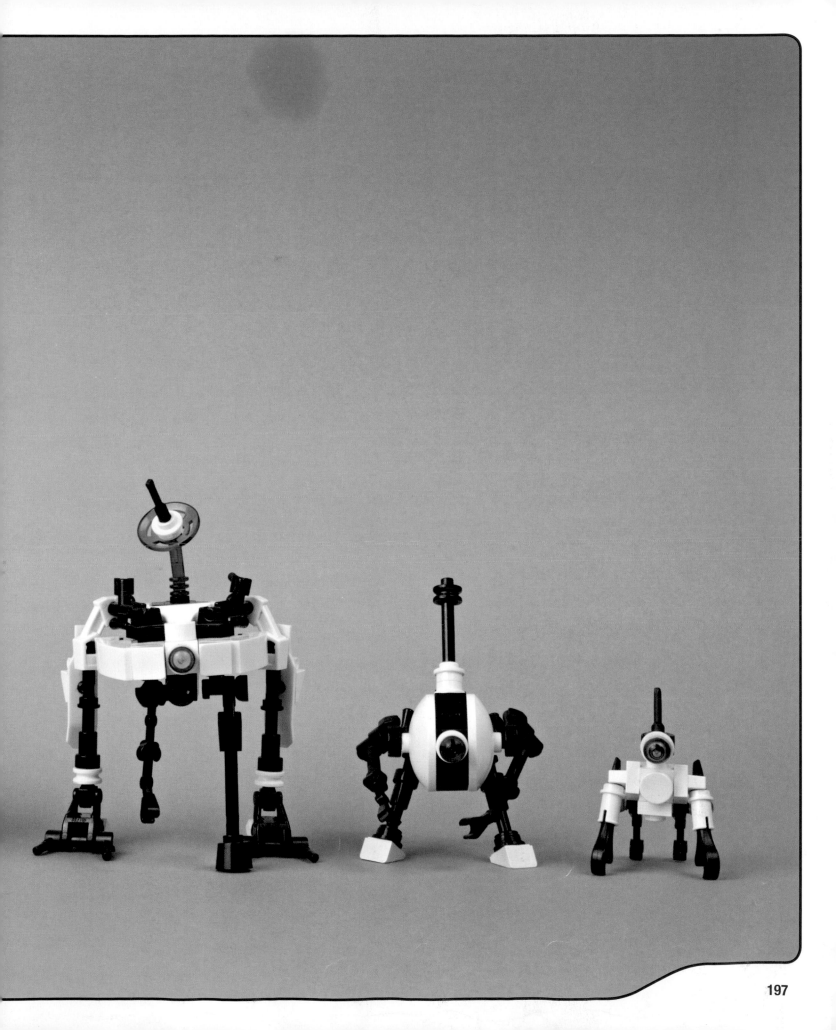

FEDERATION SURVEY ROBOT

One of the more common Valor Squadron robot types, this mechanoid is an essential part of terraforming operations. Several variants of this robot are in service on Panduro.

Designed to be fully independent, the mechanoids are fitted with an external guidance system that allows them to be remotely operated by humans whenever necessary.

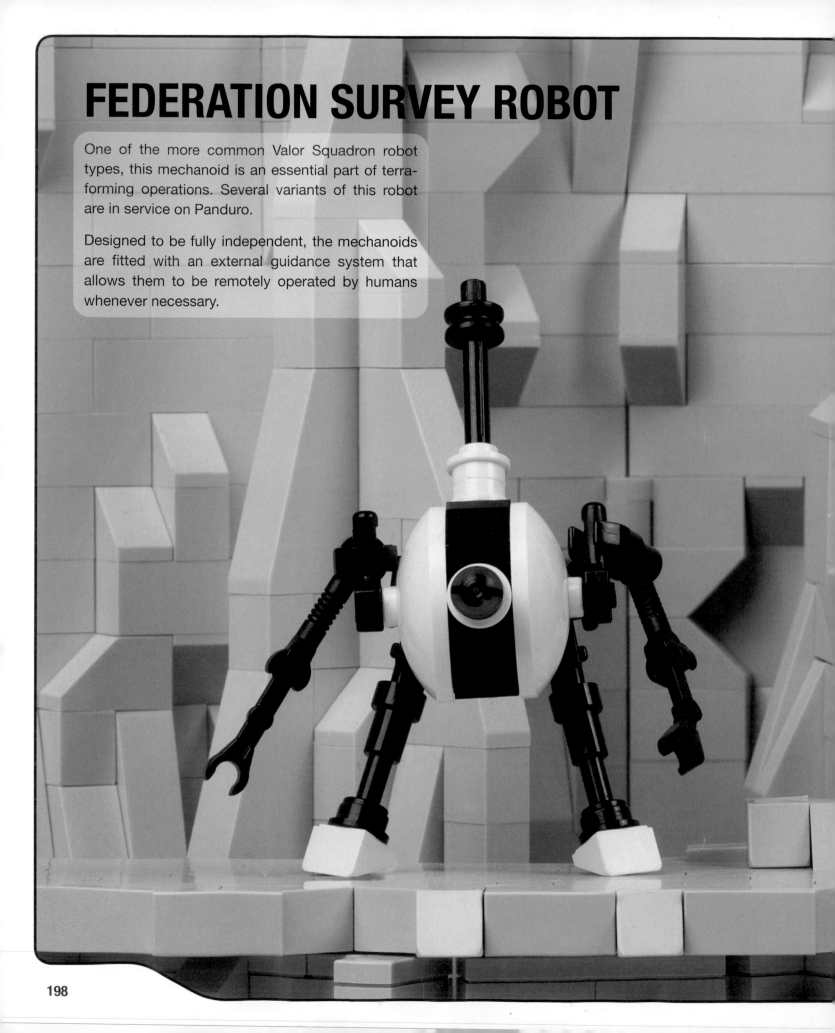

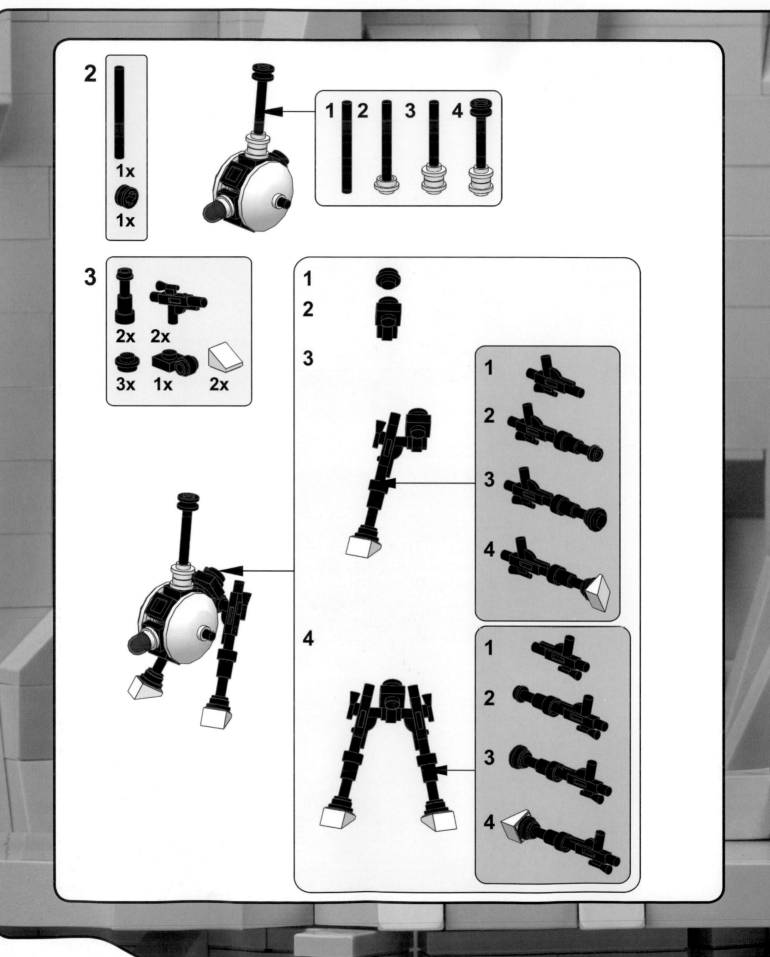

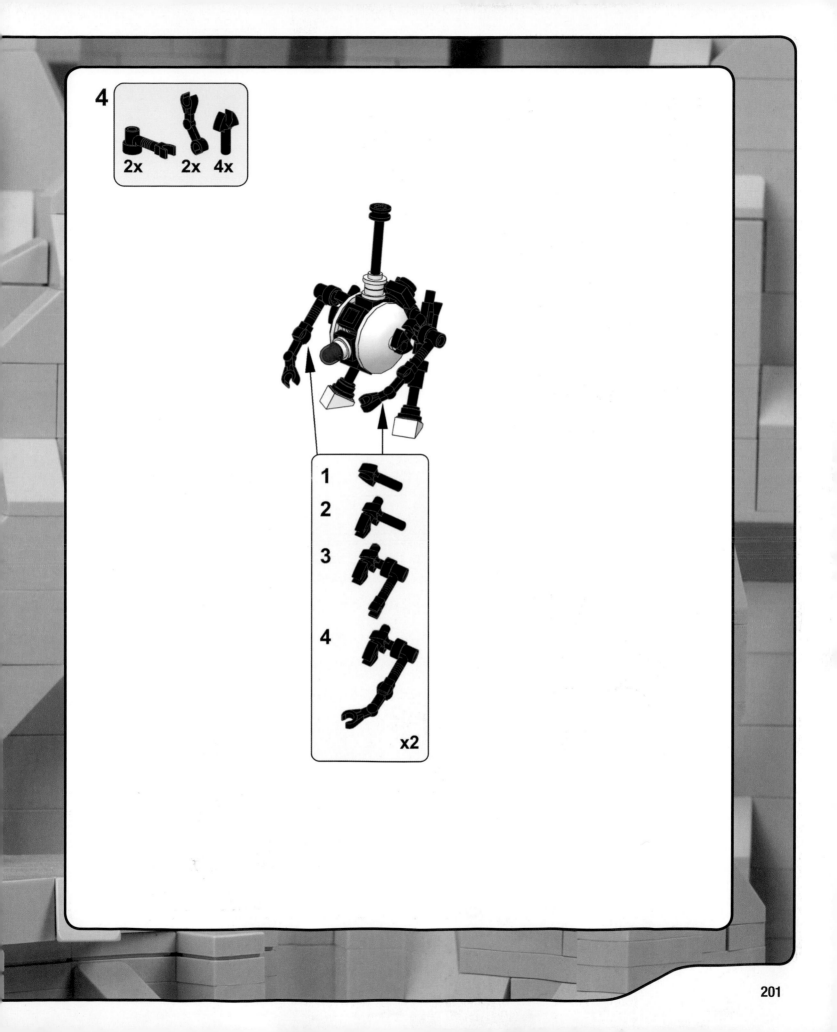

INVADERS

Hidden behind Panduro's moon, the *Tyrant* was undetectable. Kazak stealthily transported scores of troopers, robots, and vehicles to the surface of the planet. The attack force was deployed by *Octrax* shuttles to a location far from the primary Federation settlement.

The invaders were careful. They waited for Kazak's signal, then touched down in the uncharted valleys and caves of Panduro, far from regular Federation patrols. Dr. Spaltro had provided the invasion force with drugs to slow their metabolic rates. They were quite content to wait for the moment of conquest.

Exposure to the worms had turned Kazak's agents into unrecognizable hybrids. Behind obsidian visors, eyes that were no longer human glared at the colonists' progress with fear and hatred.

The dark men waited for the signal to attack. Valor Squadron was unaware that a shadow was about to fall.

Every night, under cover of darkness, Kazak ordered his warriors to move closer to the outer perimeter of Valor Base. The plan was to maneuver his forces close enough to launch a devastating surprise attack. But the invaders hadn't counted on a chance encounter that would throw their strategy into disarray.

Below: Kazak's invasion force was deployed into remote canyons, far from the colonists.

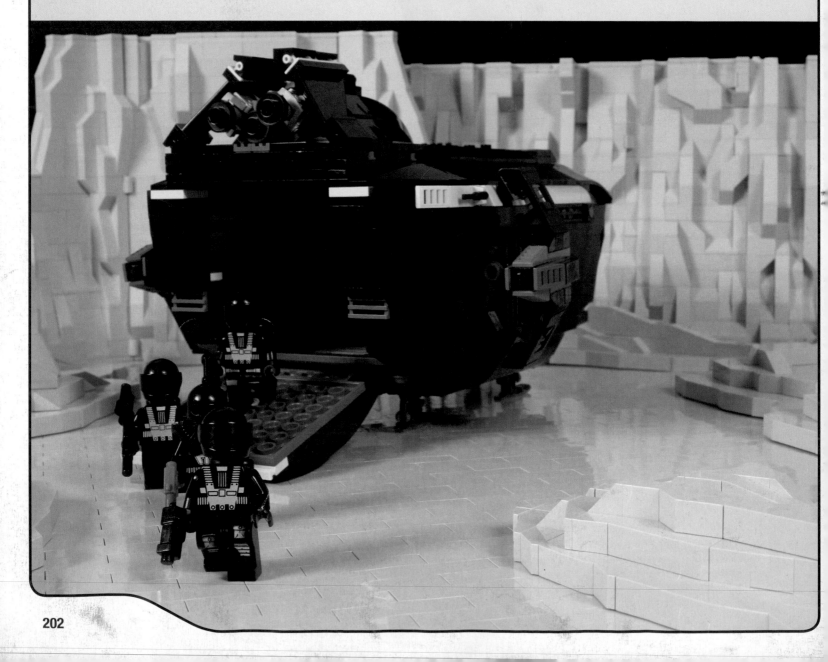

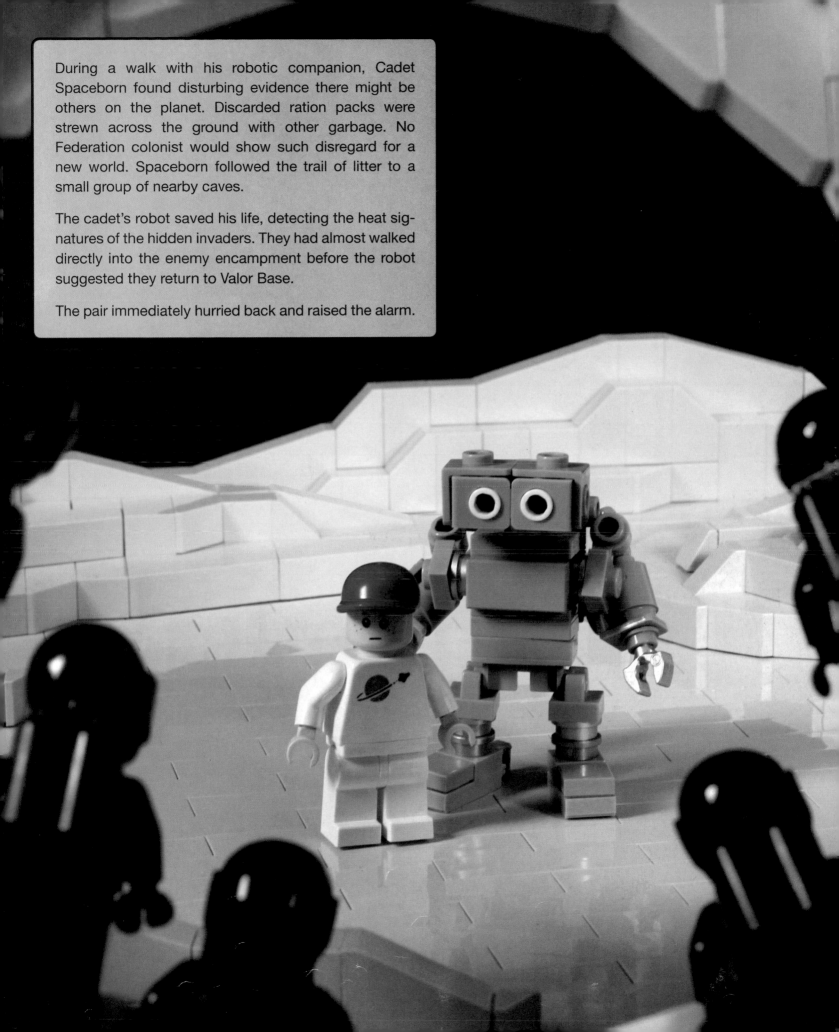

During a walk with his robotic companion, Cadet Spaceborn found disturbing evidence there might be others on the planet. Discarded ration packs were strewn across the ground with other garbage. No Federation colonist would show such disregard for a new world. Spaceborn followed the trail of litter to a small group of nearby caves.

The cadet's robot saved his life, detecting the heat signatures of the hidden invaders. They had almost walked directly into the enemy encampment before the robot suggested they return to Valor Base.

The pair immediately hurried back and raised the alarm.

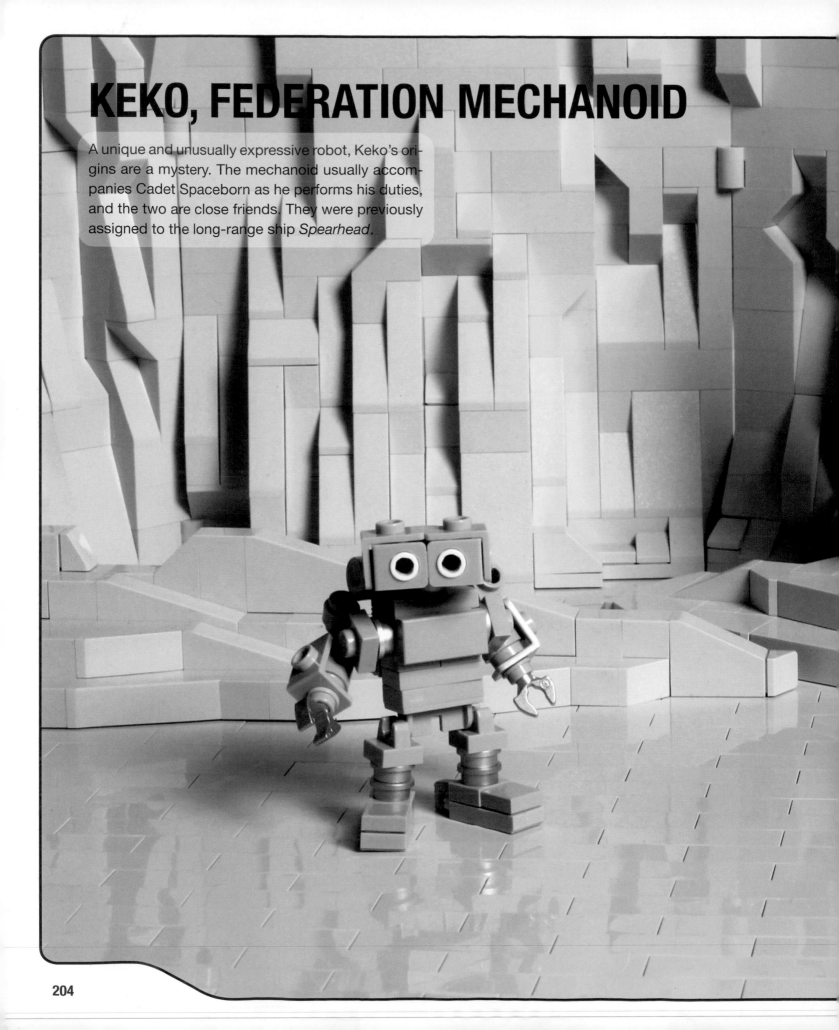

KEKO, FEDERATION MECHANOID

A unique and unusually expressive robot, Keko's origins are a mystery. The mechanoid usually accompanies Cadet Spaceborn as he performs his duties, and the two are close friends. They were previously assigned to the long-range ship *Spearhead*.

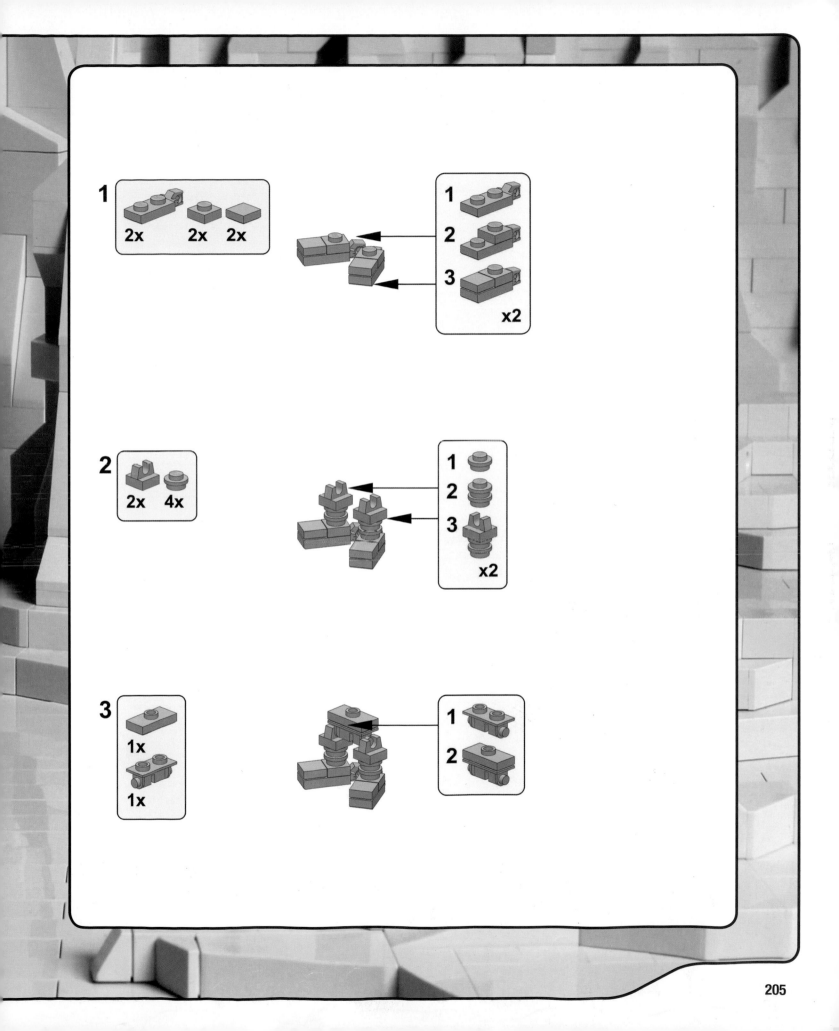

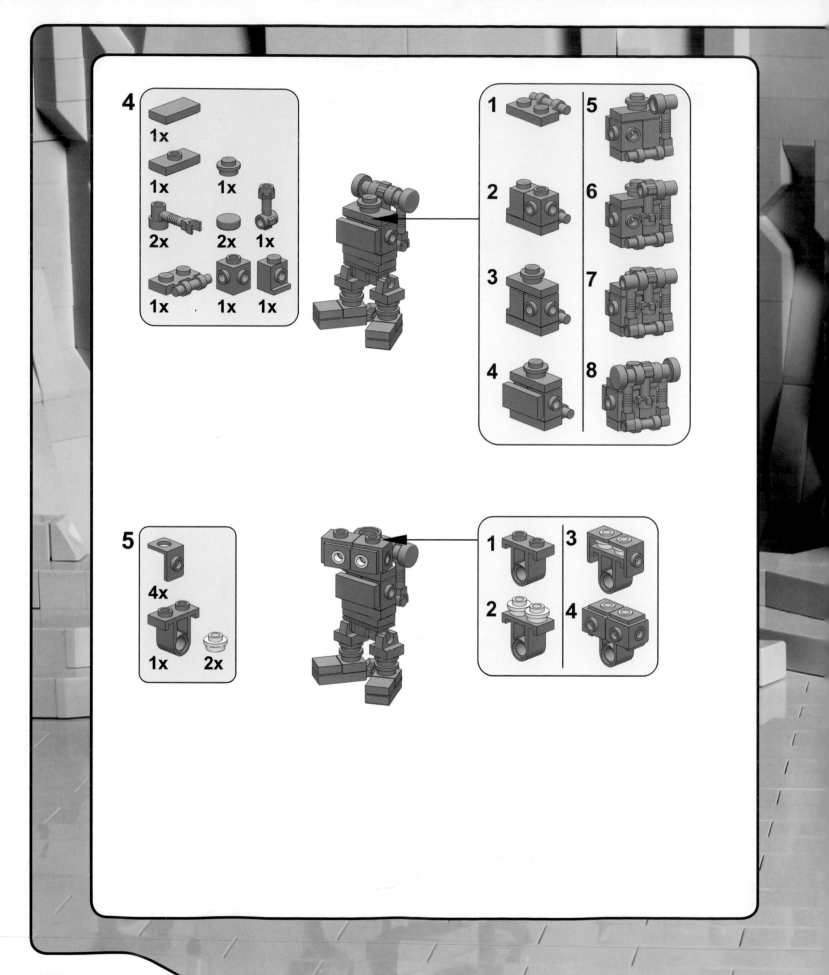

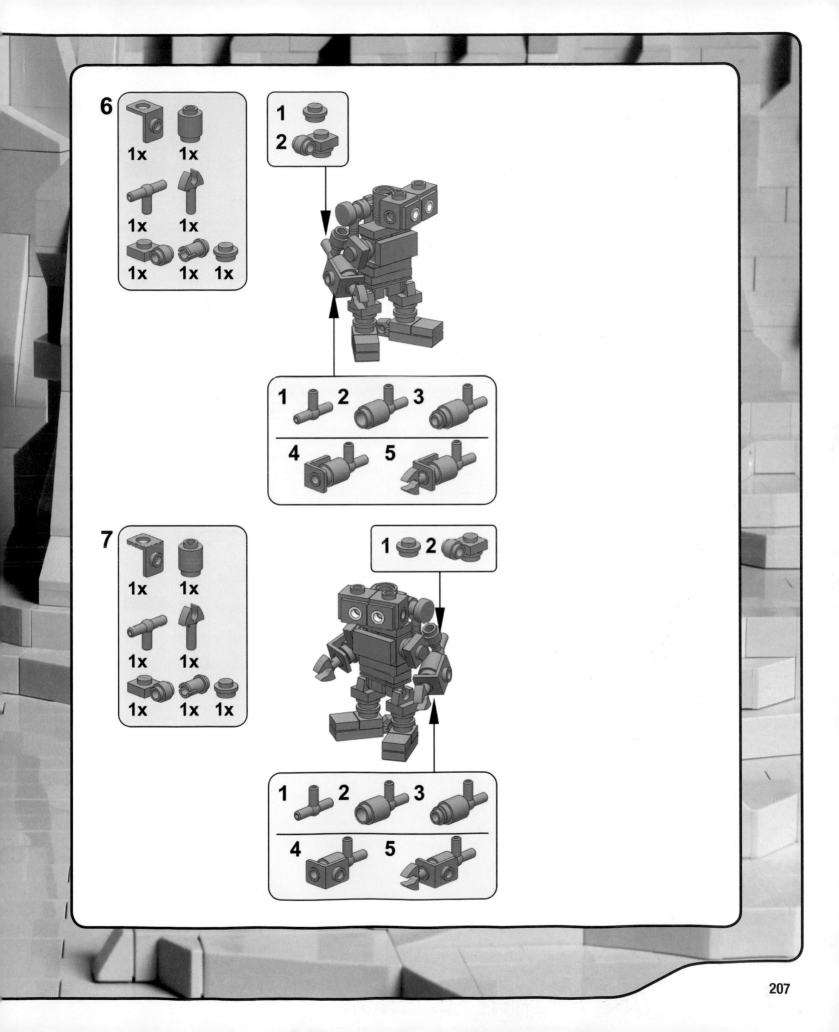

ASSAULT ON PANDURO

On Valor Base, the robot's transmission was received, and emergency orders were issued to all personnel. As the alarm sounded, all work details ceased. Engineers armed themselves from the weapons room and activated defensive protocols.

Kazak knew the moment had to be now. He gave the order to attack.

Kazak's ground troops swarmed Valor Base from all sides. The invaders launched a fierce initial attack, but swift tactical countermeasures implemented by Commander Delthorn ensured damage was minimal.

Mounted on Jetbikes, the dark warriors flew around the perimeter of the base, chasing members of Valor Squadron. The indvaders' Jetbikes were faster, but the Valor Squadron riders were familiar with the area and knew the terrain. They had no trouble leading the dark riders away from the base.

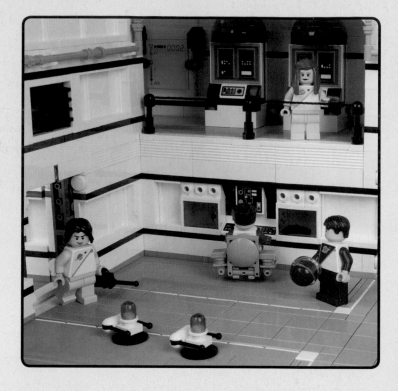

Above: Valor Base receives Keko's emergency transmission.

Below: Valor Squadron riders lead Kazak's forces away from the base.

Opposite: The attacking forces were held off by a lone FT-828 walker fitted with an adapted mining laser.

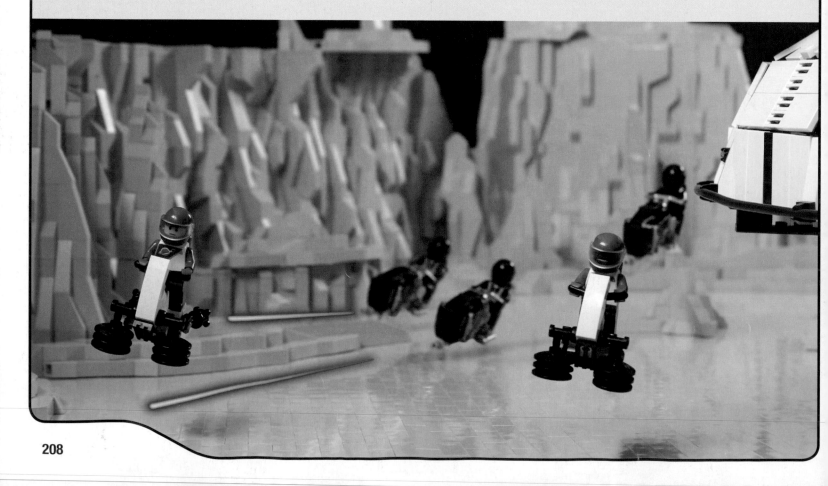

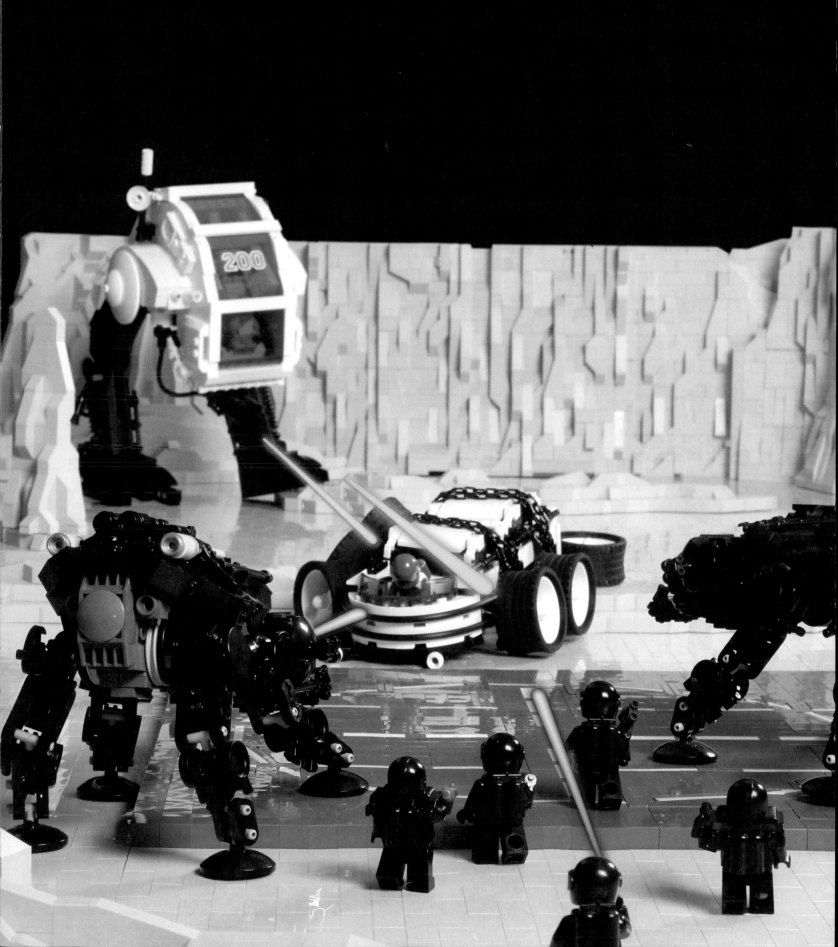

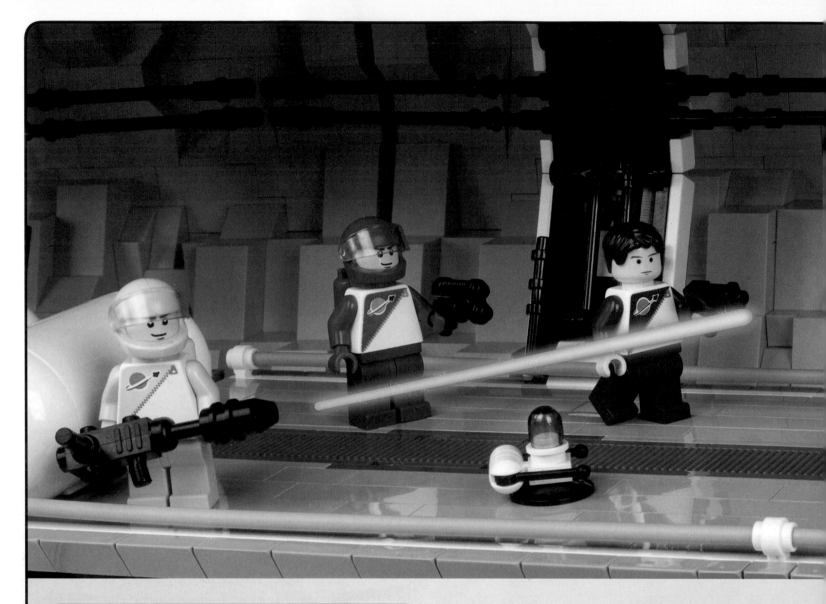

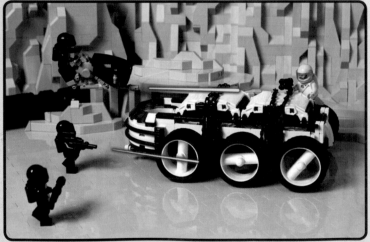

Above: The battle raged on the surface of the planet. Casualties were high.

Top: The dark robots proved ineffective in battle.

Valor Squadron arranged themselves into defensive formations to protect the colonists, who had taken refuge within the depths of Valor Base. Squadron members who were stationed beyond the base perimeter heard the alarm and made their way toward the battle.

Kazak directed the assault from the bridge of the *Tyrant*. He did not send the worms down to assist the invasion force. He deeply regretted the loss of the worms he'd left behind on Krysto Base and would not risk losing the creatures again.

His plan was bold but deeply flawed. The invasion force was undernourished, many of them suffering from prolonged use of Spaltro's medication. Daylight on Panduro was harsh and unfiltered, revealing the full extent of their transformation. They were weakened by the light, outnumbered, and outgunned.

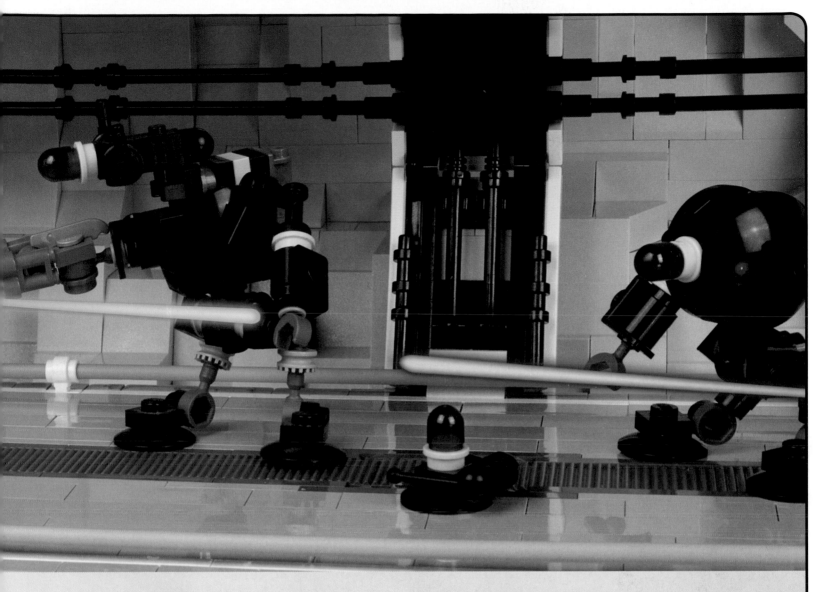

A small team of dark robots managed to breach an access corridor leading directly into Valor Base. This could have turned the tide of the battle in Kazak's favor. But even with extensive processor modifications, the dark robots failed as warriors. Despite the best efforts of Kazak's engineers, the safety protocols in Professor Dade's chip could not be disengaged. When faced with a human target, the machines simply shut down. LMD processors reset to their factory settings, and the dark robots laid down their weapons the instant their targeting systems passed over a human.

The assault on Panduro lasted just two days.

Above: Two Valor Squadron members track down and deactivate a malfunctioning dark robot.

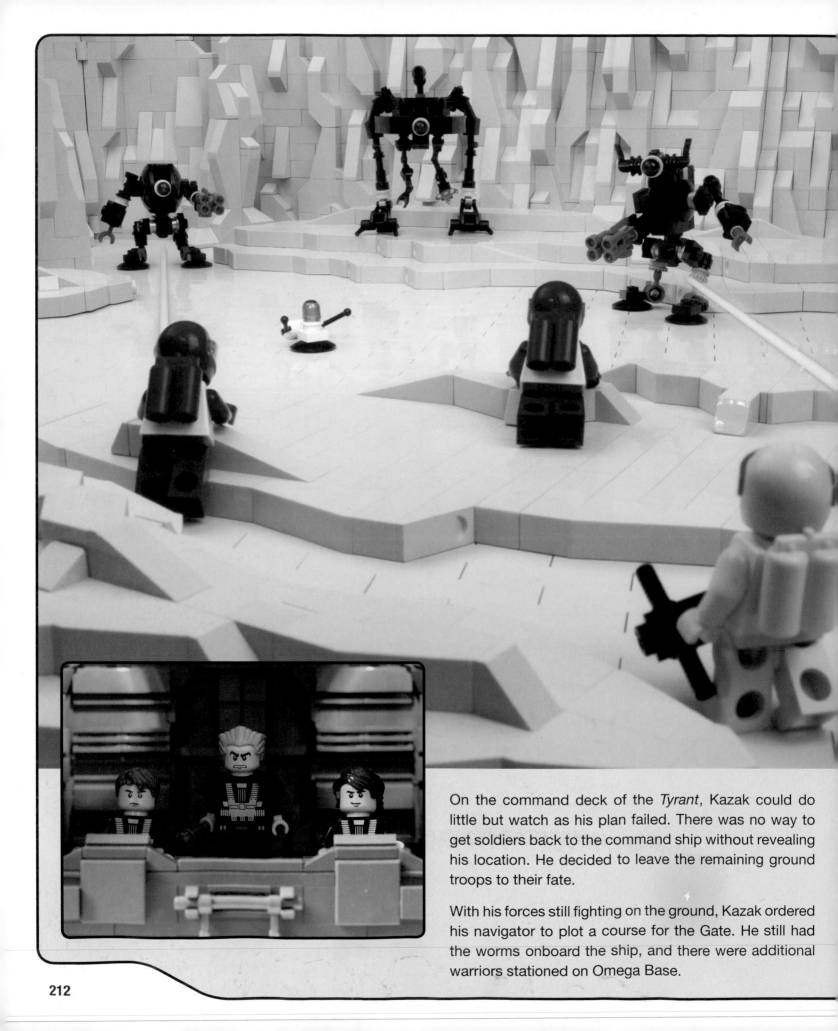

On the command deck of the *Tyrant*, Kazak could do little but watch as his plan failed. There was no way to get soldiers back to the command ship without revealing his location. He decided to leave the remaining ground troops to their fate.

With his forces still fighting on the ground, Kazak ordered his navigator to plot a course for the Gate. He still had the worms onboard the ship, and there were additional warriors stationed on Omega Base.

Federation *Interceptors* exploring the Altair system converged on the battle zone. The ships blasted Kazak's army from above, their powerful weapons laying waste to the invaders. *Octrax* drop ships were destroyed by *Interceptors* as the retreating squads attempted to board for takeoff. Commander Delthorn ordered all units to concentrate their firepower on the heart of the battle.

There were no ships close enough to intercept the *Tyrant* as it emerged from behind Panduro's moon and made its way to the Gate. Kazak powered up the Gate through a remote command, with the final part of the virus activating as the ship came within range. The *Tyrant* powered its way through the Gate and vanished from the Altair system.

Opposite top: Valor Squadron mops up the last of Kazak's robot forces.

Opposite below: From the bridge of the Tyrant, *Kazak gives the order to retreat.*

The Tyrant *escapes through the Gate.*

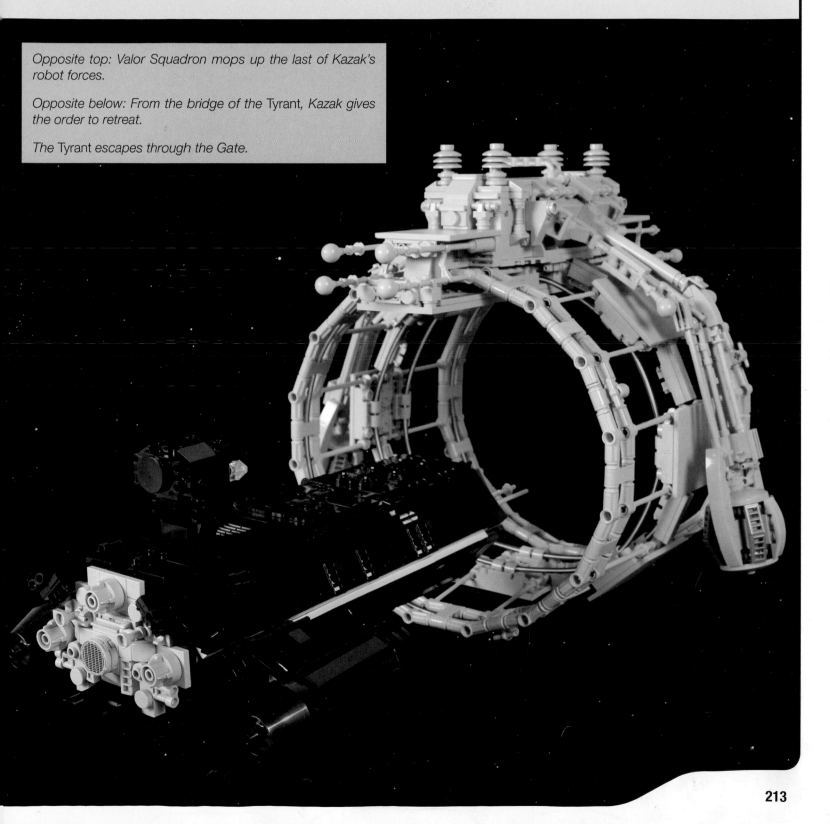

Back on Panduro, Valor Squadron took no prisoners. This was a new world, and the forces of evil had no place among the good people of the colony.

The remaining dark warriors fought to the very end. Their humanity had been stripped away by exposure to the worms. They asked for no mercy and received none from the colonists. Valor Squadron was meticulous in wiping out the last remnants of the dark force. Unwilling to take a chance by recommissioning the dark machines, the colonists recycled them. The materials found new life as farming units and weather beacons.

Security patrols would remain on high alert, and the Gate was fitted with additional safeguards to prevent any future infiltration. Valor Squadron resumed its efforts to transform Panduro. The colony was safe. Scans detected the *Tyrant* on a course for Hyperion, and reports from the Core System confirmed that the ship had returned to Omega Base. Kazak's army had truly left the Altair system.

On Panduro, atmospheric processors continued to pump vast quantities of oxygen into the skies. Eventually the ratios stabilized, reaching acceptable levels. The pioneers tended to the land, planting crops and using weather drones for directed rainfall. Genetically modified plants began to grow around the perimeter of the base. Atmosphere processors gradually reduced their efforts, and vegetation did the rest. Lichens, grasses, and moss spread over the plains, providing a foothold for future life. At last it was possible to take shallow gasps of rough, foul-tasting air. The atmosphere on Panduro had become breathable.

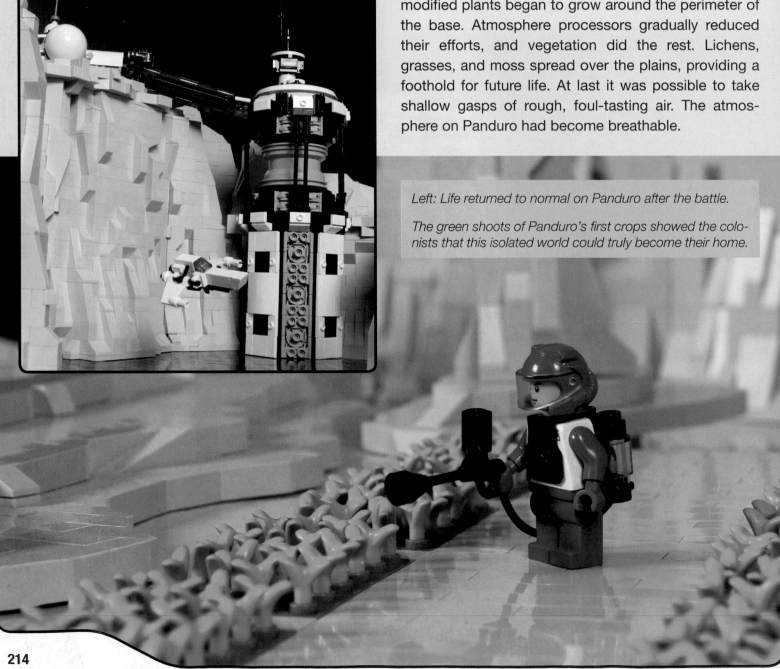

Left: Life returned to normal on Panduro after the battle.

The green shoots of Panduro's first crops showed the colonists that this isolated world could truly become their home.

Five years after the very first engineers arrived, the planet was ready for a new generation of settlers. Hundreds of pioneers began their migration from the Core Systems, eager to build a future on Panduro.

With so many people living on the distant planet, the future of mankind was assured.

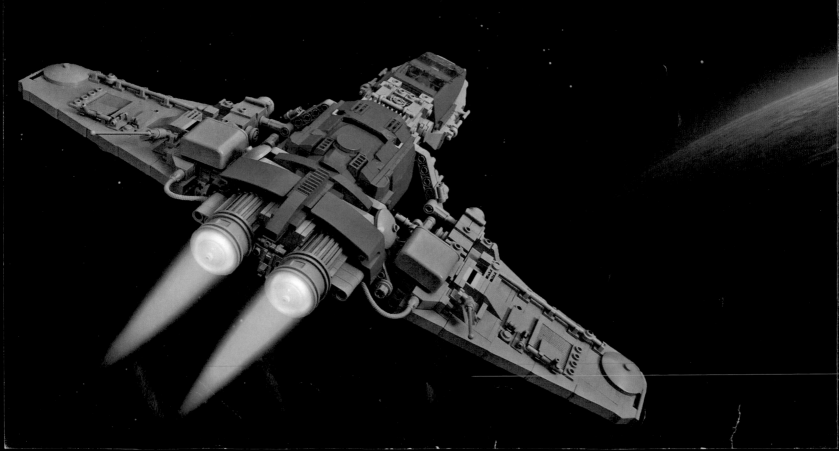

Special thanks to:

Our parents and Yvonne, Sharon, Julie, and Julie.

Tyler, Serena, Rich, Kenny, Tommy, Megan, Nick Barrett,
the Federation officers, and all our LEGO friends.

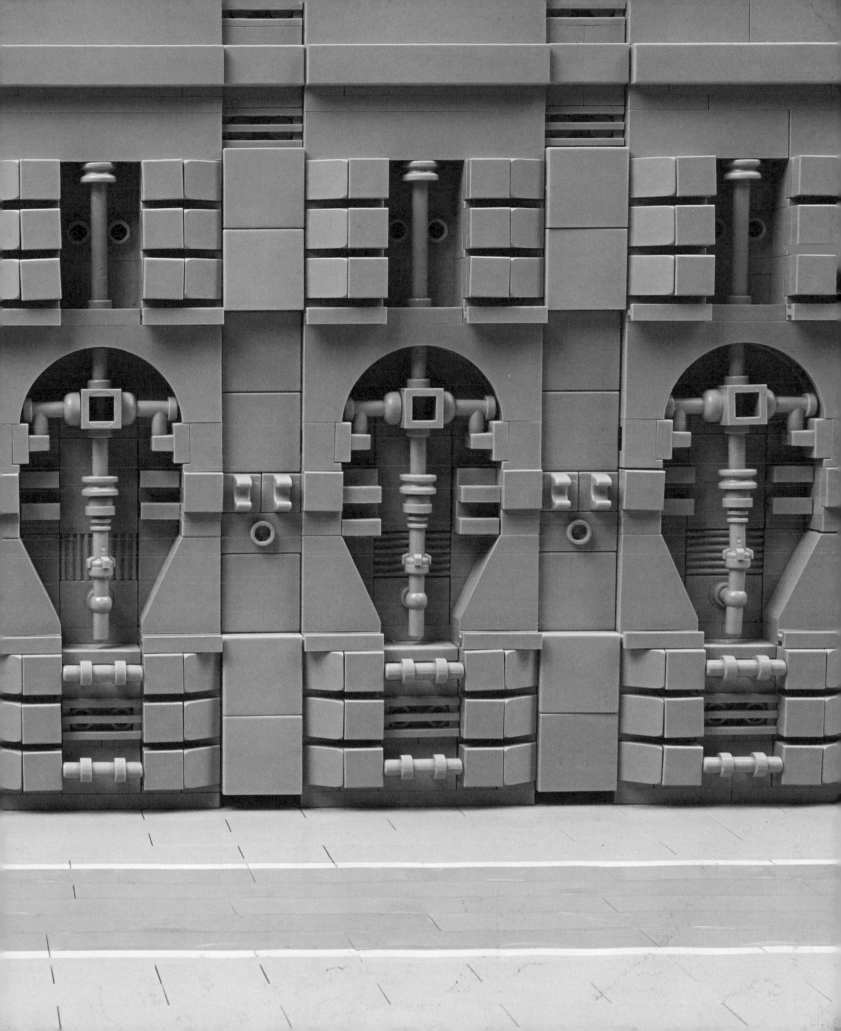

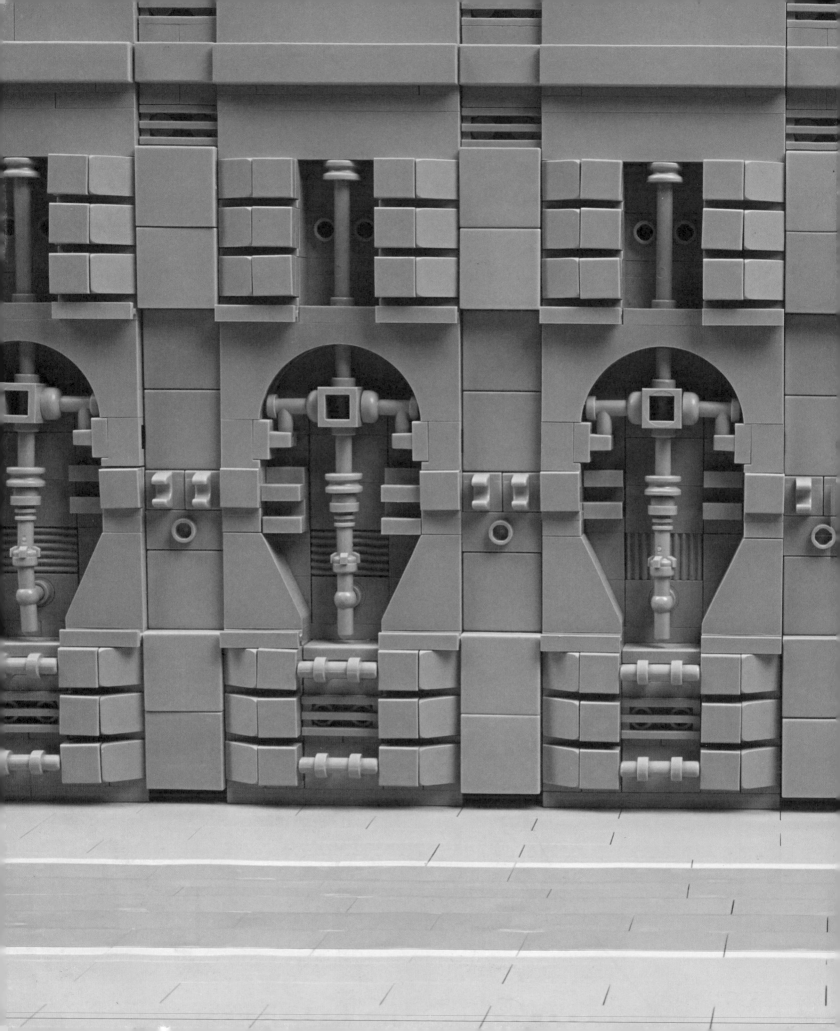